Photographer

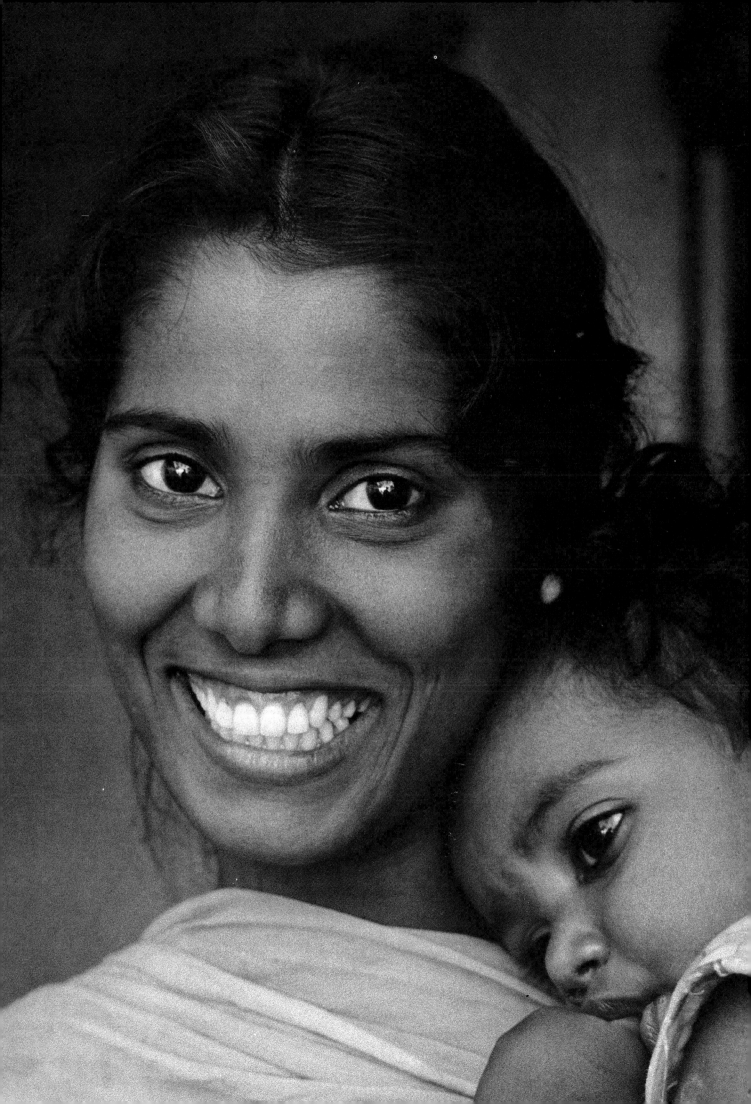

CLAUDE
SAUVAGEOT

Photographer

ZIFF-DAVIS PUBLISHING COMPANY
NEW YORK

I must thank Jean Barthélemy, who contributed greatly to the development of this work.
I also wish to express my gratitude to André and Gilles Abegg, Marie-Ange Donzé, Jean-Claude Gautrand and Denis Vicherat. Their suggestions and ideas helped me greatly in the composition of the text and were the origin of many of the examples cited in the book.

All photographs are by the author.
Designed by Raymond Babigeon.
English translation by Geoffrey O'Brien.

Contents

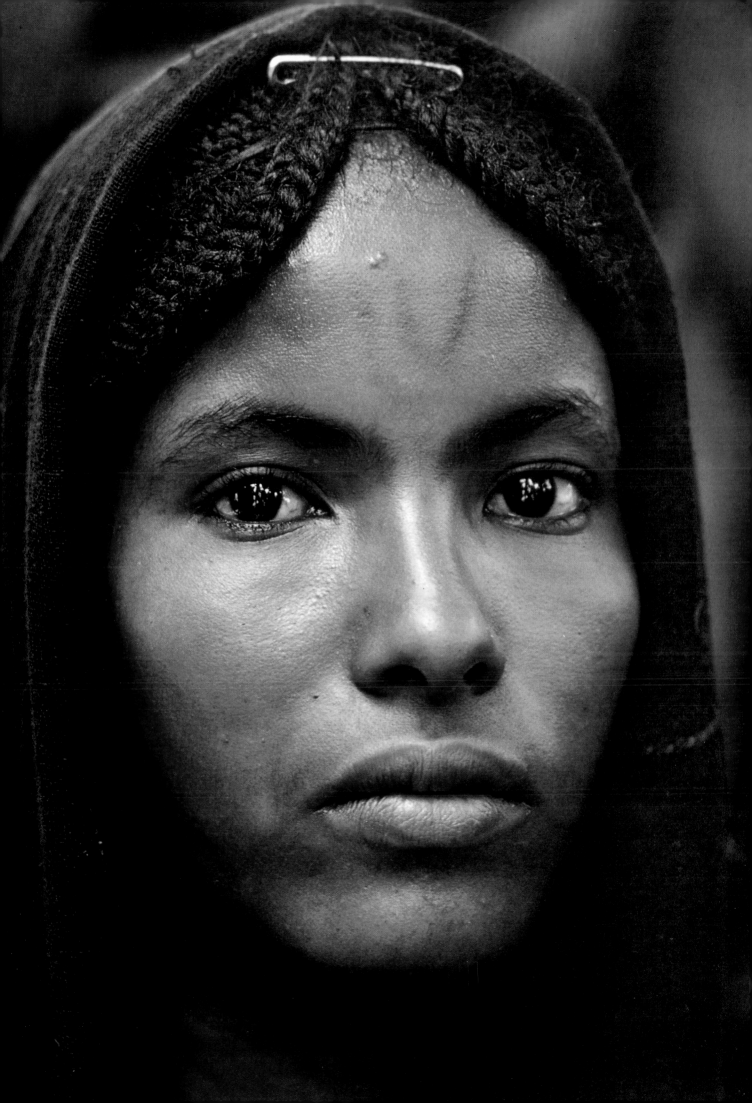

The World and Other People

The technical details about the photographs in this book offer only general indications. It would not be possible for a professional photographer, whose job is to create a document which transmits information, to take time in the midst of his work to note down the technical details of each shot. All too often he does not even have time to take explanatory notes for the caption which must accompany any published photograph.

Ethiopia. 1974. Young nomad woman of the Afar tribe, in the Danakil desert.
Leicaflex, Elmarit 90mm, f/4, 1/60 sec., Kodachrome II.

Opposite title page: India, New Delhi. 1968.
Mamiya C 33, Sekor 135mm, f/5.6, 1/60 sec., Tri-X.

To take a good photograph you must have a certain sense of artistry and some degree of technical knowledge; but above all you have to know how to look with understanding, in order to be able to extract the essence of what you see.

The art of photography is not an inborn human activity; it must be learned, like reading or writing. In the United States this was understood earlier than in Europe, and consequently this new art is taught in many American colleges and universities.

Millions of photographs are taken each day. However, the people who take them are generally disappointed with the results. The picturesque Greek market where they strolled eating melon, the veiled woman they snapped stealthily in the streets of Kairouan, even baby's first steps have been reduced to small, barely visible points in a blurred image, with washed-out colors and no sense of space.

Some people think all you need for taking a good picture is a camera equipped with multiple wide-angle and telephoto lenses. Nothing could be further from the truth, because success really depends not on the camera but on the person who composes the picture and clicks the shutter at the right moment.

In the first place, what is the criterion that makes a photograph good or bad? Above all, the impact it makes: what the viewer feels when he sees it, and what he learns from it. Much of that impact will obviously depend on what subject is chosen, but also on how it is framed, where it is placed, how it relates to the totality of the image. The impact will depend furthermore on the precise instant when the subject was captured on film, and on the light which, if correctly handled, will set it off and give it added depth.

Choosing the Subject

Nowadays anybody can take a photograph, but taking a good one is more difficult than most people imagine. It requires patience, imagination and perseverance. Train yourself by spending hours shooting the same subject. Any subject will do: a tree, your dog, a nude. Move around it, climb up on a stepladder, get down on your stomach, photograph it from above, from below, from the side, against the light, from very close or from a great distance, and then compare your results. Think about them, ask yourself why one has more impact than another. Learn how to obtain precisely the depth of field you want. Apertures are like the speeds of a car; you have to learn to handle them almost instinctively. Above all, don't get discouraged, even if the first results are not as good as you hoped. Mastering photographic technique is a learning process. Tell yourself that the next attempt will be better, and remember that nothing should ever be done haphazardly.

Bear in mind that a photograph must always be interpretable at a single glance; it is no use clicking the shutter at random. Always ask yourself why you are taking a picture, what you want to photograph and what you want to show. Think about the image frame and about what methods you can use to emphasize the main subject. Take time to look for an original and personal composition. Play intelligently with light in order to enhance the subject. Click the shutter with awareness, neither too early nor too late. Don't panic, and don't hesitate.

9

Remember that a photograph is a kind of violation. Learn to limit this aggression. Never run away like a thief after photographing a stranger, and never forget to thank him, if only with a smile or a wink. This is elementary etiquette.

Framing

The beauty of a photograph, and its meaning, depend to a large extent on its framing. Get as close as possible to your subject, and avoid leaving large empty spaces or filling up the picture with unnecessary details. Framing a portrait from the neck up emphasizes the sitter's expression, the character of his glance, all of which is not even noticed if the face is lost amid a jumble of other things (unless, of course, you are setting out to show the subject in his environment). To capture a Moslem at his prayers, his hands lifted toward the sky, and make a close-up out of it, is already interesting in itself. It becomes even more interesting if you show him in front of his mosque, the man very sharp (you are basing your focus and depth of field on him), and the minaret in soft focus behind him. The image becomes a document. But don't neglect to photograph the praying man in a low angle shot, a little bit from below, in order to bring out his character: if you shoot from above, his meditative expression will be flattened out.

A landscape will be devoid of interest if three-quarters of the picture consists of an insipid blue sky. On the other hand, if the sky is stormy, the landscape will take on a new intensity when photographed from the same angle and with the same composition as before. The use of a red filter (for black-and-white) or a polarizing filter (for color) will add an even more dramatic effect to the clouds. In any case, don't forget to put a foreground in your picture, whether it be a tree branch, a clump of grass, or a fence, in order to give it an impression of perspective and depth. The person looking at the picture must feel he is *in* the landscape, not miles away from it. The thistles in the foreground, even if they are blurred, must seem to be within reach of his hand. The horizon should never divide the image into two equal parts but should rather as a rule be in a 1:2 ratio. This is what is known in pictorial composition as the law of the golden number. All these small, seemingly insignificant details make the difference between a good and a bad photograph.

The Right Moment

To click the shutter with full awareness is without a doubt the most difficult thing of all. Never press the button in haste. Take time to compose your subject. Look for original ideas and angles that are out of the ordinary. Make your imagination work. Wait until the movement of your model's arms or eyelashes are graceful, or until the clouds dotting the horizon come into line with the space between the two trees in the foreground. You must compose your photographic image as you would a painting.

The clicking of the shutter is the decisive instant on which the interest and life of the picture will depend. At a bullfight, for instance, wait until the exact moment when the matador rises and places his banderillas on the bull's spine. If you hesitate two seconds more it will be too late; the animal will be seeking a new adversary on the other side of the ring. A second earlier, nothing was happening.

Lighting the Subject

Light plays an essential part in the success of a photograph. Do not forget that light is the very basis of photography, since film only registers impressions according to how much light it receives.

In the early days of photography, when film was insensitive and lenses not very fast, bright light and, often, a long waiting time were required in order to register an impression on the emulsion; hence it was necessary to place the subject in direct daylight or in front of a large floodlight. Those days have passed; in fact, today it is advisable to do just the opposite. If you take a portrait in direct sunlight, the subject will blink and his face will tighten up. In a portrait, the eyes and their expression are the primary points of interest. The same

(1) Seville. 1972. Holy Week procession. Contarex, Distagon 28mm, f/5.6, 1/60 sec., Tri-X.

(2) Amsterdam. 1973. Spokesman of a hippie community living on board a boat. Contarex, Planar 50mm, f/2, 1/20 sec., Tri-X, available light.

(3) India. 1968. Tahar desert, Rajput peasant. Contarex, Sonnar 85mm, f/8, 1/125 sec., Tri-X.

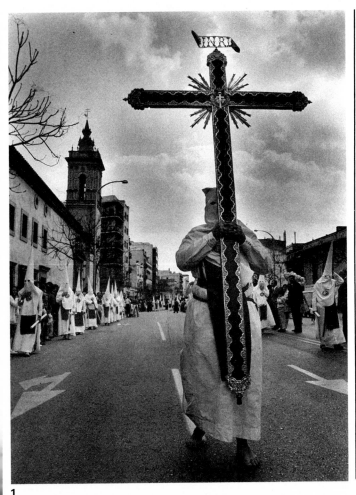

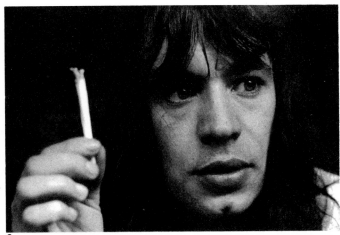

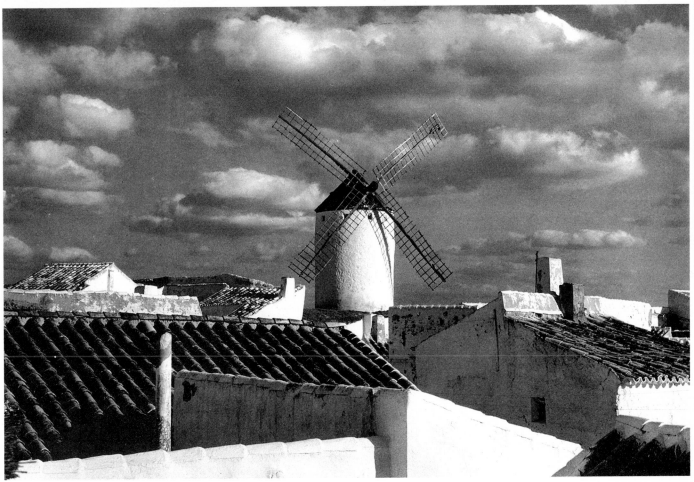

(4) Spain. Don Quixote; one of the famous windmills of La Mancha. Rolleiflex, Planar 90mm, $f/11$, $1/125$ sec., Agfa 17, yellow filter.

1

2

3

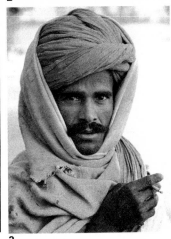

4

(1) Paris. Easter service in a Russian Orthodox church. The church was lit only by candles.
Contarex, Planar 50mm, f/2, ½0 sec., Tri-X, available light.

(2) Spain. Seville. 1972. Night procession during Holy Week.
Contarex, Distagon 28mm, f/2, ½0 sec., high-sensitivity Ektachrome, ASA 160.

1

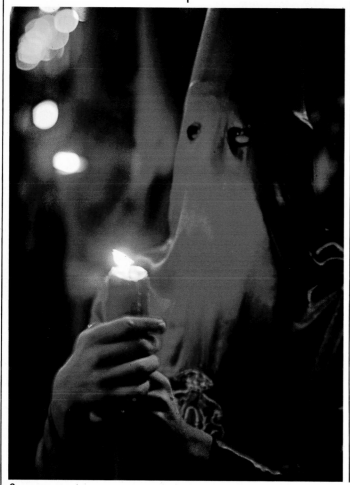

2

3

person, in shade or with backlighting, will surprise you by the intensity of his expression.

A landscape or a monument photographed in the sun's axis (that is, with your back to the sun) loses dimension because the different planes, blotted out by the excess of luminous rays directed toward the image, can no longer be differentiated. On the other hand, if you place yourself at an angle of 45 to 90 degrees in relation to the sun, the shadows of each element will be emphasized, giving the picture a strong sense of depth.

In most cases—and especially in hot climates—the best light is at daybreak or in late afternoon. Avoid taking pictures between 11 A.M. and 3 P.M. At noon, the contrasts between sunny areas and shadows are so violent that they literally burn the emulsion and wipe out all the details.

It is a mistake to think that the sun is indispensable to the success of a photograph. With the sensitivity of today's high-speed films it is no longer the

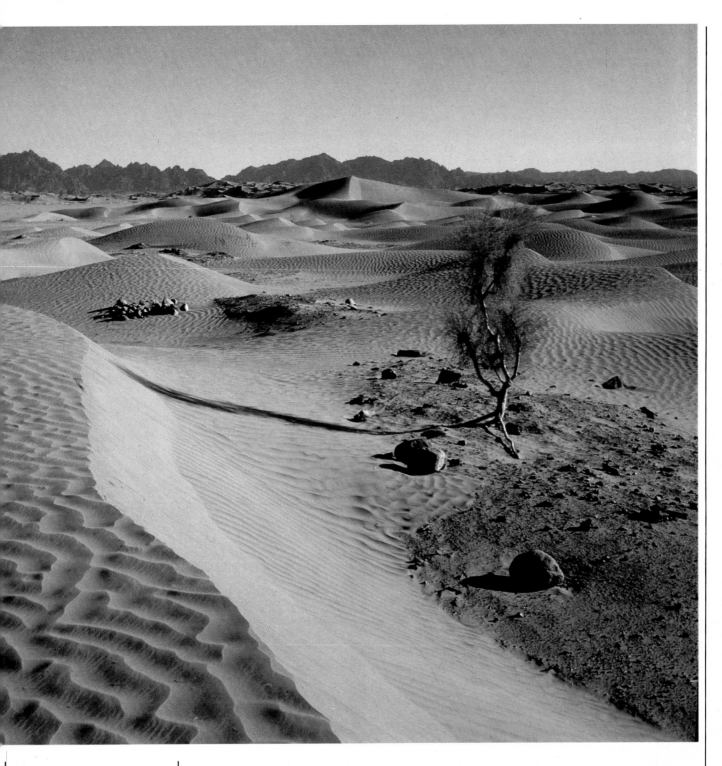

(3) South Pakistan. 1966. Contarex, Distagon 35 mm, f/8, 1/60 sec., Kodachrome.

intensity of the light that matters, but only its direction. Any beginner can photograph a pretty's girl's bust, even in color, using only a candle for lighting; in fact the result will be livelier and more intimate than if you used a flash. It is sufficient to use a wide lens opening at a fairly slow exposure. Of course the model—and above all the photographer—must make every effort not to move.

A flash, whether electronic or manual, flattens the photograph with the strength and direction of its light (if it is built into the camera) and removes all the atmosphere from the picture. Therefore, as much as possible, it is better to bring light reflections into play by shooting with available light, even if it's very weak. When the lighting of an interior is especially weak, make sure the objects and people you are photographing are never backlighted, but directly face the light source, whether it is a window or a lamp.

Whether you are working in sunlight or shade, leave a sunshade permanently attached to the lens. In many cases it will prevent underexposure if you are

13

photographing against the light. It will also protect the lens in case of rain.

Movement

The lack of sharpness typical of most amateur photographs is usually due to the movement, not of the subject, but of the person holding the camera. Whatever exposure speed you are using, even to a thousandth of a second, if you move as you click the shutter, the image will be distinctly blurred. Always hold the camera with both hands, one gripping the body with a finger positioned above the shutter button, the other under the lens attachment and regulating the focus. If you have a tendency to shake, find a point of support and lean on your elbows to steady yourself.

Only use a tripod in extreme cases, when the shutter speed is slow (less than 1/60) or when a large telephoto lens is being employed. A stable tripod is heavy and cumbersome to transport, and its use precludes all possibility of spontaneity. It is better to take a picture at 1/250 (f/5.6) than at 1/125 (f/8), 1/60 (f/11) or 1/30 (f/16). Most lenses produce the sharpest results when their diaphragm is closed two stops higher than the widest opening. Thus, a lens that opens at f/2 will give the best definition between f/4 and f/5.6.

For a moving subject you should always use the highest possible speed of exposure. Otherwise the main subject will be blurred, even if the rest of the picture is sharp (unless you are looking specifically for a grainy effect). To capture a horse in full gallop or a water-skier in action (you being positioned at the rear of the boat pulling him) you will need a minimum speed of 1/500 if you want the image to be relatively sharp.

Black-and-White or Color

It is a mistake to think that the transparencies with the most color are the best. Too many gaudy colors work against each other. The best images are often monochrome shots enlivened by a single touch of color.

Don't photograph exclusively in color. The expression of a friend's face will often be more eloquent in black-and-white. On the other hand, a sunset or a rainbow ought to be shot in color, since it is color that gives them their full significance.

The Age of Exploration is Over

One of the primary goals of the photographer is to go where no one else has gone, in order to discover and show what no one else has seen. But do you have to travel far away to do that? Not necessarily. Today, thanks to long telephoto lenses, the amateur, like the professional, can close in on his subject from any point he chooses, even if it is not physically accessible. For example, no tourist is allowed to climb up on the spire of Sainte-Chapelle, but with a 2000mm telephoto lens he can spy on the swallows that have built their nest at the tip. But if you confine yourself to seizing unusual moments in bizarre or unknown places you are limiting yourself.

There are few corners of our planet which have not already been filmed a thousand times, whether they be the last Indian tribes of the Amazon, Saharan rock paintings, or uninhabited Pacific islands. It's increasingly difficult to bring back unique and original documentation of what no one has ever seen.

On the other hand, one of the major roles of the photographer is rather to bring to light, thanks to his unusually profound sense of observation and his sharpened sensitivity, the everyday realities which our jaded eyes have long since ceased to analyze or even to notice: the beauty of a gesture, a moment's emotion, an atmosphere of tranquillity, an anxious glance . . . the thousand brief instants which, no matter how trivial they seem, are in fact what make up the richness of life. But first you must be able to perceive them.

Refining Your Visual Perception

Although some people consider photography to be, like music or painting, a gift or a predisposition you are born with, it is nevertheless possible to develop your vision to a considerable degree, just as you can your ear or your memory. And just as a pianist acquires extraordinary dexterity through constant practice, the

Sikkim. 1972. Rumtek monastery, Tibetan student.
Contarex, Distagon 28mm, f/5.6, 1/125 sec., Tri-X.

14

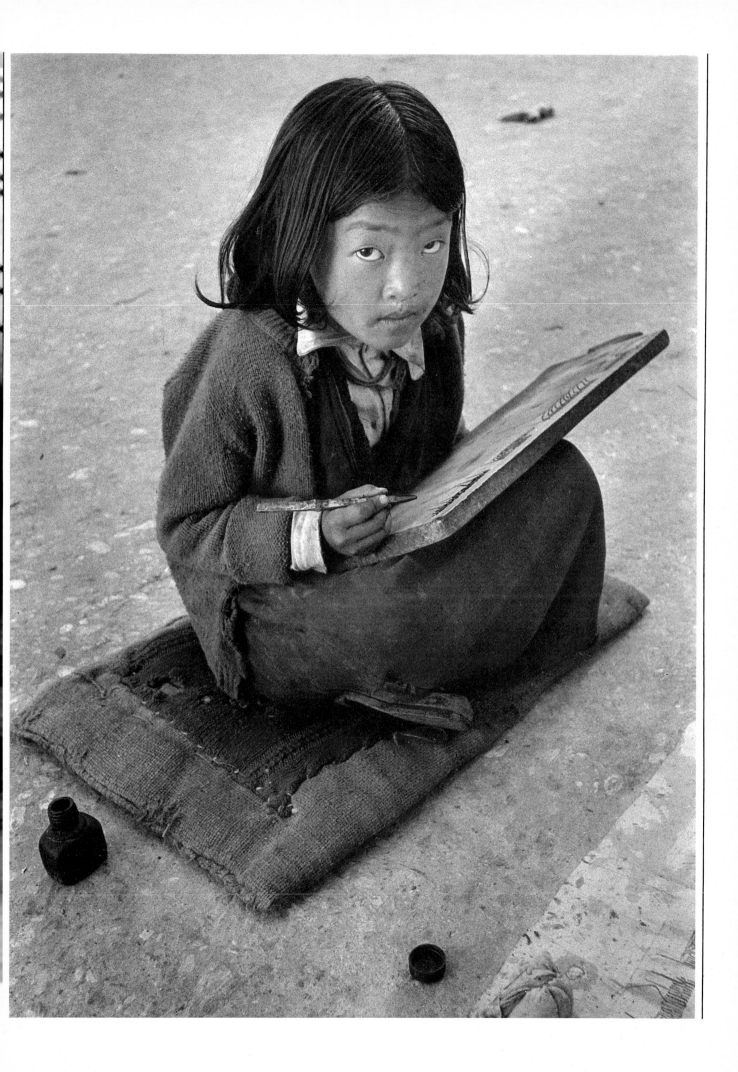

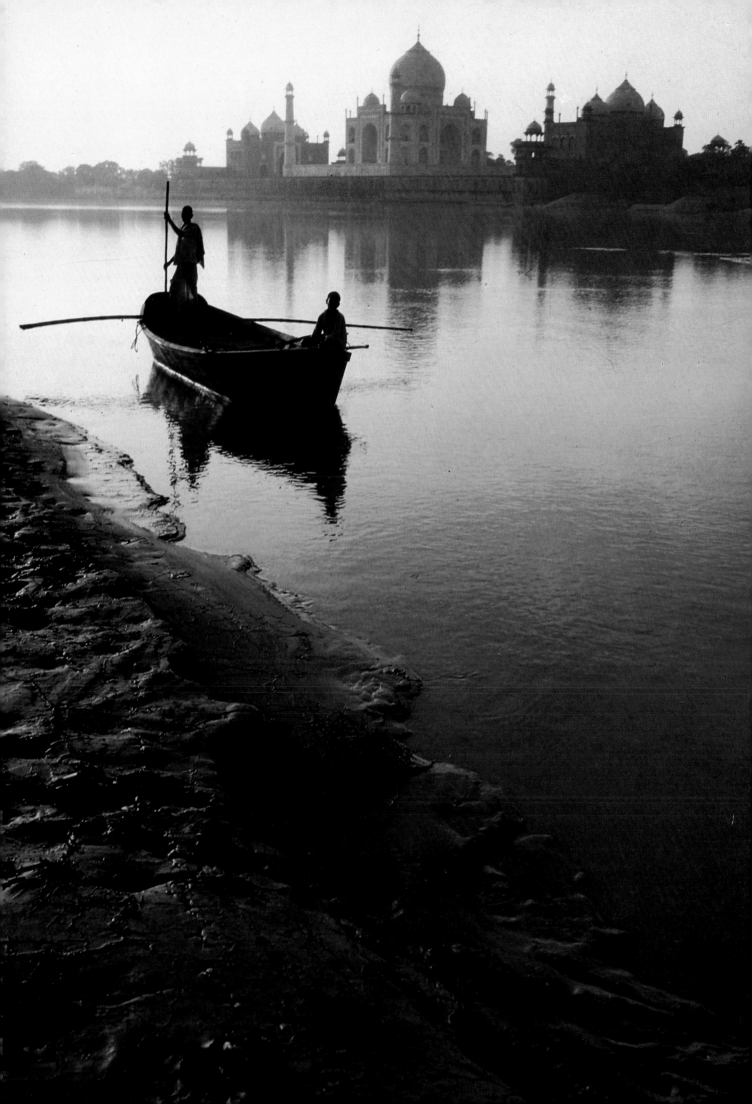

photographer who habitually analyzes movement and light finally comes to see nature with a perception that most people lack.

Imagining the chemical reactions of a particular film to a landscape or a still life is a way of rediscovering their colors—colors which an untrained eye no longer even sees. Because it does not analyze light, the ordinary eye does not perceive the effects that light can have on objects and on nature; it remains content with conceptions rooted firmly in the brain once and for all: a tree is green, the sky is blue or gray, a poppy is red.

Photography, like painting, is a way of refining your perception of color and, above all, of the imperceptible nuances that can make a sky sometimes more mauve or violet than blue. This education in sensitivity will lead to understanding the hues that will dominate a color emulsion under varying conditions. When the film comes back from the laboratory with too much indigo or magenta, it is easy to believe (at least when you are a beginner) that the fault lies in the processing or in the quality of the film. Such rationalizations are a good way to excuse one's own incompetence. And you may ask, how important are such defects anyway?

First you must ask yourself why you are taking pictures. It makes all the difference in the world whether you view a photograph as a souvenir, as a means of expression, as a document, as a work of art, or as all of these things.

A Photograph Is Always Subjective

When photography first made its appearance, many people considered it objective in contrast to the subjectivity of painting. After much reflection and analysis, it is now understood that there is no more objectivity in photography than there is in painting. This has not prevented people from striving for objectivity in photography.

There has been much talk about photorealism and *cinema-verité*. But the mere fact of photographing or filming a certain object or event at a certain moment makes it nonobjective, since a particular moment and place have been singled out.

No matter how honest a photographer may be, he translates what he sees and perceives, not only in terms of what is in front of his eyes, but in terms of his sensibility and thus of his subjectivity, or (more humbly) in terms of his competence or incompetence at clicking the shutter at the right time. Still, you can talk about the objectivity of the image. But the attitude of a photographer and the results he obtains can be very different, if not absolutely opposite, to those obtained by another photographer looking at the same phenomenon. It is a question of temperament, of the way he reacts to the subject. There is no such thing as absolute truth.

Every photographer perceives reality according to his own subjectivity, but also according to how his lens shows it to him. The photographic apparatus merely translates the photographer's will as expressed in the framing and in the instant chosen for taking the picture. Everyone has his own way of behaving in a given circumstance.

The Lens Is Also a Screen

You must also realize that the photographer's glance is protected by the lens, which establishes between him and his subject a barrier tending to neutralize the impact of the situation he is in (a war correspondent perhaps would be unable to bear the atrocities he witnesses if he were not detached from reality by the screen of the lens).

It might be well at times for the photographer to leave his camera behind in order to make it easier for him to meet people. In France, and even more so in other countries, the camera is always perceived as a barrier by the local inhabitants. A photographer who under certain circumstances chooses to forget his vocation will perhaps lose a few beautiful images, but he will retain in his heart the warmth of a glance, or the intensity of an encounter that a photographer with a camera would not be able to bring about. And that, sometimes, is perhaps more important.

India. 1972. Taj Mahal at daybreak.
Contarex, Distagon 24mm, f/8, 1/60 sec., Kodachrome II.

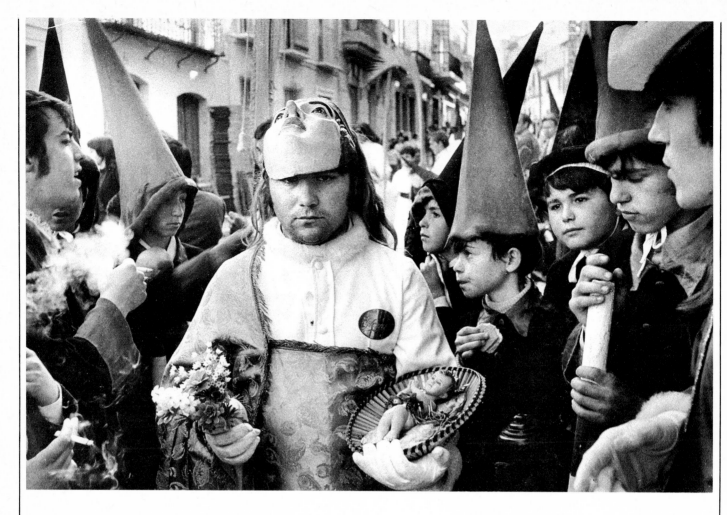

Photojournalism: A Trade To Be Learned

Every amateur photographer dreams of being a great photojournalist. You could almost say there are as many reporters as there are reflex cameras with interchangeable lenses sold. But the truth is that photojournalism is a profession that must be learned, and is not something you can improvise simply because you have been lucky enough to find some good material.

Anyone who wants to enter this difficult profession must remember that taking a photograph is not only an artistic act but also frequently a political act. A photo essay is edited, exactly like a sequence in a movie or even like a novel. There must be an introductory shot, explanatory shots that make up the main subject matter, a concluding shot. It is an entirely different process from that of an amateur, who is usually content to photograph what he likes. It is what separates a professional photographer from the others.

A journalistic snapshot must contain a certain number of facts that the reader can discover at a single glance. He will be able to make sense of the picture more or less easily according to the talent of the photographer. That is what makes the difference between a bad photographer and a good one; the latter is capable of transmitting, intelligently and artistically, what he has discovered or what he knows through the intermediary of his camera. But the same holds true for amateurs as well as for professionals.

Spain. 1972. Holy Week procession in a small village near Seville. Contarex, Distagon 35mm, f/8, ¹⁄₁₂₅ sec., Tri-X.

The City

To take photographs that really capture a city you should either know it very well . . . or not at all. The instant you first arrive in a new place and the thirtieth year you spend there are two apparently dissimilar, even opposite, stages, but both are equally intense. Between these two periods of extremely sharp perception, there is a neutral zone often devoid of any enthusiasm. The first time you see New York you are necessarily dazzled. Powerful impressions instinctively make themselves felt. You are shocked or surprised by a way of life foreign, even entirely unknown, to you, a way of life the inhabitants themselves are not entirely aware of.

On the other hand, if you live for a long time in the same place, if you have an inquiring spirit and an observant eye, you end up being able to penetrate the soul of that place. You know its smallest windings, and even in a large crowd you can pick out the regulars of a particular cafe. You become aware of the slow evolution of those thousand seemingly insignificant details that make up the soul of a city.

You can always take interesting pictures, at any place, at any point in a trip, even in the midst of a long stay in the same city. Luck can be a factor, but a systematic search is the most important element of success. You never know when an interesting event will take place, one that will let you collect a maximum of valuable documentation.

Approaches and Techniques for Street Photography
There are a number of techniques for capturing raw moments of life on the street. The first, which is the most effective and the most honest, consists in surprising your subject, but without hiding.

Set yourself up with your equipment in the midst of a crowd, and observe what's going on, on all sides. Your glance moves continually from one face to another, without stopping. From time to time you take a shot of someone passing by and advance your film while continuing to look at the subject—not directly into his eyes, which has a provocative effect—but without hiding from his glance. A smile is usually the best presentation, and the best way to excuse your intrusion. You will know right away if you have gained the model's involuntary cooperation.

The second technique consists of taking the picture but looking away immediately afterward with an air of sudden inspiration, as if your attention had been attracted by the surrounding architecture.

Another approach consists of hiding in a doorway or behind a tree, literally trapping the subject from your hiding place, in order to capture his full spontaneity while remaining incognito. In some ways this method resembles a sociological study, since it consists of intercepting and analyzing the behavior of strangers in the street without their being aware of the person spying on them, the idea being that you must avoid disturbing the environment and therefore must remain completely apart from what is going on.

But ultimately, the best formula for street photography seems to be the first: to stand immobile for a while in the midst of the passing crowd, to change place

(1) Paris. May 1, 1958. Pentacon, Biotar 58mm, f/8, 1/60 sec., Plus-X.

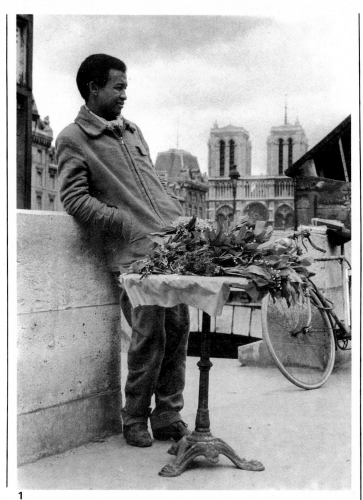

1

(2) Paris. Tourists picnicking on the banks of the Seine. Contarex, Sonnar 135mm, f/5.6, 1/60 sec., Kodachrome.

(3) Paris. Evening of July 14th, on Ile Saint-Louis. Contarex, Sonnar 85mm, f/4, 1/125 sec., Tri-X.

(4) India. 1967. Calcutta, very early in the morning. Contarex, Sonnar 135mm, f/4, 1/250 sec., Kodachrome.

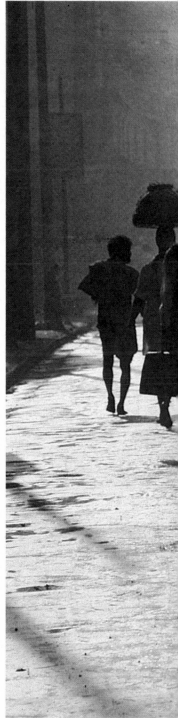

from time to time, without provocation and without making a display of the fact that you are there to take pictures, but without trying to hide the fact, either. According to temperament, there are a thousand and one ways to integrate yourself into an atmosphere, into a landscape, depending on the situation. It is up to the individual to discover the technique that puts him most at ease.

The Equipment: Wide-Angle or Long-Focus?
As for the equipment, there is no absolute rule. You can pick a wide-angle, standard, or long-focus lens, according to the effect you are aiming for. In general, big telephoto lenses are not advisable—except for static subjects— unless you are undertaking a study of a face, or of details, or of close-ups of hands.

Wide-angle lets you photograph the totality of an action within a single frame, and lets you situate the person you are photographing in his context (an important consideration in the domain of photojournalism). With a 35mm or 28mm lens you can photograph people passing by at point-blank range while keeping them in their environment, yet without any feeling of intrusion. They are aware that they have been the object of your attention, but they haven't had the time to become fully conscious of it, and by the time they do they are yards away from you and have let the matter drop.

To fully and calmly assume your role of photographer you must feel comfortable, and not self-conscious because you are carrying a camera. It is precisely when you feel a little guilty that difficulties crop up. You must not be afraid of people watching you while you work. In general, there are fewer problems when you present yourself frankly to people as a photographer than when you try to conceal yourself.

Just because you are photographing people in the street does not mean you will be taken for one of those photographic panhandlers who snap you as you

20

4

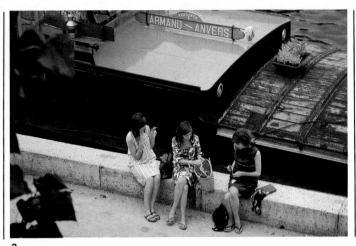

2

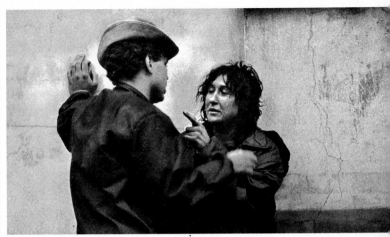

3

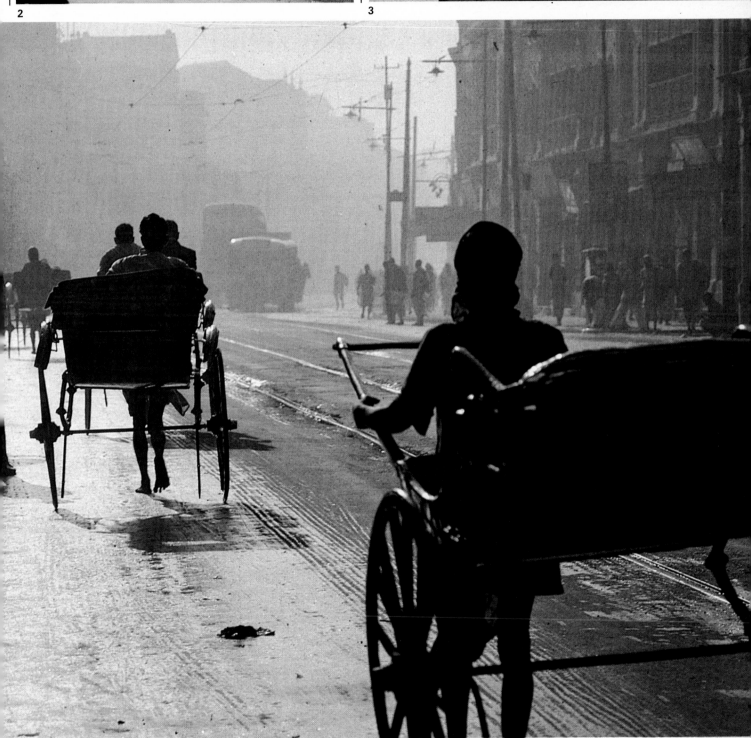

go by and then get angry if you refuse to buy their picture. They can hardly be qualified as photographers.

When You Feel a Little Uncomfortable . . .

When you are photographing certain particularly delicate subjects, or when you are in a third world country and are faced with highly distressing situations, you may well feel a kind of malaise in relation to your subject and in relation to yourself.

For a professional, the ideal would be to photograph only when he wants to or needs to; that is, every time he is motivated by an impulse stronger than the restraint that usually paralyzes us when we begin to work.

On the other hand, once you have overcome your initial reluctance, you may find yourself caught up in the subject from the moment you start shooting. You enter a different state of mind, up until the moment when someone reacts violently because you have passed the limits of moderation.

Then, according to reflex or temperament, you stop, or you keep going as if nothing had happened, or you take advantage of the ambiguity of this new situation in order to take things further and provoke a real explosion. Your own reactions will often be unpredictable in rapidly changing situations like that. Even if you know yourself well, you never know exactly what attitude you will adopt in the face of imminent danger. The situation can flare up into violence or end with a cordial handshake. Everything depends on how the photographer reacts. Will he be able to impose himself and at the same time be forgiven his indiscretion?

The Speed of the Action

Spontaneity cannot be invoked; neither can it be foreseen. You must always be technically ready for it. In one-fourth of a second you cannot measure light, focus, and choose your lens and shutter speed. You should always set your camera on hyperfocal distance, with a medium speed and a relatively narrow aperture.

This method is all the more effective when you work with wide-angle. That will allow you, in effect, a greater depth of field when you widen the aperture slightly.

Thus, when you are walking around, you must always pre-regulate your aperture and speed according to the available light, and you must be aware that a particular subject in a particular lighting corresponds to a particular aperture and speed. When you enter a shadowy area you must instantly rectify your setting and automatically make your calculations over again each time your frame and your lighting change. If an interesting subject suddenly appears, there is then no need to hesitate before clicking the shutter button. With the lens set on hyperfocal, there is a good chance that the picture taken on the spur of the moment will be sharp; in this way you can devote all your attention to the composition.

Hyperfocal distance is the lens setting that permits the maximum depth of field for a given lens, a setting where you are sharp all the way from infinity to the closest range. Every aperture has its hyperfocal. For example, if you close your lens at $f/16$ for 50mm, you are in focus from infinity to 2.5 meters, when you are set on 5 meters. In this way you can photograph without worrying between 3 meters and infinity, whereas if you leave your focus on infinity the image will be sharp only at 5 meters. But, on the other hand, if you focus on 2.5 meters, the field of sharp focus will extend only from 1.7 meters to 5 meters. If your opening is at $f/8$ and you remain set on infinity, the image will be sharp only from infinity to 10 meters. Set on 12 meters, you extend the depth of field, and the image will be sharp from infinity to 6 meters.

On most lenses, depth of field is measured in both feet and meters. It is up to you to pre-set the focus according to the chosen aperture and speed, in order to obtain the maximum sharpness so you can work spontaneously with a maximum of security.

Paris. Pont-Neuf, an autumn evening. Praktisix, Sonnar, Jena 180mm, $f/4$, 1/125 sec., Tri-X.

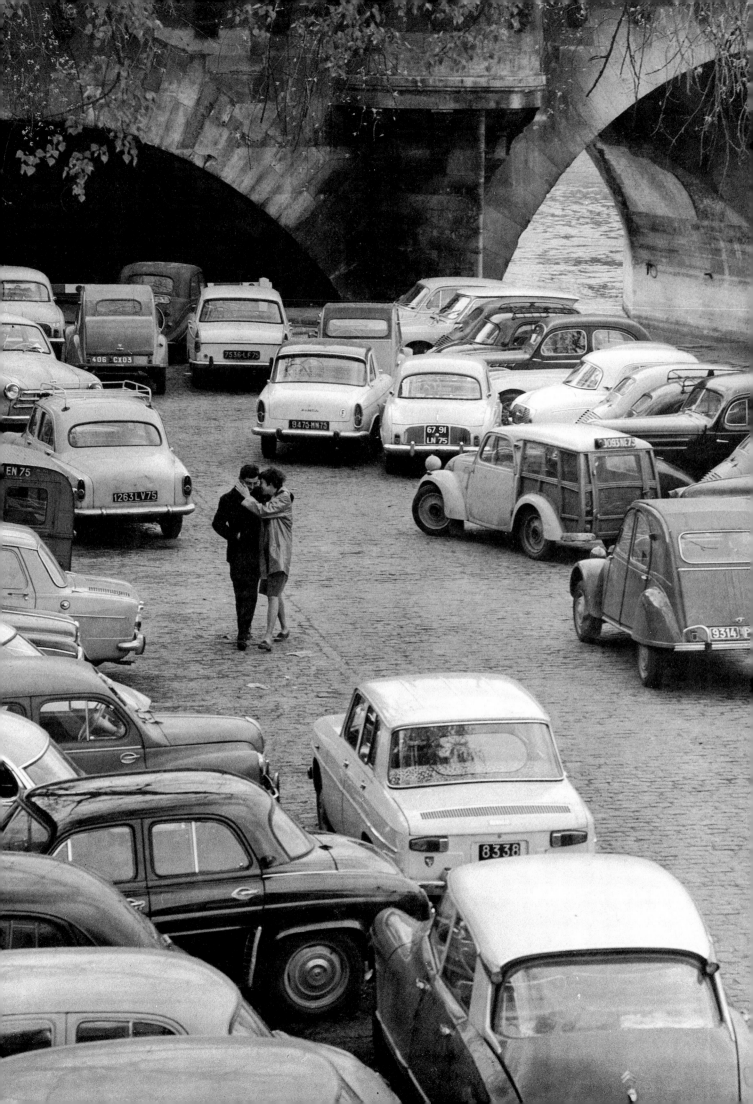

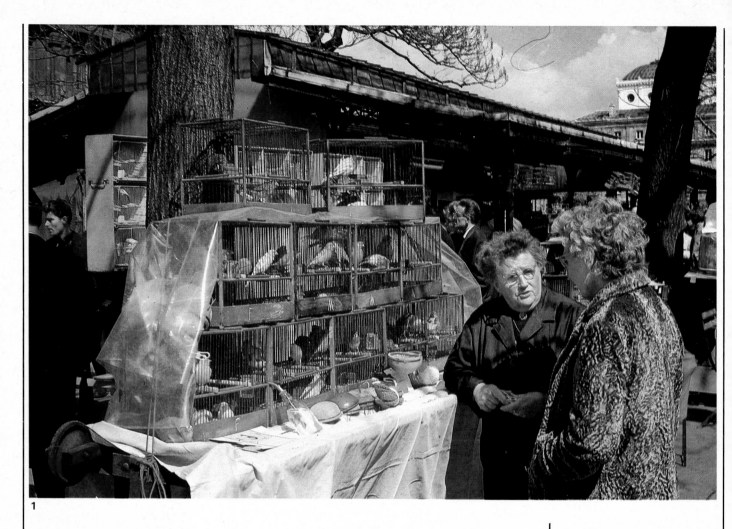

1

Knowing How to Wait

Since events, like spontaneity, cannot be summoned up at will, the photographer must sometimes wait a long time in the same place before capturing the picture which will best symbolize the ambiance of a city or of a situation.

Knowing how to wait is one of the outstanding qualities of any good photographer. The professional's obligation to meet his deadline at all costs no doubt imposes constraints. On the other hand, staying in the same place too long doesn't necessarily lead to better pictures than you could take in the first days, or even the first hours, after your arrival in Timbuktu or Concarneau. Don't wait until your curiosity gets stale.

The professional photographer, with a large budget and plenty of time, has a tendency to embellish his surroundings. Take the case of the correspondent from a major American magazine who was assigned to do a story on Venice. He decided there weren't enough pigeons at Piazza San Marco. After taking hundreds of pictures of pigeons in flight without getting the results he had hoped for, he went elsewhere and bought several thousand supplementary pigeons which he set loose at the right moment in front of his camera. Was the photo taken under these conditions really better than the one with only a few pigeons? The latter approach, less spectacular, would doubtless have required a little more patience and ingenuity.

Discovering the City

A great city is an inexhaustible subject for every photographer who is interested above all in people. Everything you find dispersed throughout a country, dramas of suffering or joy, can be found gathered in a few neighborhoods. The discovery of a city is thus one of the most enriching experiences for a photographer with a passion for human spontaneity.

Don't be afraid to go off the beaten track and don't forget that a supermarket, for all its apparent banality, can make an excellent subject for investigation. Any

(1) Paris. The bird market, a Sunday morning in winter. Contarex, Distagon 35mm, f/5.6, 1/60 sec., Kodachrome.

(2) China. 1973. Wuran steel factory. Leicaflex, Sumicron 50mm, f/2, 1/60 sec., Kodachrome.

place—church, store, station, restaurant, cafe—where people gather and meet, whether to work or to play, should be closely observed. Commercial streets are particularly fertile. On the other hand, the wealthier a residential neighborhood is, the more tranquil and monotonous it tends to be.

Markets are often key places for rapidly absorbing the atmosphere of an area, for they provide a bond of intense communication among the inhabitants, and at the same time are a link between city and countryside. Every market, indoor or open air, daily or seasonal, has its own personality. There is no resemblance between the great bazaar of Istanbul, with its labyrinth of alleys, and the market of Acapulco, covered in reinforced concrete, with its halls reserved for fishmongers and tiny restaurants, where fricassees of giant prawn or thick soups are served from dawn onwards to a multicolored and exuberant crowd.

The Arab souks, with their mysterious quality and their indefinable spices, the feverish animation of the market in Addis Ababa which extends for miles around, the fish market in Bombay, the stalls of the African merchants at the base of the mosque in the great square of Agadez, the open-air slaughterhouse for goats and camels: for a photographer these are all privileged subjects.

But it isn't necessary to travel so far to obtain picturesque images. Every European city has its secrets and its treasures. Many Parisian photographers may regret the disappearance of Les Halles, but there is still the flea market. (One note of warning: many of the dealers there, having been photographed time and again by inconsiderate tourists, have become allergic to photography and get angry the moment they see a lens.)

Most markets, especially when they are held outdoors, are difficult to photograph. The contrasts of light are often violent, between the merchants shaded by their parasols and the buyers standing in direct sunlight. If you don't pay attention you will end up with areas of excessive brightness alternating with areas of shadow. If you take a picture of the woman merchant counting her change under her tarpaulin, the surrounding area, being bathed in intense

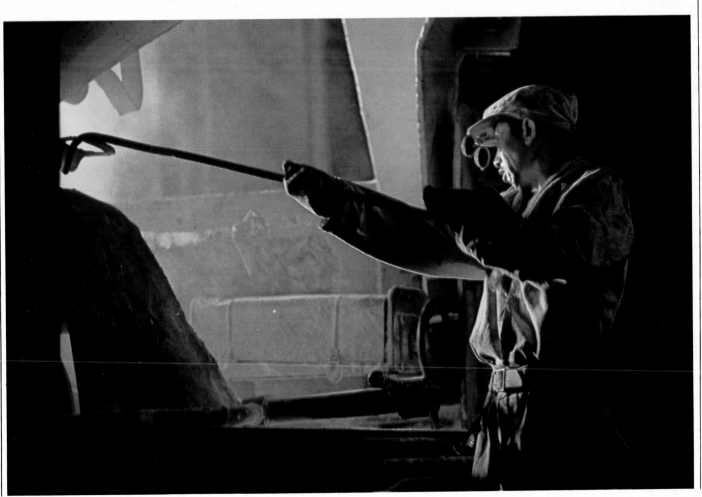

sunlight, will be overexposed and completely washed out. If you adjust your setting for the exterior, you will no longer see the merchant; she will vanish into a dark blur. The best times for photographing a market are either early in the morning, when the dealers are setting up their stalls, or at night when they pack up. These are in effect the most animated moments of the day.

Don't forget to show the architecture of a city as well, letting the viewer understand better what links the inhabitants to their dwellings. To get an overall perception of a city, outside of the points where commercial, political and artistic events take place, you must wander in the streets. Walking for hours on end is the essential task for a photographer who wants to capture the totality of a city. Don't hesitate to go around in circles or to go back on your tracks. Keep strolling, climb incessantly up the streets until something happens.

Choosing the Subject
To reflect the atmosphere of a city, you must walk around in its most real and

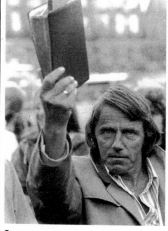

2

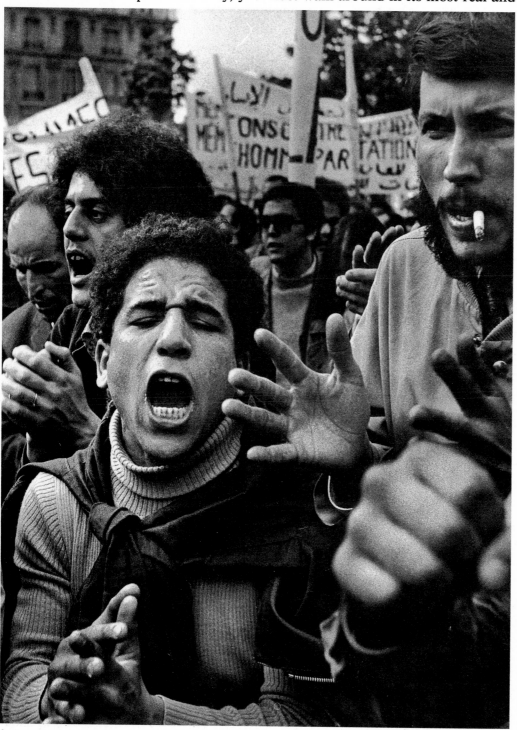

1

(1) Paris. May 1st march, Place de la Nation. Contarex, Distagon 24mm, f/5.6, 1/500 sec., Tri-X.

(2) Amsterdam. 1973. Protestant pastor preaching the Gospel, Bible in hand, in a public garden. Leica M5, Elmarit 90mm, f/5.6, 1/250 sec., Tri-X.

(3) India. 1972. New Delhi. Hasselblad, Sonnar 150mm, f/5.6, 1/500 sec., Tri-X.

typical neighborhoods. In Paris, Belleville, Ménilmontant, the Marais, the Avenue de l'Opéra and the Champs-Elysées are all witnesses of a past sometimes miserable and sometimes glorious. If on the other hand you want to display the modern aspect of the capital, the antiseptic, standardized, utterly depersonalized aspect, you should visit la Défense or the new neighborhoods located behind Tour Montparnasse, near Place de l'Italie or Front de Seine. In some places you may no longer know if you are really in Paris instead of Germany or Sweden.

Every city has its own characteristics and its own secret places. You don't have to be American to feel that in Buffalo, N.Y., much of the activity of the citizenry is centered around the supermarket. No point in going to the Protestant churches scattered through the city; they are empty inside. In Seville, on the contrary, the highest paroxysm of liveliness will be found in the churches on mass days. Even if it has become a cliché, Paris remains famous for the atmosphere and the drama found in its bistros, especially in the peak hours.

To photograph a city in depth, you must give yourself time to understand it

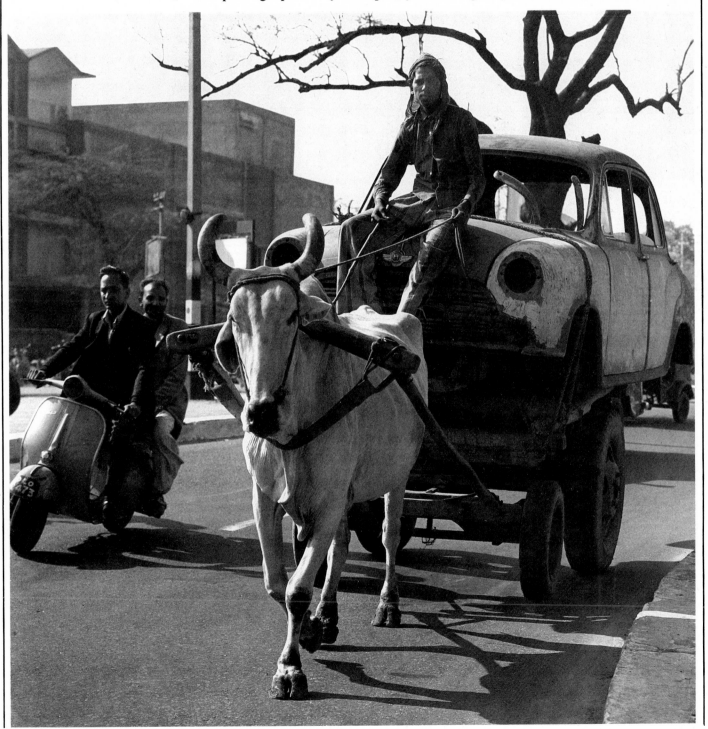

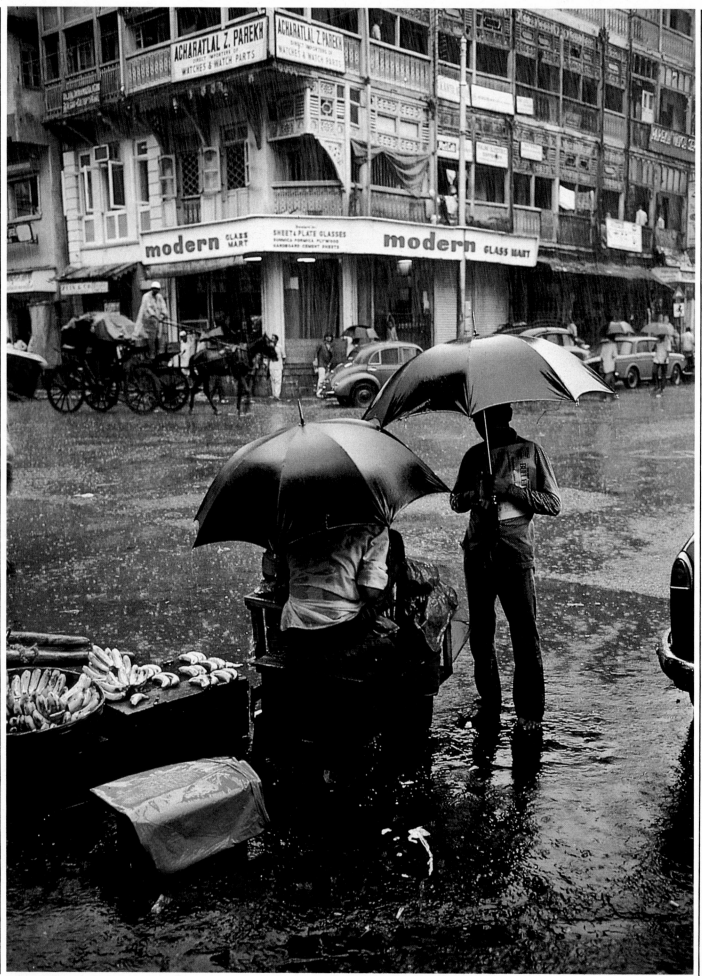

(1) India. Bombay. 1975. One of the main streets of the city during the monsoon.
Minolta XM, Rokkor 35 mm, f/2, ⅟₆₀ sec., Kodachrome.

3

2

(2) Peking. 1973. Avenue of Eternal Peace, which extends 44 kilometers through the city. Leicaflex, Elmarit 135mm, f/4, ⅟₂₅₀ sec., Tri-X.

(3) France. Grenoble. The Sports Palace during the Olympics of 1968.
Contarex, Planar 50mm, f/4, ⅟₆₀ sec., Kodachrome.

and gauge it, in order to give a focus to your attempts.

It may be beneficial for your work not to formulate an opinion immediately. The more famous and burdened with stereotypes a city is, the more important it becomes to abandon your preconceived notions. You must never be content to show merely one side of what you find. It is much more interesting, and more honest, to oppose the positive to the negative, to underline the contrasts and the extremes. Don't forget the other side of the coin. Don't let yourself get too intoxicated with spectacle and pretty images.

The Modern City

It is very easy to take pictures which emphasize the avant-garde architecture of a modern city. But you can equally as well show the completely inhuman side of these buildings, which can be perceived as very oppressive even when the construction is very beautiful. Such contrasts pose a double problem. What should you show, and how? To what should you give priority? Seen from an airplane, from a distance or in the architect's models, this high-rise is magnificent. But in reality, when you live there, you realize that it is not at all geared to its inhabitants. This kind of urban planning is the work of architects who have no intention of living in the buildings they construct. They see their creation in terms of a model, a project, an aesthetic idea that will make them stand out from the others because they have stumbled on a new conception of architectural art. But do they really care about the final result? No doubt, if you like modern architecture, the total effect is very nice, from a distance . . . but living inside it is inhuman. A pedestrian walkway 3 meters wide passes between two concrete walls 30 meters high. Not only is this passageway permanently drafty, but to thread this cement labyrinth, especially at night, is nightmarish. Trying to render this simple impression in a photograph is not simple, hence the vital importance of the photographer's point of view. He must decide at the outset

what he wants to show, and then try his best to express it according to what he feels in the place itself.

You may very well like a modern building. In that case it is fairly easy to take sympathetic and appealing photographs of it. But if you wish to comment negatively on a building whose exterior is beautiful, it becomes very difficult. How can you express the anguish or, at least, the discomfort of its inhabitants? Photography is a medium that ought to be able to suggest the reason for this disordered response. But how will you approach it? Using wide-angle to systematically distort the building's appearance is not very honest, nor is it a very effective way of showing the monstrosity of this narrow corridor wedged between two cement walls. In wide-angle it takes on unreal proportions. You have the impression of looking at something far away, something minuscule and solitary amid a demented architecture that completely envelops it. The pedestrian becomes the center of the subject, which is to say the least misleading, whether you intend it that way or not. The exaggerated distortion caused by this lens brings about an unacceptable difference in proportion between the pedestrians (who are one of the key elements of the pictorial problem) and the massive structure that surrounds them and which they appear unable to understand. According to the distance at which you are shooting, they are either ridiculously small or gigantic, but never in their real dimensions. If, on the contrary, you use very long focus, inhabitant and habitation are reduced to the same scale. No more volumes or distances. The standard lens, for lack of distancing, fails to convey the overall impression.

You can also photograph details and show the bizarre and inhuman side of things which from another point of view are aesthetically beautiful: the joins of concrete flagstones, a sophisticated perspective of windows, a stylized elevator.

This example leads to the conclusion that in certain circumstances it is very difficult, if not altogether impossible, to realize a photograph that will convey a given point of view. And, in fact, that is very much the case.

The Souvenir Shot

Naturally, if all you want is a souvenir of your vacation in a city, a village or a countryside, you don't have to worry about all these problems.

For your travel records you don't need special effects, just simple compositions that make the image instantly readable.

Even in the most beautiful spot in the world, don't automatically take a picture if the light is bad, too weak or too dull. There is no point in wasting film.

But if the subject is interesting it is not necessarily a waste of film to take picture after picture, even in the rain. You have a chance, even shooting outside the usual norms, for at least one of them to come out, giving you an unusual image. No matter what the atmospheric conditions, you should consider from all angles if the subject is really worth it, and if the bad weather will impart a certain atmosphere to the picture.

Sometimes disastrous lighting can produce an unexpected quality. You can take advantage of rain to photograph a particular place or city and show what it looks like in the rain. At such times you must take account of the weather and choose the slowest possible speed in order for the rain to be visible in the photograph. Use the rain as an element of the photograph and emphasize the atmosphere it creates. Don't try to disguise the fact that it's raining, as some people tend to do, and photograph as if it were a nice day.

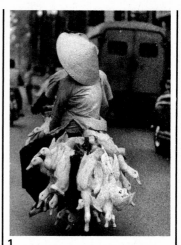

2

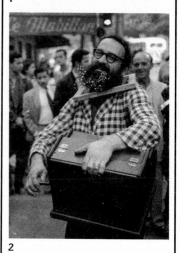

1

(1) Vietnam. 1970. Saigon. Contarex, Sonnar 135mm, f/4, 1/1000 sec., Tri-X, photograph taken from a motorbike.

(2) Paris. 1958. Boulevard St. Germain, a summer evening. Pentacon, Biotar 58mm, f/4, 1/60 sec., Plus-X. This was one of the first reflex cameras marketed in France. It had no automatic preselection. It was necessary therefore to focus with full aperture and then manually set the diaphragm to the chosen aperture. This did not make taking snapshots any easier!

(3) Spain. 1960. Burgos. Preparation for the Festival of Branches. Rolleiflex, Planar 80mm, f/5.6, 1/125 sec., Plus-X.

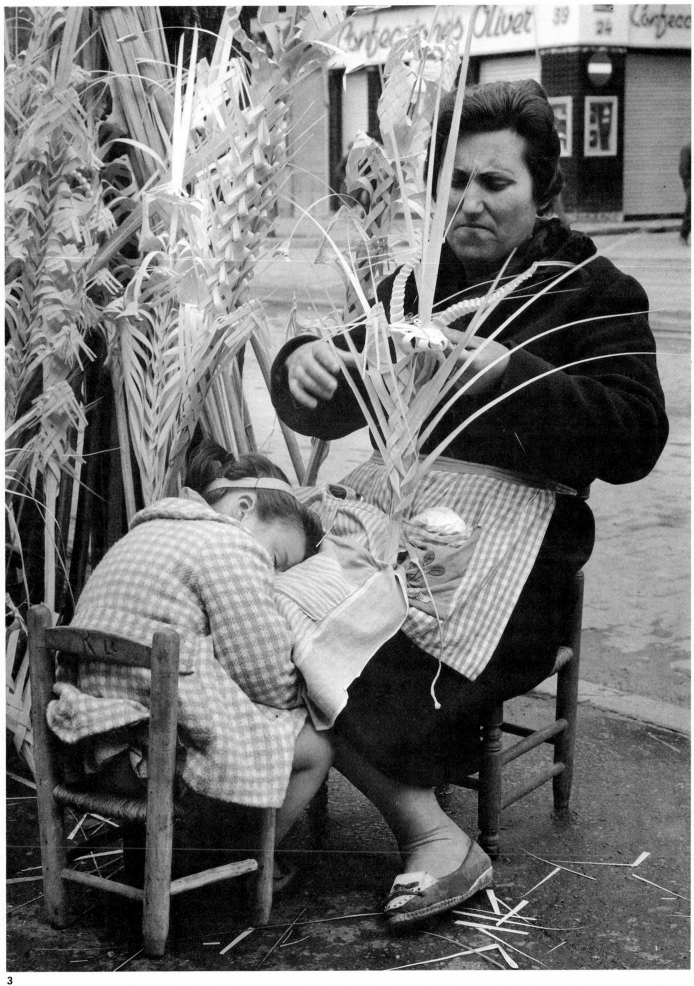

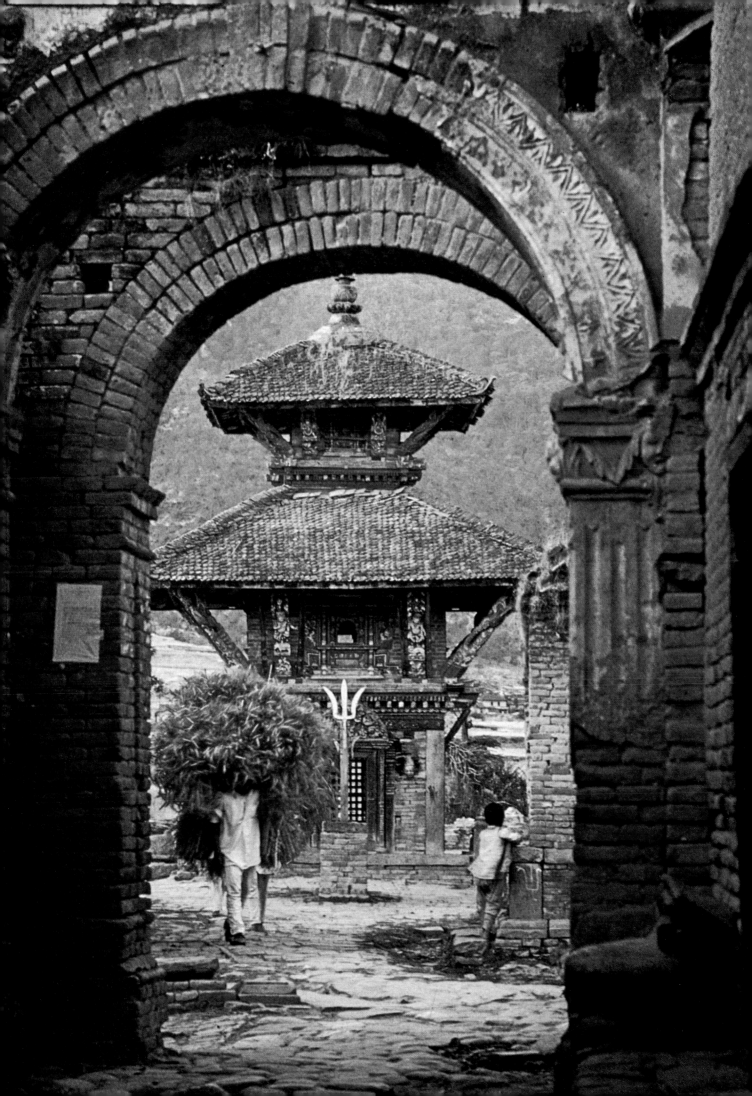

The Arts

MOST architects begin with an idea, which they develop and exploit until the final result is attained. Be aware of this; understand it; give it a great deal of thought. Before using your camera, walk all around and through the monument, taking note of how the light harmonizes with the volumes. Look for the central points which correspond to the strongest design elements of the architecture. You must demonstrate the specific characteristics of each monument.

For example, if you were to photograph Notre Dame from certain angles it might look like any other cathedral in France. But if you take a three-sided view, from the terrace of the cafe located at the intersection of Quai Saint-Michel and Rue du Petit-Pont, or from behind, from the intersection of Pont de l'Archevêché and Quai de Montebello, no confusion is possible.

Point of View and Choice of Lens

Professional architectural photography calls for very complete equipment: it requires in particular a perspective (or shift) lens in order to prevent the verticals from converging excessively when you are not standing far enough back. A view camera with plates is sometimes indispensable for maintaining the straightness of the main lines. You should have a sufficient range of telescopic lenses so you can make the composition tighter or less tight without having to draw closer or move back.

For photographing a statue located at the top of a cathedral, even if you don't have the proper equipment, you can still ask permission of the neighbors whose windows give on the facade to shoot from their homes. Usually they will be cooperative. But don't take advantage of their kindness, and don't disturb them except with good reason. It is often in your interest to be on the same level as the object photographed, even if it was intended to be viewed from below, since if you photograph it at ground level you may perceive only the feet and thus obtain a distorted impression.

Given an almost identical composition, a statuette in a Roman portico will have an entirely different impact depending on whether it is shot at 5 meters distance, from below, with a 100mm, or almost horizontally, at 15 meters, with a 500mm. In the first case, it will look the same as it would appear to any passerby. In the second case, the image obtained will be close to what you would get if you looked at it from a distance with a strong pair of binoculars. In this way you penetrate its intimacy. The expression of the face takes on a new strength.

The art of using a very powerful telephoto lens makes it possible to reveal certain richly detailed forms of ancient architecture which the eye cannot see: the expression of some angel or gargoyle located on a ledge 20 meters high. A good photographer must play the role of archeologist or explorer and go beyond what any ordinary tourist could discover.

It must be noted, however, that an image obtained with a very long telephoto lens may sometimes be inferior in quality. With an identical composition, the picture of a statue taken at 10 meters will be inferior to a picture taken at 50 centimeters with a shorter lens. A high-quality telephoto lens is extremely

Nepal. 1961. Hindu pagoda in a small village in the valley of Katmandu. Contarex, Sonnar 85mm, f/5.6, 1/60 sec., Kodachrome.

33

expensive. But even if you work with high-precision equipment, there are multitudes of particles invisible to the naked eye that float in the air between camera and subject and affect the brightness and sharpness of the final image.

At a distance greater than 200 or 300 meters, it is imperative to use a high shutter speed and a stable tripod. But if it is a windy day, the camera will probably shake even if it is fixed on a tripod.

To take a good architectural photograph, you must combine the talents of geometrician and lighting cameraman, and you must know how to wait and choose the privileged instant.

The Importance of Light

Waiting for the right light should never be an excuse for not taking pictures. You should start from the principle that if it is technically possible to take the picture at a given moment, then do so, instantly. You can never be sure of having

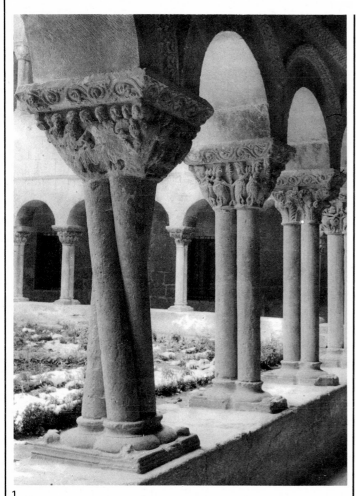

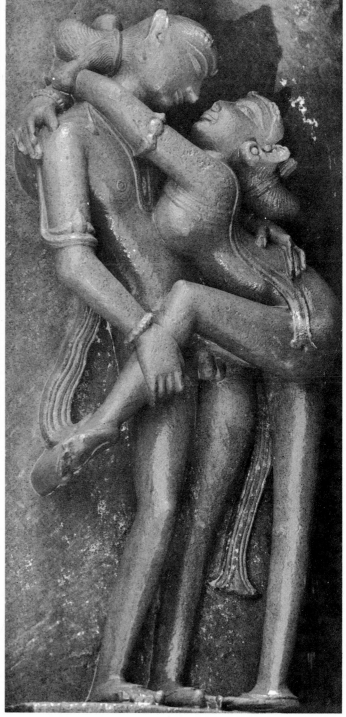

1

(1) Spain. 1962. Burgos. Roman cloister. Rolleiflex, Planar 80mm, f/11, ⅛ sec. with tripod, Plus-X.

(2) India. 1968. Kajuraho Temple. Hasselblad, Sonnar 150mm, f/11, very long exposure on tripod, Tri-X.
This sculpture was located in a very dark corner, and it was necessary to sprinkle it with water to provide some perspective.

(3) Cambodia. 1970. Angkor Wat. Hasselblad, Sonnar 250mm, f/5.6, ⅟₅₀₀ sec., Tri-X.

2

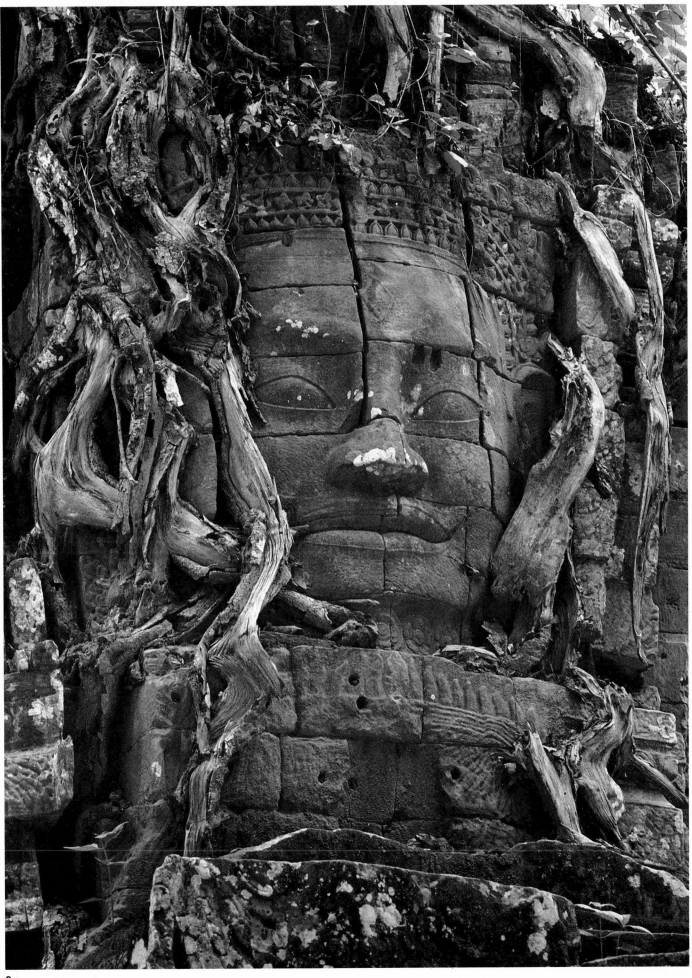

the same atmosphere again. People who are forever saying things like "Tomorrow, at such-and-such a time, the sun will be in such-and-such a spot," often miss the unique moments. Tomorrow the sun will indeed be in the position calculated, but it may be hidden by unforeseen clouds, or perhaps there will be rain. The sun is never perceived with the same intensity two days running; neither is architecture.

So, after walking around a monument, it is better to photograph right away whatever seems most interesting to you in terms of light and contrast; afterward you can analyze what you still lack. Then it is time to make a careful study of the lighting conditions, and figure out which hours are best for catching, say, the southwest facade bathed in sunlight. Stay flexible. Don't become too obsessed with famous landmarks.

To reveal the particularity of an architectural monument through photography is both a journey in time and an exciting experience. Too many details in the same shot can only be confusing. It is better to take a close-up of a single cornice than to try to squeeze in a whole fresco.

Really inspired architectural photography should be capable not only of reviving, but of remaking, intellectually and culturally, the architecture being photographed. Whether you are dealing with Roman art or Gothic art, the ideal would be to be sufficiently well versed in the area so that you can find instantly, almost instinctively, the points where the divergence of arches is accentuated or where the arched openings of the hemicycle begin their downward curve. For certain forms of construction, it is important to find the perpendicular of a vault just as a builder would.

The direction of the light plays an essential role in the photography of architecture. Especially if you are working in color, don't hesitate to photograph early in the morning or late in the evening, when the stonework may take on a warm color that, in a matter of seconds, can change again into a loud purple or a deep rusty tone.

It is important, especially in conjunction with a telephoto lens, to use a tripod. In architecture, a horizontal line that dips to one side is unpardonable. A leaning clock tower is an insult to its builders.

Except when you are consciously seeking special effects—graininess, pointillism, dominance, infrared—fine-grained films give the best results.

For black-and-white it is advisable to use films whose sensitivity varies between ASA 25 and 125. In color, Kodachrome 25 is far and away the most highly recommended film because of the fineness of its emulsion.

The grain of the stone should be almost palpable; the smallest details, the tiniest outcroppings of lichen on timeworn granite have their importance. Never work with full aperture, but choose the aperture which gives you maximum sharpness: in general, this will be two stops smaller than full aperture.

Personalizing Your Subject
It is very difficult, especially when you are in a hurry, to apply a personal style to what might be called "postcard shots." By this is meant the monuments and landscapes that everybody has photographed and that have been reproduced a thousand times.

To find an original angle from which to photograph the Taj Mahal, the Pyramids or the Eiffel Tower is not easy. Nevertheless, if you look at Francisco Hidalgo's book *Paris*—even if you don't care for it—you must admit that the photographer, even if he uses too much camera trickery, has found an interesting, personal and very subjective approach to monuments we see every day and that thousands of people have photographed before him. There are thus always possibilities for seeing even the most classic things differently.

What are these possibilities? You can have fun parodying the postcard. That is perhaps the simplest method. For that you need a standard or slightly wide-angle lens. Wait until the sun is at three-quarters in relation to the monument in question, so that the main facade is illuminated but not too much and not directly; in this way there will be sufficient detail visible in the statues and sculpture that decorate it. Add a filter to reinforce the sky and above all don't

1

2

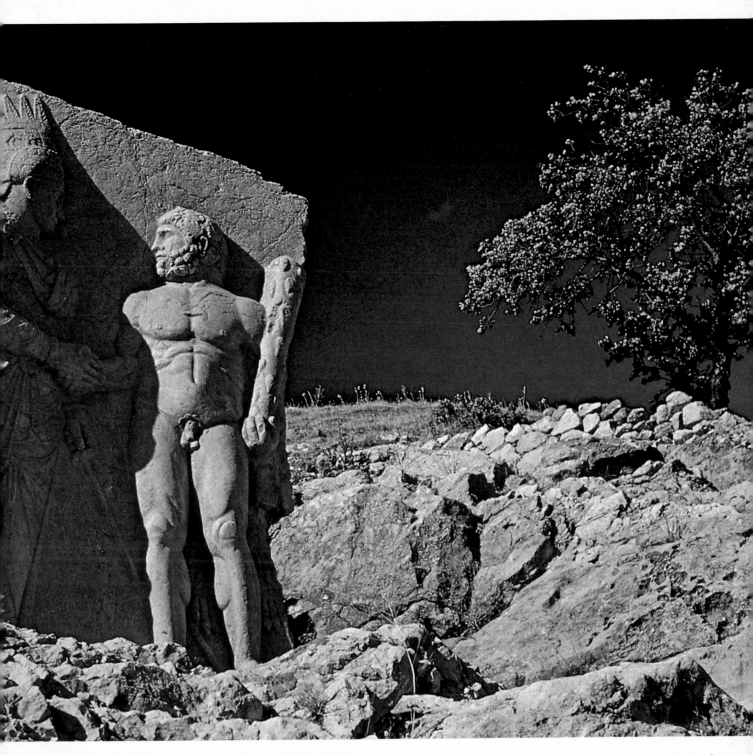

(1) Turkey. 1972. At the foot of the tomb of Antiochus, on Mt. Nemrum Dag.
Contarex, Sonnar 85mm, f/5.6, 1/60 sec., polarizing filter, Kodachrome.

(2) Southern India. 1972. Bas-relief on a Hindu temple. Contarex, Sonnar 135mm, f/5.6, 1/60 sec. on tripod.

(3) Northern India. 1961. Interior of a Jain temple in Rajahstan. Contarex, Planar 50mm, f/2, 1/30 sec.; Kodachrome, available light.

3

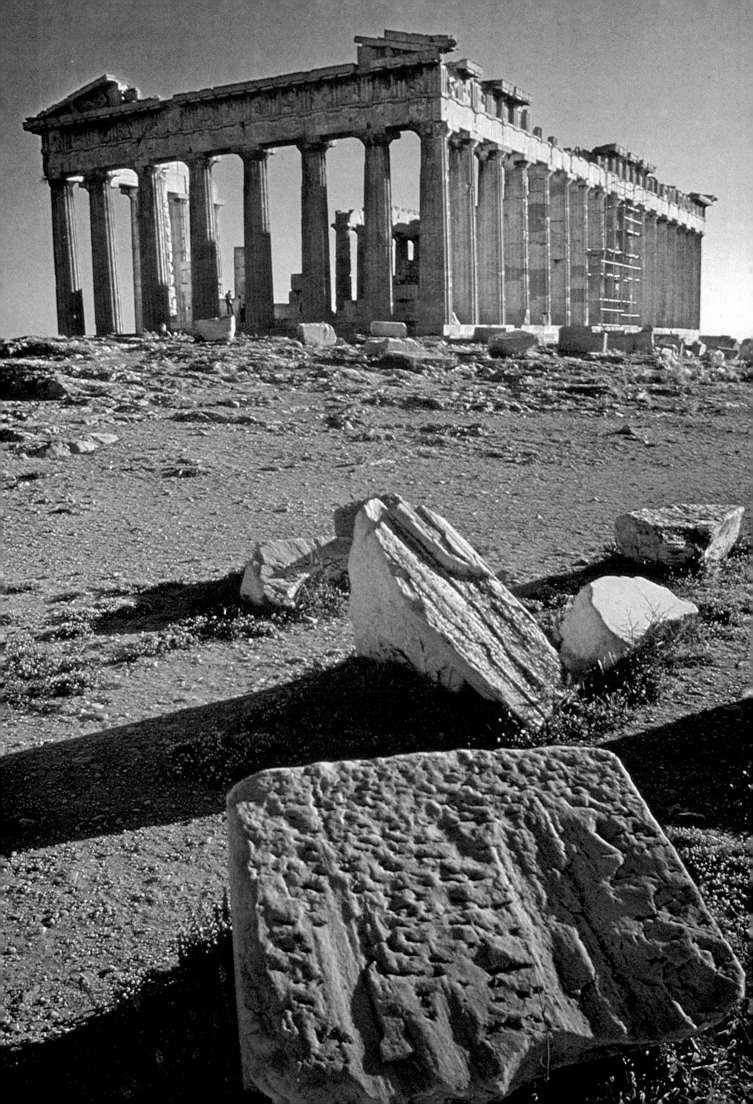

forget to choose a foreground comical enough to personalize the photograph.

There are a thousand and one other ways to photograph the same subject. You can play with lenses and choose a 500mm mirror lens to shoot Notre Dame from a great distance. One of the advantages of a really large telephoto lens is that it flattens and combines the different planes. The Seine, the sightseeing boats, the Sunday fishermen, the lovers, the docks, the cathedral, all seem to become entangled with each other. The impression that these various elements are mixing and melting together will be increased by the atmospheric haziness which is unavoidable when photographing from far away.

You can reinforce this soft-focus effect by using a grainy film, which will have the effect of incorporating the monument or landscape into the sky and into its environment. You obtain a kind of halo which covers everything and gives the whole composition a pointillistic effect, a little like the way David Hamilton photographs his Scandinavian girls, or like Andre Martin when he photographs his plains and forests with the 500mm mirror lens.

When you use a 500 or 1000mm lens and an Ektachrome E6 ASA 200 set at ASA 400 or 800, because of the dust particles suspended in the atmosphere, particularly in summertime with the vibration of the warm air rising from the ground, you often get this halo effect, which is not the same as being out of focus; it is just like colors which, when you blur them slightly, turn into very pastel tints.

The writer and playwright Antonin Artaud said: "A sunset is beautiful because of everything it takes from us." In effect, when you admire a sunset, the details of the landscape are blurred, drowned in shadow. An ordinarily banal location becomes sublime, because all the planes and details have been rubbed out. In photography this intentional abstraction can become a style. When you use high-grain film in low light or at sunset, you lose many details whether you want to or not, and the whole image is perceived through a more or less artificial halo.

You can also use wide-angle in such a way as to completely distort the monument you are photographing.

The professional is obliged to use a perspective lens to correct the perspectives and permit very precise measurements, so that historians and archeologists can use his pictures for reference and as a working tool; but the amateur doesn't need to worry about such things, since all he wants is to show what he saw on a trip. For the amateur, the most far-fetched eccentricities are entirely acceptable. He does not need to render exactly the thing he is photographing.

That being the case, why not use a wide-angle very freely to play outrageously with perspective, so that the towers of a cathedral join together, or so that the lampposts in different areas of the image form a semicircle? You can even do very low-angle shots, with the widest possible aperture, so that in the foreground you have an architectural detail or some pigeons which are as sharp as the buildings on the horizon.

Human Presence
As with landscapes, it is interesting and often useful to incorporate a human element into the site you are photographing, to give more life to the image.

In that connection you can also play with the shutter speed. Set up your camera on a tripod so that the monument is very sharp, and choose a slow speed so that the passersby are completely blurred.

When you photograph Notre Dame, there is no interest in having the tourists in the foreground sharp; you lose the charm of the old stonework. But if these same people are no longer individually recognizable, but are merely highly stylized human forms evolving in space like multicolored phantoms, the result can be both very beautiful and very strange. Luck counts for a lot in how such a picture comes out; to be on the safe side, take many exposures.

It is impossible to predict the effects of camera shake, or even of panning. If you choose an even slower speed, the pigeons you have startled into flight become utterly unreal. They are now only white splashes, hardly recognizable as birds, but they animate the scene pleasantly.

Some people wait for hours before clicking the shutter, hoping for a moment

Greece. Athens. 1973. The Acropolis. Leicaflex, Elmarit 25mm, *f/8*, 1/60 sec.

39

when nobody is standing in front of the historic monument they are trying to photograph. But all architecture, regardless of style or era, issues from the human imagination. It is linked to man, and there will always be someone walking behind it or in front of it. Sometimes it is a mistake to try to isolate it from its human context.

Church Interiors

To photograph architectural details, sculpture and even paintings (frescoes or canvases) inside a church, and especially in its dark areas, requires a great deal of thought.

Even if a detail appears very dark at first, there is usually enough light to photograph it with the help of a tripod (you may have to resort to a 30-second exposure). Certain sculptures must be shot at very precise times of day in order to take maximum advantage of natural light. Wait until the direction of the light through the windows is at its most favorable.

If it is not possible to stand level with what you are shooting, the best angle is the one from which the original artist intended it to be seen. As for using a flash, even if there is no guard around to forbid it, it flattens the relief and creates reflections which are hard to control, especially on the bright surface of oil paintings and marble statues.

Museums

When you want to photograph inside a museum, first of all find out the days and hours when it is open, so that you don't waste time lugging your equipment there at the wrong time. In some private museums photography is not permitted, and often visitors must check their cameras in the vestibule. On the other hand, in most national museums you are allowed to film and photograph if the camera is hand-held. (In France these are closed on Tuesday.)

Usually you have to pay a tax for the use of a tripod, in exchange for which you are given a coupon good for that day only and which you must pin to your

(1) Cambodia. 1970. Angkor Wat. Contarex, Sonnar 250mm, f/4, 1/60 sec., Ektachrome high sensitivity.

(2) Peking. 1973. The Summer Palace. Leicaflex, Sumicron 50mm, f/5.6, 1/60 sec., Ektachrome.

1

lapel so the museum guards can see it. Use of a flash is absolutely forbidden, as its radiance can damage the colors of the paintings.

Use of professional electronic equipment usually requires special authorization; after the museum has examined the request (which painting? for what purpose?), authorization is given for the museum's weekly closing day. This day is reserved for copiers of paintings and professional photographers specializing in the reproduction of painting and sculpture, and who for that reason are obliged to use large-format plate cameras.

Unless one is a specialist or a historian, photographing paintings is not very interesting for the amateur. If all you want is a souvenir you can buy reproductions which will certainly be of better quality than what you can obtain yourself with available light. On the other hand, it is always entertaining to observe the behavior of museum visitors, their ecstatic or disdainful expressions depending on whether they like or dislike what they see.

Robert Doisneau has published in one of his books a series of very amusing shots of tourists of all nationalities gazing at the smile of the *Mona Lisa.* Try standing next to a famous work of art and photographing discreetly, one by one, the people who come to look at it. You will be surprised by the diversity of expressions you will gather in a short time. The experiment is worth trying.

How to Photograph Collections on Display
To photograph an object protected behind glass, whether it is a relic or a gem, often requires the use of a polarizing filter in order to soften the reflections which create interference between subject and lens. Watch out for the areas of brightness caused by light bulbs and even by the reflections of natural light on an oil painting. Often it is necessary to stand at a slightly oblique angle to avoid any refraction of light, but in that case keep your eye on the parallax and the resulting distortions; otherwise your painting may end up as a trapezoid.

When you take pictures in a museum, you should of course avoid using a high-sensitivity film to make up for the lack of light. The resulting image will lose definition. To reproduce a painting it is important to show the details and the grain of the canvas. Thus, a tripod is indispensable. If the light is very weak, use a long exposure or else wait for the moment of the day when the light is just right.

To conclude, it can in general be said that even by resorting to a polarizing filter it is practically impossible to photograph a painting behind glass if the reflections are excessive, unless you have the advantage of a side light, which is rare. Even when there is no glass it is often difficult to eliminate reflections. Furthermore, polarizing filters absorb between one and one-and-a-half apertures, and since you usually have to work with very little light (museums tending to be dark), it is difficult to shoot without a tripod and additional lighting.

It must be remembered as well that lenses used at full aperture often result in a poor rendering of the semitones and a certain loss of sharpness. Aside from several aspheric lenses of the Canon type or the Leitz Noctilux, which opens at $f/1.2$, it is a mistake to think that lenses that are equipped with apertures of $f/1.4$ or even $f/1.2$ are good when they are opened wide. The major problem for the manufacturers is to make increasingly luminous lenses without losing quality, rather than to improve the sharpness of the rendering of colors. Most commercial lenses today, even those of the largest manufacturers, are inferior to the older ones. These wide-aperture lenses are very ill-suited for close-up photography without setting the aperture. They give good results only between $f/4$ and $f/5.6$.

If it is true that most museums are very dark, certain of them nevertheless lend themselves better than others to photography; especially those that contain sculpture too large to be kept behind glass. Mention can be made of the Musée des Arts et Traditions Populaires, the Musée Rodin, and the Musée Guimet (with its very beautiful collection of Indian sculpture in stone and bronze) in Paris, the Victoria and Albert Museum in London, the Archeological Museum of Madras with its unique collection of dancing Shivas, and above all the

Paris. 1965. The Louvre. Rolleiflex, Planar 80mm, $f/2.8$, 1/30 sec., Tri-X.

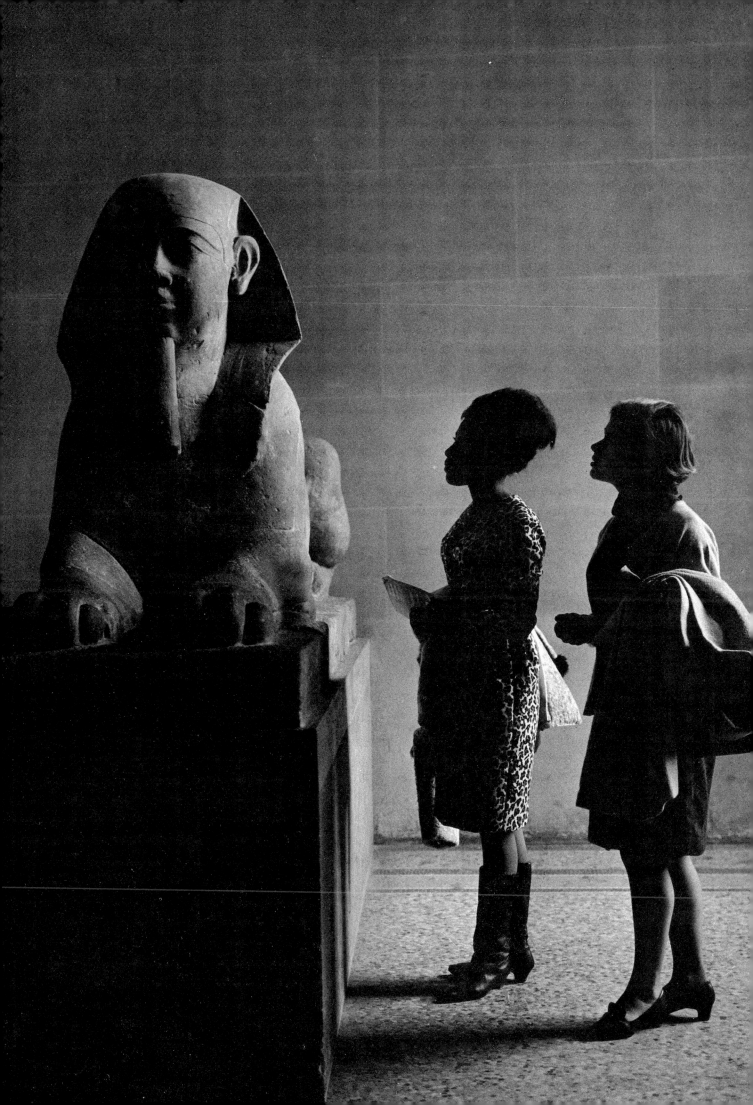

National Museum of Anthropology in Mexico, one of the richest and best-run in the world.

Even if the lighting conditions are not too bad, it is always risky to try to photograph a statue in its entirely, for you are rarely far enough away to avoid distortion.

On the other hand, it is rarely possible to eliminate the extraneous lights situated behind the sculpture or in the surrounding decor, which can interfere with the subject's impact. However, in the case of a statue, it is often possible through the use of telephoto to show simply close-ups of facial expressions, hand postures, details of hair. Play with the forms and volumes. Choose the angle that gives the maximum of relief while maintaining a neutral background. If the framing is very tight, the telephoto will permit a completely blurred background.

Movement

Most blurred photographs are due not to the movement of the subject photographed but to camera shake. Even a statue photographed at 1/1000 of a second may come out blurred if, at the moment of clicking the shutter, you shake the camera ever so slightly. It is rare to find sharp pictures taken from moving trains or cars, even if a high shutter speed was used.

To avoid camera shake at the moment of shooting, never push abruptly or with a single motion on the shutter button; instead, do it gently as you would with the trigger of a rifle. Press delicately until you feel some resistance, then squeeze firmly. In this way you avoid a sudden movement of the index finger. For someone who has a good grip on the camera and is not subject to trembling, it is recommended that, in order to avoid blurred images, a speed equal to or greater than the focal length of the chosen lens be used:

1/60 sec.	= 50mm
1/125 sec.	= 105mm or 135mm
1/250 sec.	= 200mm
1/500 sec. or 1/1000 sec.	= 500mm

This method can be considered as a general guideline. Some photographs may blur even at 1/250 sec. with 35mm, others will be sharp at 1/30 sec. with 150mm.

No matter what speed is chosen, you must always hold the camera in both hands so that it is completely immobile. One hand holds the camera body, the other the lens attachment. The most frequent case is for the camera to be shaken when pressing the shutter button. This explains the fact that often, no matter how much care one has taken with the composition, the horizon lines are slightly askew. Even if you have a steady grip on the camera, to avoid any supplementary risk of trembling, hold your breath before pushing the button; above all, lean or kneel if necessary in whatever position will give you the most stability. This applies especially when you are using slow speed or long lenses. The shutter speed should be chosen in relation to the lens being employed, the mobility of the subject and the distance of the photographer from the subject.

Someone running should be photographed at 1/500 sec., a moving car at 1/2000 sec. unless it is photographed head-on, in which case it advances less rapidly in the viewfinder than if photographed from the side. You might choose a slower speed if you are following the subject by moving the camera, since in this case you keep the subject in the frame at all times.

To obtain, for any mobile object, an impression of movement or speed, it is in your interest to choose a slow speed, even as slow as 1/10 sec. (according to your skill), and to follow the subject; the subject will remain sharp, while the landscape in front or behind will be in soft focus. This method is especially valuable for auto races or for showing a horse in full gallop.

Nepal. 1968. Katmandu. Vishnu resting on a bed of cobras. Contarex, Sonnar 135mm, *f*/4, 1/125 sec., Kodachrome.

For this kind of shot, rangefinder cameras like the Leica are easier to use than any reflex camera, as long as there is a supplementary viewfinder fixed to the camera body, because during the period of exposure the mirror lifts and you can see nothing in the viewfinder.

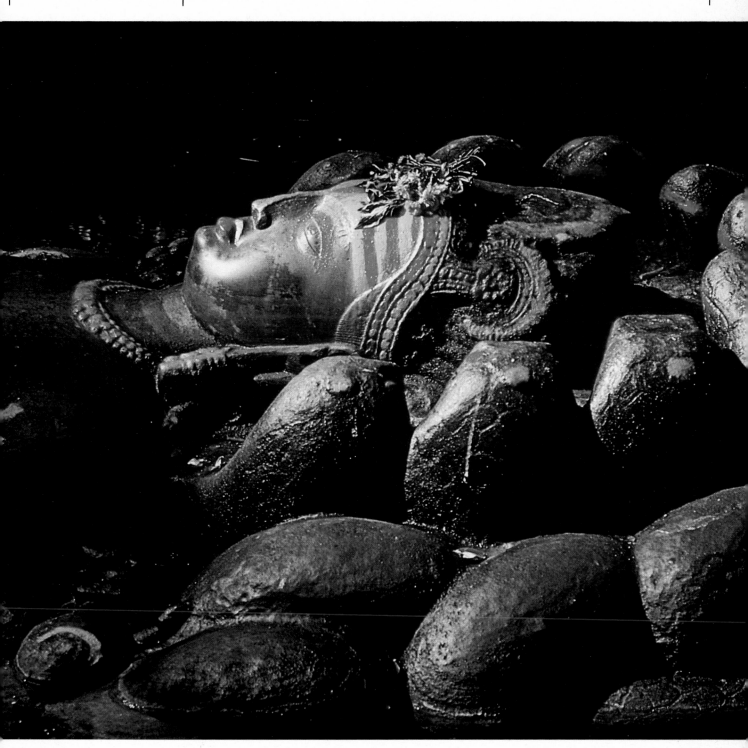

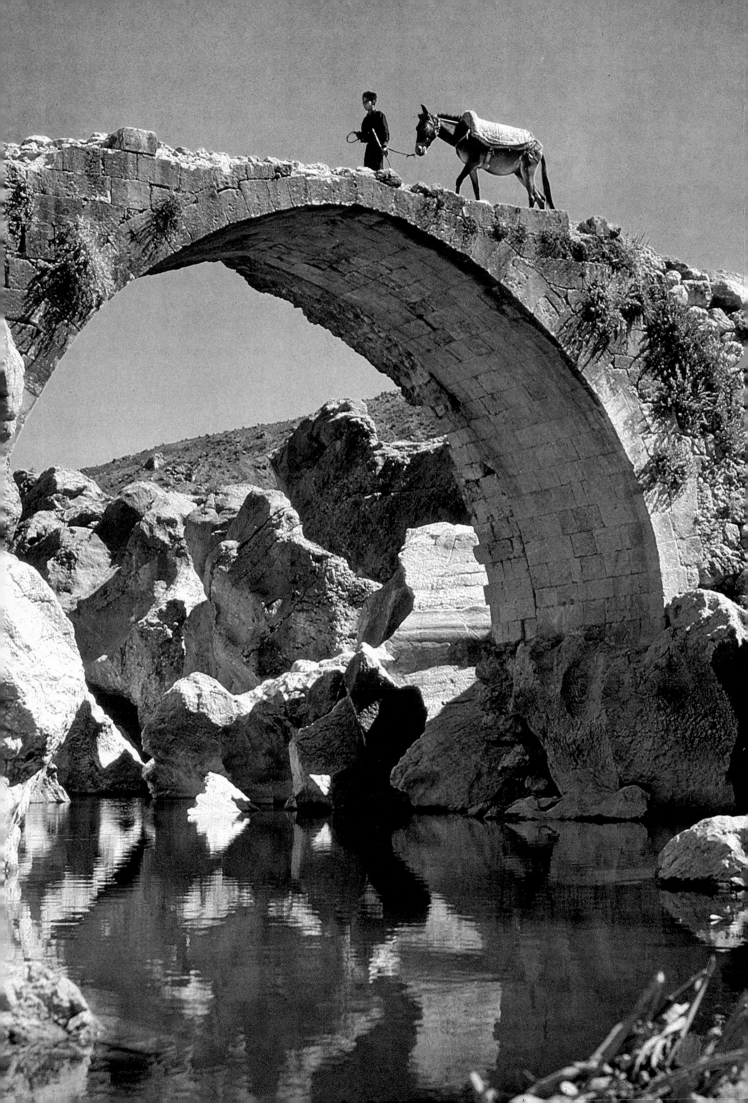

Landscape

O UT of all the traveling we do in the course of a lifetime, it is landscapes that linger longest in our visual memory. They arouse intense emotions in us, whether we had long and devotedly prepared our approach to them or whether we discovered them suddenly and unexpectedly.

These moments are privileged because of what they teach, because of the sense of the unknown and the marvelous that we feel when confronted with nature, because of the shock of the present instant and traces of the past. To successfully photograph a landscape is particularly difficult, because it is a question of translating into a single image both the spontaneous emotion and the emotion you had more or less consciously anticipated.

More than for portraiture or any other human subject, good landscape photography implies a thorough knowledge of your equipment. You must be capable of expressing without restraint the lived instant and the felt emotion by means of photographic technique. This requires a certain amount of experience.

Thus, to photograph a landscape calls for preliminary reflection on photography in general and on yourself in particular. That in turn calls for meditation and observation of the intensity of the moment and the place that you want to film. On the basis of this analysis you must choose the lens and the film—black-and-white or color—that will best suit the state of mind and the data you wish to transmit through your composition.

From Fish-Eye to Telephoto
To photograph a landscape it is often advisable to choose a moderately wide-angle lens, one that will not accentuate too much the distortion of volumes and perspectives. In 6×6, the 50mm, and in 24×36, the 35mm or even the 28mm, give a wider image than the standard lens, which narrows the field too much and does not give the impression of space that is needed.

Quite the opposite of the telephoto lens, the extreme wide-angles can more easily create a sense of space. Even when you photograph a very beautiful location, such as the amphitheater of Gavarnie or the cliffs of Etretat, it is often difficult to render accurately the distances between the different planes and the proportions of the volumes among themselves. The sense of distance and remoteness disappears completely. Depending upon the lens you use, mountains will give the impression of being very near or very small, but they rarely appear in their actual location and their real dimensions. With wide-angle, the fact that you benefit from an increased depth of field allows you to show both infinity and the tuft of grass 20 centimeters away in clear focus. These two superimposed planes contribute to a sense of depth, but the distances are often exaggerated.

In fact, there is no absolute rule or miracle lens. Everything depends both on the nature of the landscape and on the nature of the person admiring it. Any lens can give interesting results if you know how to use it.

Sometimes, depending how you feel, it is better to use a long-focus lens.

In 24×36, with a supertelephoto lens of 500mm or 1000mm and high-grain high-speed color film, you can achieve an effect very similar to pointillism in painting, and make enlargements as wide as seven meters despite the ridicu-

Turkey. 1972. Cappadocia. I intentionally waited for someone to pass over this bridge in order to give it a sense of scale.
Contarex, Planar 50mm, f/8, 1/125 sec.

47

lously small dimensions of the negative you began with and the exaggerated graininess of the film stock. But undoubtedly it is just as possible to take an interesting picture with fine-grained film and extreme wide-angle, as long as the photographer handles them with mastery.

Interpreting What You See

The photographer must always *interpret* what he sees. To do that, he has to choose equipment that fits what he wants to express.

By definition, a landscape is extensive and can rarely be reduced to simply a wheatfield or a row of poplars. It might be a village seen from a distance, a seacoast seen from the top of a cliff, or a chain of mountains, or even all of that seen at once. There is thus a great interest in synthesizing a great number of different elements, contemplated simultaneously from the same standpoint. Wide-angle makes it difficult to emphasize this juxtaposition, because it creates a distancing effect between the separate planes. If these are diminished, it becomes practically impossible to distinguish them in the image. On the other hand, the telephoto lens brings the planes closer together, superimposing them on each other in the same way the human mind does; for if the eye is a lens, it is the brain that synthesizes the images it receives, the images that will ultimately be perceived by the self as the unified concept "landscape." The photographic image of a place should not, then, confine itself to what the eye sees in a given instant, but should on the contrary contain a great variety of data and be in effect a summary of the whole, by the selective elimination of certain elements. This is perhaps a rather abstract notion, but it seems an important one to me for the approach to nature I have in mind.

Though landscape pictures in the classic postcard style are nowadays usually taken with moderate wide-angle (35mm), you will realize by leafing through photography magazines that there is no absolute rule. You can get beautiful results with a fish-eye just as well as with a supertelephoto. Every photographer has his own perception and his own approach. Francisco Hidalgo works mainly in wide-angle, Andre Martin with a 500mm mirror lens, Jean-Lou Sieff in 21mm, Cartier-Bresson in 50mm, Jean-Claude Gautrand in 28mm. Personally, I use mainly 28mm and 135mm. In fact, there is no lens that is uniquely appropriate for landscape. You must always interpret.

Contrary to what you may think, landscape photography is very subjective, if only because you can freely choose the lens and the film, which is not necessarily the surest way to obtain a faithful reproduction of reality.

The Human Element in Landscape

It is sometimes useful to incorporate a human element into a landscape, no matter how beautiful it is in itself, in order to show that it is alive and to impart a sense of scale. However, few amateurs do this. It is rare to encounter truly dead landscapes, which require absolute solitude, like certain deserts (the Negev or the Valley of the Moon near La Paz, Bolivia, for example, whose main interest is precisely that of being an utter wasteland). Even in the Sahara, the distant profile of a caravan of camels visible at the top of a dune incontestably adds another dimension.

When you discover a rice paddy there is a tendency to think that the dynamic structure which makes up this purely artificial setting is natural. In reality this landscape is the result of centuries of work. The smallest patch of ground required days of effort. The pair of cows sunk in the mud up to their haunches, pulling the plow held with great effort by the Chinese or Indonesian peasant, are an integral part of the place. Without man, this sublime setting would not exist.

The human element need not necessarily be present in the form of a person. It can be a house, a pagoda, or, in the foreground, placed carelessly against a bale of hay, a rake or a billhook.

Especially in Africa or Asia, where nature takes on monochrome tints of yellow or green according to season, it is nice to have a discreet splash of color somewhere in the composition. With wide-angle it is easy to show a purple or violet flower in the foreground to break up the monotony of the landscape.

48

(1) India. 1973. Desert of Tahar in Rajahstan. Camel market.
Leicaflex, Elmarit 135, f/4, 1/125 sec., Kodachrome II.

(2) France. 1962. Cliffs of Etretat.
Exacta, 90mm, f/4, 1/60 sec., Kodachrome.

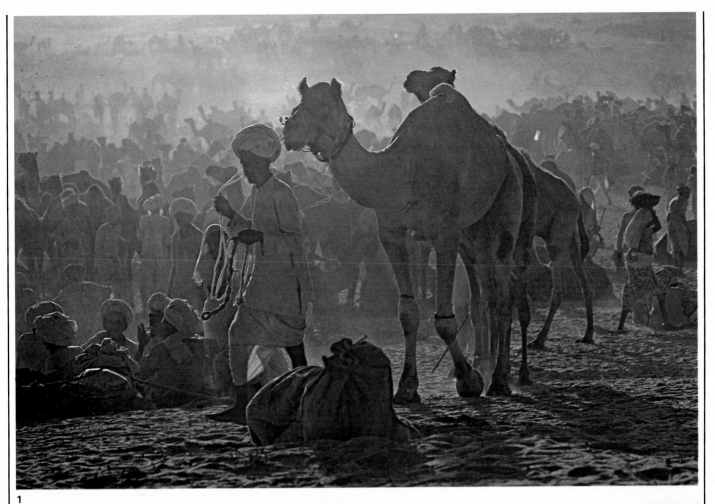

1

2

(3) Southern Sahara. During the Sahel drought of 1974.
Minolta XM, Rokkor 35 mm, f/8, 1/125 sec., Kodachrome.

(4) Ethiopia. 1974. Fanakil Desert. Sulphur pit near Lake Assal and the volcano of Ertal.
Leicaflex, Elmarit 25mm, f/8, 1/60 sec., Kodachrome II, polarizing filter.

3

4

Monochrome landscapes can be a dangerous trap for unwary amateurs, who don't know how to play, through the use of subtle lighting or elaborate filters, with the semitones and nuances of a single color. To avoid a dreary picture, it is often advisable to put a flower in the foreground, or even, why not, a person working in a field, the color of whose sarong or sari will contrast agreeably with the uniform tint of the image as a whole.

Color or Black-and-White

Concretely, in photographic terms, a landscape can be summed up as the atmosphere of a place as created by the light that bathes it. To photograph the place is thus, first of all, to be in a given spot at a moment when the light corresponds to your original idea. It is in relation to these two elements, the structure of the panorama and the time when you take the picture (since the light varies constantly throughout the day), that you must choose which type of film you are going to use.

This choice is fundamental to the impression you are going to create. Black-and-white permits complete transposition. It transforms and disguises the landscape, making it a scale of more or less abstract grays which nonetheless can bring out in pure form the impression you wish to express. Color, on the other hand, creates a more direct and objective rendition of the same perception, by means of a more ordinary and accessible language.

An emulsion, depending on whether it is slow or fast, will make the image respectively more or less objective. A fine-grained film will obtain a very sharp and definite image with rigorously separated planes, and will respect the contrasts and values of color. On the other hand, you can completely transpose what you see by choosing a grainy and rapid emulsion. The grays will blend more, the colors will melt together and become more homogeneous.

You can accentuate this impression further by adding filters to give more presence to the blue of the sky, to the clouds, above all to the weight of the air in the landscape. (Use an orange and red filter for black-and-white, and a polarizing filter, tinted or graduated, for color.) There is no absolute rule. It depends on your taste and temperament. With graduated filters, you can even divide your image in two, with one half light and the other dark.

Infrared films or grainy films, polarizing or diffusion filters, powerful tele-photo lenses, huge wide-angles, multiple screens, zoom, etc., are all technical assets that can be used for interpreting a landscape. But, as with anything else, they should not be abused. Every temperament, every landscape, requires its own approach.

It would be somewhat pointless to photograph a sunset or a rainbow in black-and-white. The peak of Mount Everest will be perhaps more striking in black-and-white, on soft film and with a red filter, than in Kodachrome 25 or Agfacolor. In landscape photography, the filter often plays a very important role.

The Use of Filters

The impact of a landscape picture and the emotions it arouses will be very different, even opposite, depending on which methods and techniques you use, both in shooting and in developing, whether you use color or black-and-white.

You can make a very realistic figurative document from the same landscape which could just as easily be made into a pointillist picture. All you need is to choose a very grainy film, develop it for as long as possible and use the appropriate filters and grids to obtain a picture which resembles an Impressionist painting. For certain rural scenes, taken early in the morning or late in the evening, a diffusion filter will soften the contours even further while preserving a certain sharpness. The resulting atmosphere will have a vaporous quality. Other filters (yellow, green, red for black-and-white, graduated for color) reinforce the contrasts and the values of the sky, blacken the blues and delineate the clouds more sharply.

In earlier days portraitists used grids to beautify a face, to mask defects, to make it look younger. Using this method, no pores were visible and the deepest wrinkles were smoothed out.

A grid is nothing but a miniature grillwork, the separation of whose meshes and the fineness of whose threads vary according to the effect you want. It is placed in front of the lens when photographing. It can also be used when printing, by placing the grid directly in front of the enlarging lens. The results thus obtained are certainly very different, but not without interest. If you forego a diffusion filter or the special glass which is sold commercially under various names such as "low-contrast" or "fog" or "diffuser" and which are very expensive, you can make do with a silk scarf or stocking.

The use of a diffuser, a filter or a grid necessitates a great deal of skill and precision. In this domain, no manual can replace experience. Each case is different. The results are dependent simultaneously on the distribution of the light, the nature of the subject, the characteristics of the film used and how it is developed, the type of filter used, and the focal length. Certain subjects lend themselves to interpretation better than others. Above all, don't try to develop a formula. Too many photographers overuse a chosen technique, whether it's zooming or multiple filters or infrared film.

Zooming is a technique that consists (when you have a zoom) in shooting at a slow speed so that you have time to adjust the focus during the period of exposure, i.e., while the shutter is open. This movement has the effect of making certain planes sharp and others blurred, but with an overall impression of concentric lines. The effect will be different depending on whether you zoom forward or backward, that is, if you go from short focus to long or vice versa, for the movement will be inverted. It is difficult to predict the result. In general, the center of the image is sharp while the edges are out of focus.

Certain of these techniques can add a supplementary dimension to the image in very specific cases (and especially when the subject isn't worth much!) but most of the time they detract from the image, particularly in the area of photojournalism. A good photograph should be striking enough in itself that you don't have to resort to tricks which can only diminish the intensity of the subject and deprive the document of its credibility.

Black-and-white films barely distinguish different colors of the sky without the addition of special filters. Between a relatively bright blue and the white of the clouds the negative shows very little difference. In this case, to bring out the clouds when you print, the developer must expose the sky portion longer. This is painstaking work which an amateur who has his film developed commercially cannot insist on.

In black-and-white, yellow, orange or red filters are most commonly used to overcome this handicap. A yellow filter sharply emphasizes the clouds without modifying the other colors. An orange filter further accentuates this difference. A red filter gives the whole landscape a dramatic quality. After a storm the blue of the sky will appear almost black and the clouds, in contrast, extremely white. A green filter darkens the horizon like the yellow filter, but in addition it brightens the greens slightly, as well as the color of skin. It was often used in the period when orthochromatic films, less sensitive to green, were still used. Today's panchromatic films no longer require the use of such screens in order to render the semitones of foliage and vegetation.

A word of warning: filters, grids and diffusers, with the exception of an ultraviolet filter, absorb a certain amount of light. The more powerful they are, and the denser their color, the wider the aperture must be, or the shorter the period of exposure; otherwise the image will be underexposed. The coefficient of correction you must employ is written on the frame of most filters, and on the package of most commercial gelatins.

With present-day films, in general, when you photograph a landscape (aside from dense forest or moonlight) you will have enough light, especially in black-and-white, not to need a tripod, even when using most of the above filters.

Ultraviolet Filters

For color, most salesmen recommend an ultraviolet filter. Although it is supposed to brighten blues, its filtering capacity is minimal, not to say nonexistent. It is in any case far too weak to have a useful influence on the film when you are photographing early in the morning, late in the evening or in high moun-

Double page following: Iran. 1966. Contarex, Sonnar 85mm, f/8, ¹/₂₅₀ sec., Kodachrome. Intentional underexposure by a full f-stop in order to give more depth to the sky.

51

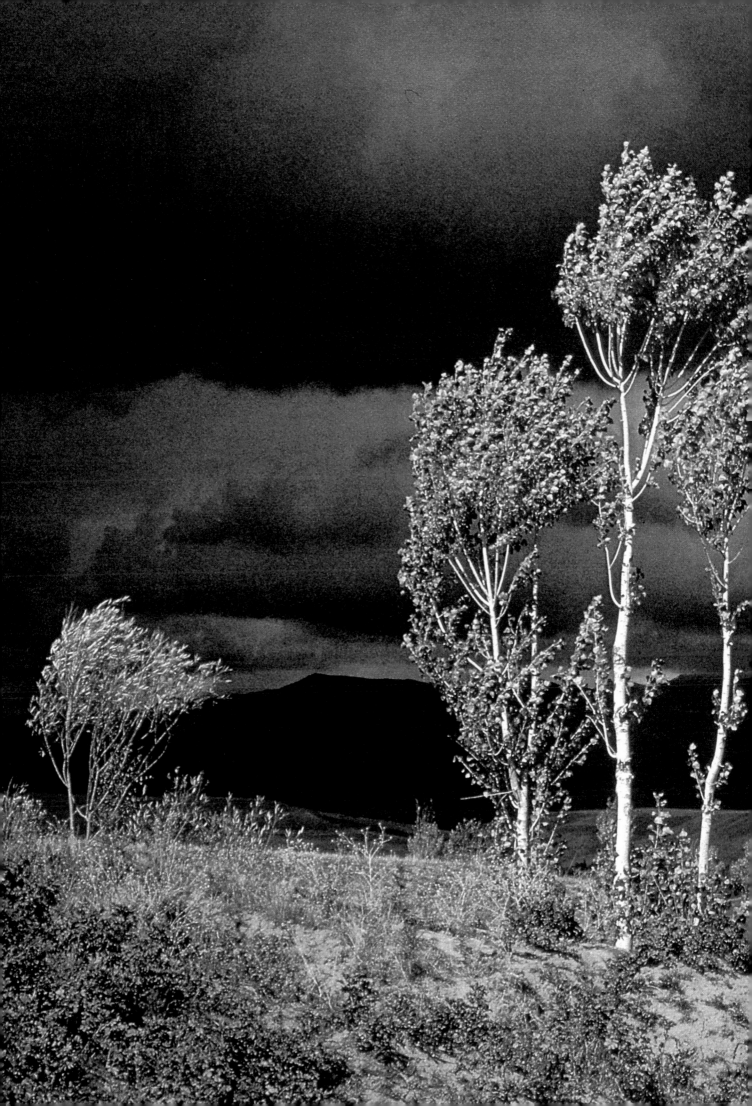

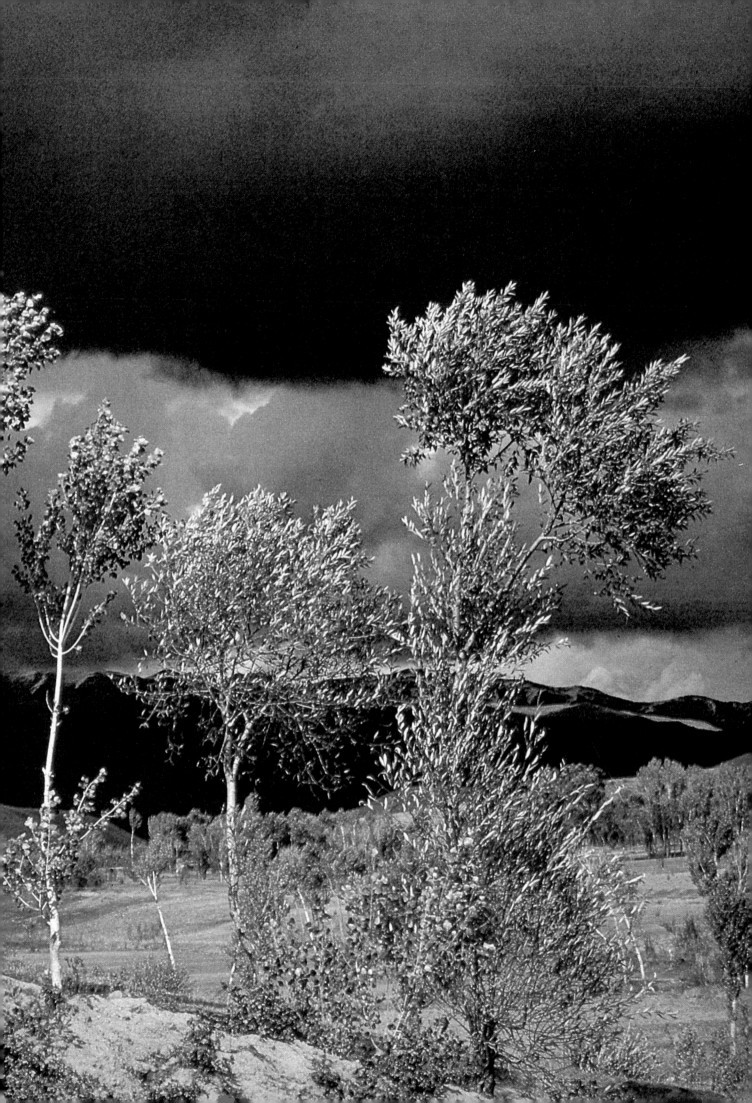

tains, for in these extreme conditions the sunbeams are especially dense. The quantity of ultraviolet rays in the air depends on time, season and altitude.

The ultraviolet filter was in reality originally a very slightly yellow neutral glass, specifically conceived for black-and-white films. Now people manufacture UV filters by the names Wratten 1A, Wratten 1B, or Skylight, which are specifically made for color film. It is their slightly pink coloring which tends to suppress the dominant blue caused by the atmospheric covering in the distance. UV and Skylight filters are mass-tinted, that is, they are cut in sections of glass whose color and density may alter in time, while the Wratten filters are Kodak gelatins which do not alter.

In fact, the UV filter, of whatever variety, serves essentially to protect the lens against dust and sunlight. There is no loss of quality in the image as long as the filter is antireflective and appropriate to the optical ensemble. Whether you shoot in black-and-white or color, it is virtually imperative to leave it permanently attached to the camera if you are working in dangerous or dusty places, or in the rain. If you break it, it only costs a few dollars to replace, while replacing a broken lens will cost you fifteen or twenty times more. A scratched lens means a loss of definition. Better to change a filter than a lens. Even if the sky is overcast, never use a filter without a sunshade, in order to avoid light refraction, which detracts from the sharpness of the image and sometimes creates undesirable areas of reflection.

Polarizing Filters

The polarizing filter is the only one that can, and should, be used for color, especially in landscape photography. It is somewhat the equivalent of the yellow filter for black-and-white. It augments the contrasts and allows you to darken the blue of the sky and to heighten the white of the clouds. Thanks to it, a very bright sky becomes much more sustained, if not almost black, while in general the color of the sky always appears more washed-out than the rest of the picture. That comes from the fact that you measure length of exposure in terms of the color and luminosity of the landscape rather than of the sky. In order to obtain a normal density of earth and trees, which are necessarily less bright than the sky, you are obliged to overexpose the sky. If on the contrary you make your adjustments according to the sky, the rest of the picture will be underexposed. Depending on whether you are shooting into or away from the light, there may be a difference of five or six f-stops between the sky and the rest of the image. The polarizing filter allows you to compensate for this difference by adding a supplementary density to the sky through intentional underexposure.

Polarizing filters are always movable, and you have to rotate them in order to polarize the light in the proportions you need. They function only at certain angles in relation to the light source illuminating the subject. In effect, they admit the radiations coming from an angle of 45 degrees in relation to the sun, and suppress all others. By suppressing the extraneous radiations, the sky is darkened, or at any rate its real value as perceived by the naked eye is reproduced.

Theoretically, the main function of the polarizing filter is to suppress the reflections which can be produced on non-metallic parts under certain lighting conditions. In practice, when these are too numerous or too powerful, it cannot suppress them all. It will be useless in front of a brightly illuminated window or cars parked in bright sunlight photographed against the light.

In color, its most interesting function is its capacity to augment contrasts at will, and to heighten the sky. It ought to be used more often, and be part of the basic equipment of any landscape photographer. But one remark must be made: when you photograph between 10 A.M. and 2 P.M.—not an advisable thing, since the sun is then at zenith and the shadows very harsh—the contrasts are accentuated even further by this filter. The shadowy areas become completely black and the sunny areas totally washed-out.

Infrared

Infrared color film allows you to obtain reversed colors and thus to create special

54

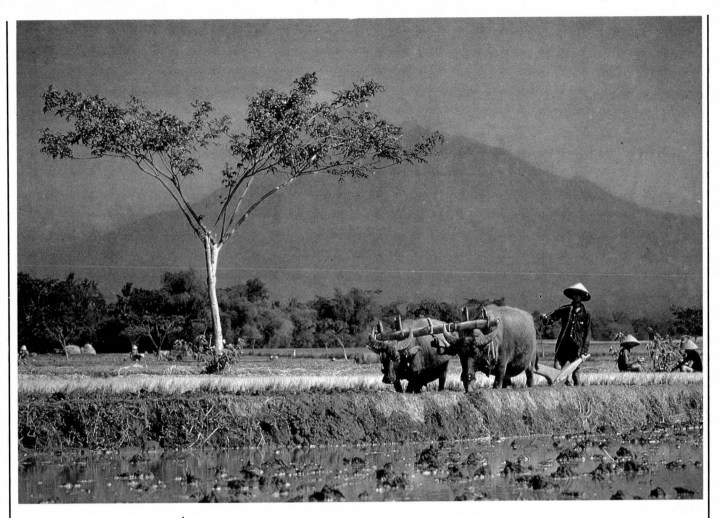

Indonesia. 1970. Rice paddies near Borobudur Temple on Java. The volcano visible in the distance is still active. Contarex, Sonnar 135mm, f/5.6, 1/125 sec.

effects. It proved very popular with landscape photographers when it was first marketed, but it has been associated with more failures than successes: this film must be used cautiously and can only be applied to a very subjective, not to say totally random, interpretation of a landscape. In spite of the directions supplied by Kodak (the sole manufacturers), it is difficult to control or even predict the effect it will produce under classic shooting conditions.

However, in the medical and scientific domain it has been used to obtain very precise results. At the outbreak of the war in Vietnam, this film had already been used for military ends by the Americans, to obtain aerial photographs of Viet Cong camps. To protect themselves from enemy bombardment, the North Vietnamese soldiers had camouflaged their equipment in the forest by covering it with felled trees and vegetation. Seen from an airplane with the naked eye, the camouflage was so realistic that it was impossible to detect it.

On infrared film the timber used to mask the camps appeared very dark, while the neighboring woods whose leaves still contained chlorophyll became very red, which made it possible to map out to the meter the limits of the military bases hidden under the dead wood. In effect, infrared film records not only the colors visible to the naked eye, but also radiations that emanate from an object. Nevertheless, you know in advance, as long as the photography and developing are handled with rigorous care, which color will change into which other tint and in conjunction with which filter. (This film must always be used with a filter; otherwise it produces a monochrome blue.)

The three most commonly used gelatins are Wratten 8 (yellow), Wratten 25 (red) and Wratten 21, which is orange and which has the peculiarity of making the sky purple. None of these gelatins filters the light completely. To suppress all visible radiations and allow only the infrared to pass, you must use the Wratten 84C and 89, which are practically black and opaque. Hence they require a period of exposure multiplied on the order of 20 to 30 times. You can see nothing through them, and their use is purely scientific.

55

Infrared film is very difficult to use on an amateur level. Its theoretical sensitivity is ASA 100, but in practice it varies according to the subject, the length of time the film is kept, the temperature at which it has been stored and used, and the quantity of infrared contained in the sky at the moment of shooting.

It is prudent to take systematically, in addition to the normal exposure, an extra picture one f-stop higher, and another one stop lower. At the outset, play around with the two most common filters. This experimental approach is the surest way to get pictures which are neither too dense nor too washed-out. It is only when you have some experience that you can see what is most suited for what you are trying to do.

In spite of its very violent contrast, infrared film should be used in bright sunlight, otherwise the colors become dull. It has very little stability. It reacts badly to heat and should be developed immediately after use; otherwise the latent image continues to develop by itself. The gelatin is very fragile; it becomes scratched or impaired very easily.

Black-and-white infrared film is very rarely used. It must in principle be used with a fairly thick red filters such as the Wratten 25, 87 or 89, all of which demand fairly long periods of exposure.

The Best Equipment for Landscape
In earlier days photographers worked with large-format chambers and used almost exclusively fine-grain films, which were consequently slow, on the order of ASA 14 to 25. This allowed them to obtain a maximum of definition, especially for distances. Today, even the most expert landscape photographers tend increasingly to use rapid films because of their flexibility.

If you choose the 24×36 as your basic equipment, you compensate for the loss of definition and quality inherent in the restricted size of the negative by the warmer and more intimate atmosphere created by the grain of the emulsion and the image's lack of sharpness. Only those amateurs who are mad about sharpness and absolutely committed to semitones still use 6×6 cm, 6×7 cm, or 4×5 in.

These formats are called for when the picture requires a maximum of sharpness and definition: landscape, architecture, archeology, crowd, reproduction of objects, paintings, etc. Most huge enlargements of mountain or forest landscapes intended for decorative purposes are taken in 6×6 cm, sometimes in 4×5 in., 5×7 in. or even in 8×10 in. For color, the surface of these enormous negatives gives more opportunities of registration, especially for advertising photography, where every element plays an important role in the composition of the image.

For very demanding photography, the ideal would be to have 24×36 mm. for portraiture, snapshots and anything taken spontaneously, in short, for living things; and 6×6 for static shots which require longer preparation. Some 6×6 cameras are very simplified and cost less than the simplest of the 24×36 reflex cameras, but their possibilities are very limited, and in view of how heavy and cumbersome they are, they offer few advantages. On the other hand, there are available on the market many 6×6 and 6×7 models with interchangeable lenses and whose numerous accessories make them an almost indispensable working tool for professionals and amateurs in the know, the real devotees, who in their search for perfection will not hesitate to spend a lot of time and money to realize the ideal photograph.

The Hasselblad, the Bronica, the Mamiya, the Rollei and above all the Pentax 6×7 are the most well-known and trustworthy, but they are of value only if you have all their very expensive optical accessories as well. A 6×7 camera, correctly called the ideal format, allows you to use the negative in its entirety without being obliged to cut it in order to change the composition, which is not the case for 6×6. It is rare to enlarge a photograph in square format, since that is not a very aesthetic composition.

The Souvenir Picture
Naturally, above and beyond all this, there is a very simple method of photographing a landscape if all you want is to have a souvenir of it.

1

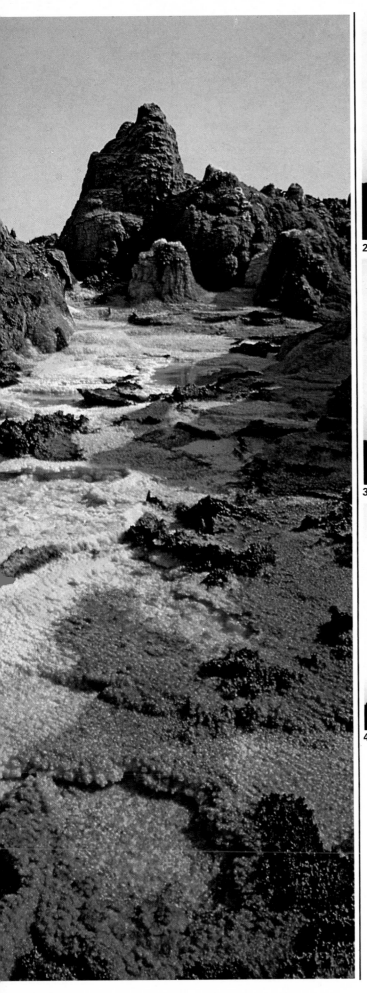

2

3

4

(1) Ethiopia. 1974. Danakil Desert. Soldier on guard near abandoned sulphur pits.
Leicaflex, Elmarit 25mm, f/8, 1/125 sec., Kodachrome II.

(2, 3, 4) India. 1967. Coal mine against open sky. Hasselblad, Sonnar 250 mm, f/16, 1/500 sec., Tri-X. Intentional underexposure at time of shooting in order to get this low-light effect, and printing on very hard paper to augment the contrast.

57

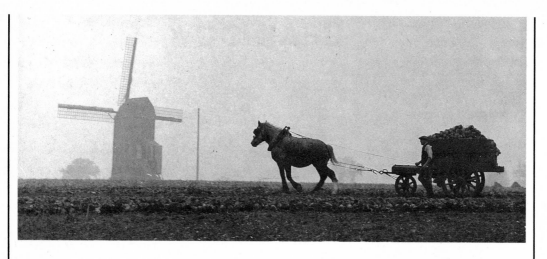

Modern man has more and more opportunities to travel in airplanes and see the world. It is normal to want to share with your friends the privileged moments you have experienced in remote places. Your only purpose in such a case is to show images that reflect what you were lucky enough to see. There is no question of artistic quest. All you need is the simplest possible camera that will record everything that strikes you as different. Such photographs can be considered simply as travel notes. They do not require any creative approach: they should merely be as simple and immediate as possible.

A lens on the order of 100mm is enough for this kind of picture, since it allows you to make both portraits and landscapes, to film most of the things you are likely to encounter in the course of a walk, and to photograph a village seen from a distance, or a herd crossing the road, or a peasant backing up his tractor.

These travel notes call for color. Black-and-white is a purely photographic domain which requires more introspection and analysis. Unless you explore its possibilities in depth you will be disappointed by the result. It is better to content yourself with transparencies, which are more flattering in their effects and easier to read. Choose a film like Kodachrome 25 or 64 which is easy to use, and don't bother with filters. It is sufficient not to go below 1/125 or at the utmost 1/60 of a second, and to be in focus. With a little luck as far as lighting goes you will obtain results perfectly adequate for assuring that the prints you select will be good souvenirs, pleasant to look at.

France. One of the last Flemish windmills still inhabited in 1957. Morning fog.
Contax D, Angénieux 135 mm, Plus-X, *f*/4, 1/125 sec.

The Village

THE seeker of images, amateur or professional, should always think about what he wants to say and show before he picks up his camera. Wherever you are, don't take a picture just because the subject seems intrinsically interesting. It is important to conceive of what you photograph as a *story* rather than just some images collected at random. You should do this for your own benefit, but also for the benefit of other people; it will enable you to *talk* about your photography with enthusiasm (whether your subject is monuments, landscapes or moments of life) and not simply *show* it.

Before photographing a village, you should ask yourself: What are its unique characteristics? What is important to see here? What is most striking? Why is the place pleasant or unpleasant? What are the outstanding character traits of the inhabitants? Before you begin to work, you must think about the totality of what you are going to do. You should not concentrate on one or another specific picture, but on the relationship between any number of images and the way they complement each other.

The Traditional Market: Themes for Observation

An animal market is not just a few hundred head of cattle tied to stakes along a wall. The essential is to paint the atmosphere which emerges. All the people of the vicinity—farmers, breeders, dealers, and the merely curious—are there. There is not a minute when there isn't something important going on for one of them. The violent and interminable arguments between farmers and butchers; the recalcitrant bull, his eyes blindfolded, his hoofs shackled, an enormous ring in his nose, who obstinately refuses to follow his new owner; the whispered conversations, the trace of complicity or craftiness in the clerk's glance as he watches his employer weigh a sow; the lean and buttoned-up apprentice who drags an enormous cow behind him; the radiant smile of the peasant who, having made a good deal, suggests a visit to the corner cafe; the worried face of the small-time proprietor as a potential customer surveys one by one the animals up for sale; and those who leave empty-handed, with unhappy faces.

Intimate Scenes of Daily Life

To photograph a village doesn't mean limiting yourself to events like markets, weddings, religious processions or seasonal festivities, but on the contrary means to paint the daily life of the inhabitants in their smallest actions and gestures: the children fighting on the church steps after school; the old women knitting in their doorways; the herds of cows hammering gravely with their hooves on the cobblestoned streets at dawn; the municipal bathhouse, the old men playing dominoes on the terrace of the only cafe in town; the haughty, contemptuous tourists strolling around.

Don't forget Sunday mass, either. Photograph someone spruced up for a festival, exiting from church or on the way to a ball; and then contrast this with the same person, hair undone, in threadbare work clothes.

To seize these many seemingly insignificant details that create the soul of the village, you need perseverance and patience. Don't stride in like a conqueror,

1

2

3

(1) Guadeloupe. View from a bridge, along the road, between Pointe-à-Pitre and Saint-Claude. Contarex, Sonnar 135mm, f/5.6, 1/125 sec., Koda-chrome II.

(2) Benin. 1966. In a northern village. Contarex, Sonnar 85mm, f/5.6 1/125 sec., Koda-chrome II.

your camera strapped to your waist, the day you arrive, but rather adjust yourself to the rhythm of the country. Understand what people are about before launching your assault. Join in a game of bowls; play several times before taking out your camera. Get used to the people. They will feel more at ease and will no longer freeze at attention, waiting for the little click. Seize slices of life and capture people in their everyday spontaneous movements, without forcing the situation.

These thousand little instants of daily life are much more enriching for the viewer than deserted streets, even if they are nicely composed.

In any village, no matter how anonymous or impoverished it appears, there is no lack of subjects: the making of bread, the sawmill, the blacksmith (if one still exists in the region), the milking of the cows, the cheesemaker with his cellars full of casks sheltered from heat and light; the Saturday night dance; all of them discoveries that open up new perspectives, and occasions for meeting interesting people.

The baker will not hesitate to leave the oven open a little longer than necessary (as long as the bread doesn't burn) to give you a chance to adjust the camera, if you let him participate spontaneously in the taking of the picture. But he will just as surely turn you down if you demand his cooperation, or behave as if you were in conquered territory.

The photographer is the intruder; sometimes, at best, the invited; but he is never the master. He should never forget that.

Getting Yourself Accepted, Tactfully

To photograph the inhabitants of a village that you are visiting for the first time, you have to take into account the psychological problem represented by the sudden arrival of any intruder in an established community. Unless you wish to capture expressions of astonishment or hostility, you must avoid being the undesirable stranger who puts people off before he even starts to work.

(3) Istanbul. 1972. Ter-race of a cafe near the har-bor. Contarex, Sonnar 135mm, f/4, 1/250 sec., Kodachrome II.

(4) France. 1957. Ile de Houat. Pentacon, Biotar 58mm, f/8, 1/60 sec., Kodachrome.

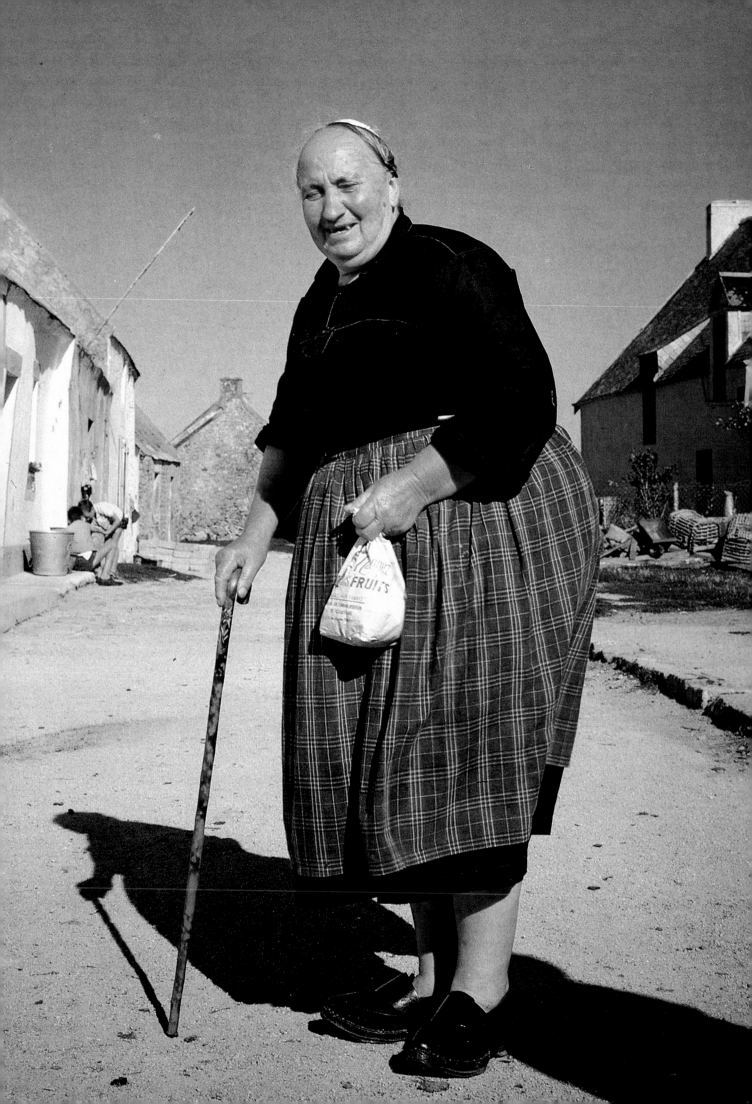

When you first arrive, with or without camera, the villagers will look at you. They observe you. They wonder about you. For many, the fact that you come with cameras means "the television is here." You must appease their uneasiness by stages.

First of all, walk around the village with your camera, but without using it too much, at least in the beginning, so you can be seen and be progressively accepted. You might even pretend to photograph everything you see, to get people used to what you're doing. These initial "blank shots" necessarily create some nervousness. But your apparent indifference to these imaginary shots reassures people. At worst someone will say, "He's cracked, that one." The tension is no longer acute. People get used to your mania. Once the first obstacle is down, you can start to work with an ease you would not have thought possible at the outset. This approach is applicable, for that matter, to any kind of photojournalism.

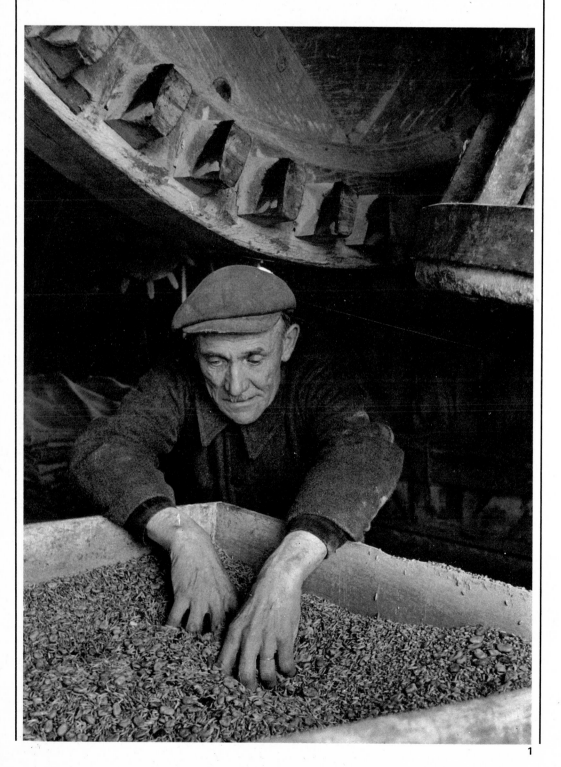

In France, in order to quickly establish natural contacts, you obviously have to spend time in cafes, since they are the only places where people are willing to talk to strangers.

The Handicap of Equipment in a Foreign Village
If photographing in Europe is sometimes delicate, you must redouble your prudence and your politeness when you arrive in a country whose customs are completely different from ours. The Westerner who enters some Peruvian village has neither an Indian's color nor his way of walking, eating or holding a glass. Even if he speaks the local language, his presence alone, representing as it does another civilization, is an intrusion; even more so if he is loaded with camera equipment and starts off photographing people right away.

This equipment is expensive; and the native, however illiterate he may be, knows this instantly. Even if they underestimate the price of camera, many

(1) France. 1957. Flemish windmill. Grinding of beans.
Contax D, Angénieux 28 mm, *f*/4, ⅟₃₀ sec., Tri-X.

(2) India. 1968. Small village in Bihar.
Contarex, Distagon 24mm, *f*/11, ⅟₆₀ sec., Tri-X.

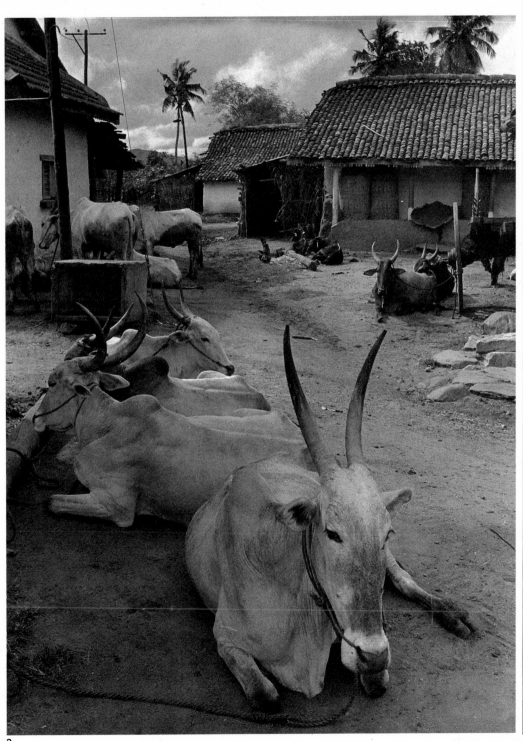

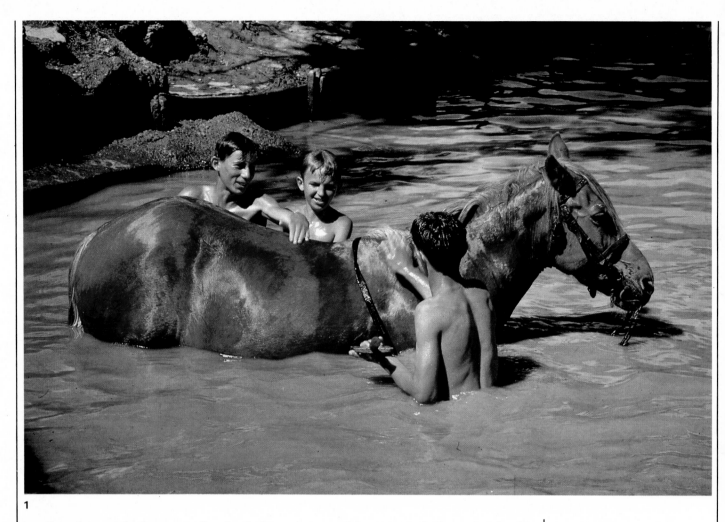

1

realize that with the cost of a single lens they could support their entire family for a year or more.

To be perceived as wealthy when confronting a poor person eliminates any chance of dialogue. Whatever your personal behavior, and however admirable it may be, no one knows immediately that the owner of such a luxury item photographs for artistic or professional reasons, and that acquiring his equipment may have cost him months of work.

Don't Overdramatize the Situation
Nevertheless, you must not, under the pretext of not feeling completely integrated and of not being able to transform yourself into a South American peasant, refuse systematically to use your camera.

In fact, a person who hides behind false alibis is often completely terrified by the world around him, but he refuses to admit it. So instead of admitting it, he photographs from far away and says that he refused to come closer in order not to disturb people. This explains the frequent use of the telephoto lens in travel photography and, in general, for all spontaneous on-the-spot photography. Whether you are in your own country or abroad, you feel secure behind a long-focus lens. Distance diminishes fear and danger.

But to photograph a scene you have to enter it, you have to go where you want to go and be capable of getting five inches away from a face if that is what you feel you must do. Someone with no courage for this will make no progress.

The minute you feel you are disturbing someone, there is a tendency to fall into the kind of reasoning which leads us to say "it's too cold" or "it's too hot" or "the timing is wrong" or "conditions will be better tomorrow." This impulse, which holds us back every time we approach a stranger to take his picture, must be resisted.

Documentary photography calls for courage and willpower, which do not conflict with respect for the people you photograph.

(1) Yugoslavia. 1960.
Topcon, Topcor 55mm, f/8, 1/125 sec., Kodachrome.

(2) India. 1967. Punjab village.
Contarex, Planar 50mm, f/2, 1/30 sec., Kodachrome X, available light.

64

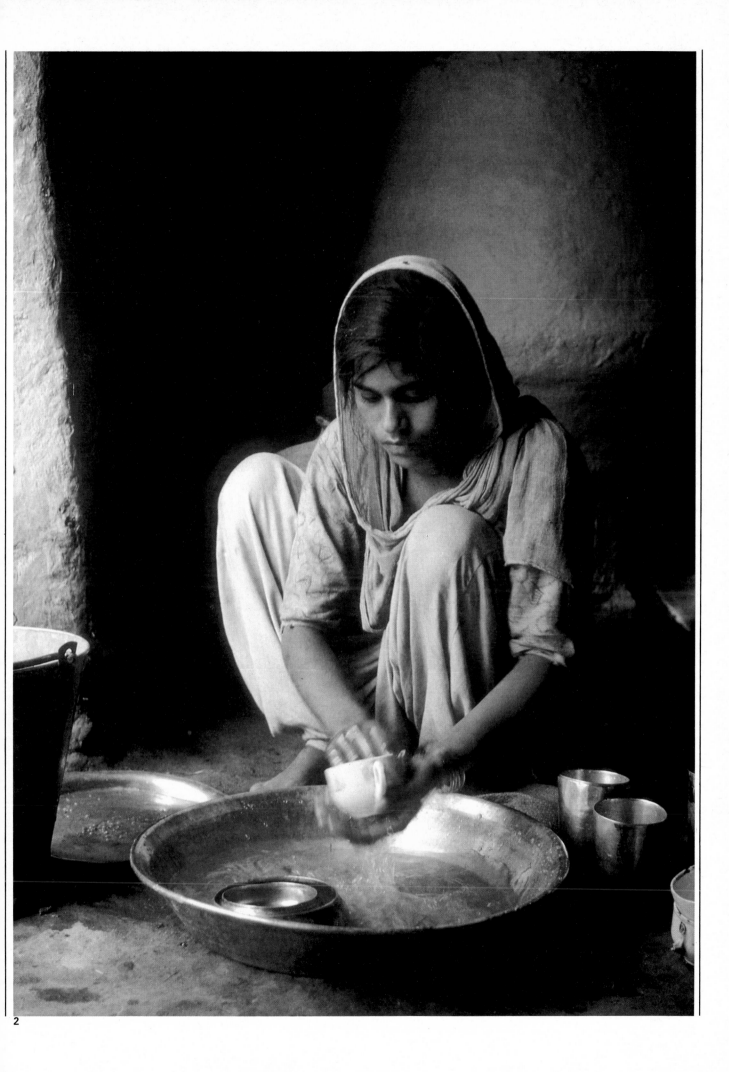

The Mountains

To photograph more easily during a ski run or on a mountain excursion it is important to carry light and easily portable equipment, with a minimum of indispensable accessories. Unless you have a Hasselblad with its interchangeable magazines or other equipment of the same type that allows you to use several emulsions simultaneously with the same camera body, the 24×36 is preferable by far to the 6×6 by reason of its light weight.

If you want to do black-and-white and color at the same time in small format, you must use—it is imperative—two cameras of the same brand in order to have a choice of lenses and filters common to both cameras. A wide-angle of 28 or 35mm, and above all a telephoto of 90, 105 or 135mm, are fully sufficient to cover the majority of subjects. The very large telephoto is heavy, bulky, and almost always requires the use of a tripod. In fact, its use at high altitude is justified only if you want to film marmots or chamois.

However, for mountain landscapes, the use of telephoto reinforces the impression of perspective by bringing the different planes closer together. The effect of the peaks crowding on each other creates a sometimes striking relief, but you must not overdo it. Wide-angle will emphasize a close-up while infinity will appear small and remote. The impact in that case will be provided by the foreground, which could be an edelweiss, a footprint in the snow or bird tracks. As for extreme wide-angle (15 and 25mm), it often requires long periods of search and reflection before you come upon an original composition suitable for this lens, whose technical possibilities are difficult to control (especially when you are numb with cold).

Avoid carrying your equipment slung across your back without protection, particularly in bad weather. In winter, especially in the mountains, you are always at the mercy of a snowstorm, a sudden downpour, or, more prosaically, a skiing accident. If you have only one camera with you, you should keep it under your parka, or wrap it in plastic and seal it tight with elastic bands in your knapsack.

The ideal, naturally, above all when you have several cameras and their accessories, is to carry your equipment carefully arranged in a watertight, airtight bag or, better still, in a carrying bag that is solid and divided into compartments, so that cameras and lenses do not knock against each other at the slightest movement. The outside pocket should be reserved for films and filters. Especially if you are engaged in mountain- or rock-climbing, this carrier bag should be as compact as possible, and equipped with an additional strap with which you can strap it to your waist, to avoid any dangling ends that might make you lose your balance. The bottom and the partitions should be covered with something soft to absorb shock in case of a fall. It is important to divide up the bag's interior sensibly, so that each camera is easily accessible in any position, even if you are on skis; otherwise you will have to unpack the whole thing every time you want to take a picture and thus risk dropping everything.

You will often come upon the most beautiful angles for a picture at the most dangerous moments of a climb or during the most dizzying descent. That being the case, taking out and putting back the camera must be a virtually automatic

Austria. 1964. Near Innsbruck during the Winter Olympics.
Contarex, Sonnar 135mm, f/4, 1/60 sec.

gesture not requiring any particular effort, especially when you yourself are in an unstable position.

Condensation

In winter, if cameras (especially lenses) stay in the cold too long, they become covered with steam when they are once more in a warm interior. Often, after a long mountain walk, you find on returning to the lodge that the lens is covered with frost or with a condensation that quickly changes into tiny drops of water, on both the exterior and interior of the camera and sometimes even on the film and in the viewfinder, which becomes opaque and gives a confused and flattened image. It then becomes impossible to focus properly.

A certain amount of time is required for the camera to warm up again to the surrounding temperature, and for the condensation to evaporate. In such a case, if you are in a hurry, there is one method: bring the camera gradually closer to a stove. When I was engaged in speleology and spent a long time underground, I had a portable heater which I used regularly to warm up my cameras so they would always be slightly warmer than the surrounding temperature. But you must never put the camera on a cooking range or hold it too close to the flame of a wood fire, for the lenses might crack or even explode under the influence of the sudden change of temperature, and the lens would be irremediably destroyed. If your cameras are really soaking wet, sponge them delicately with a tissue, or, if none is available, with ordinary paper.

The Influence of Temperature

Thanks to modern technology, recent cameras are resistant to very low and very high temperatures without any special preparation. It is no longer necessary to change the oils that lubricate the interior mechanisms of the camera bodies and lenses, depending on whether you are shooting in a cold country or in a tropical region. Not so long ago, someone who went to the Sahara had to replace the original camera oil with another, denser grease to prevent his camera from literally shrinking. This grease, above a certain temperature, would liquefy and spread through the interior of the camera without lubricating the different mechanical parts as it ought to have done. Members of polar expeditions, on the other hand, had to replace the original oil—which froze and blocked the mechanism at only a few degrees below zero—with an extremely fluid oil.

Though modern cameras continue to function, whatever the surrounding temperature, you must nevertheless be aware that the shutter speed varies according to extremes of temperature. The shutter of the camera body or the lens which is set to function at 25°C will give an entirely different speed at −20°C or at +55°C. The makers usually include in the printed instructions the conditions and limitations of their product. Anything lower than −10°C is a signal for caution. Protect your camera under your coat or jacket and take it out at the last possible moment.

In warm and humid countries, the gelatin of the film, especially color and most particularly Ektachrome, swells. The film gets jammed up and will not advance. It becomes impossible to load the camera without scratching both base and emulsion.

Cameras nowadays are greased with oils designed to remain fluid at a median temperature ranging from −5°C to +40°C. If you know in advance that you are going to be shooting in very cold weather for a long period of time, have your camera oiled with a specialized restorative before you set out, using more fluid oils in order to prevent freezing, which would result in blocking the action of the shutter curtain, the button and the shutter itself.

For landscape in general, especially in winter, Kodachrome 25 color film, despite its weak sensitivity, is undoubtedly the best film for capturing the nuances of snow because of its saturation and high definition.

Whether the film is color or black-and-white, you must be aware that the sensitivity indicated on the packaging is an average established by the makers of the film in terms of a moderate temperature and a given amount of light. It is thus not applicable to very low or very high temperatures, especially when reflections are extreme and the light is very intense, as is often the case with

68

1
(1, 2) Sahara. 1974. Plateau of Hoggar; Assekrem seen from Father Foucauld's hermitage. Both these pictures were taken a few minutes apart from each other at the moment of sunrise.
Minolta XM, Rokkor 200 mm, *f*/8, with tripod.

(3) Taken from the same spot with a wide-angle lens.

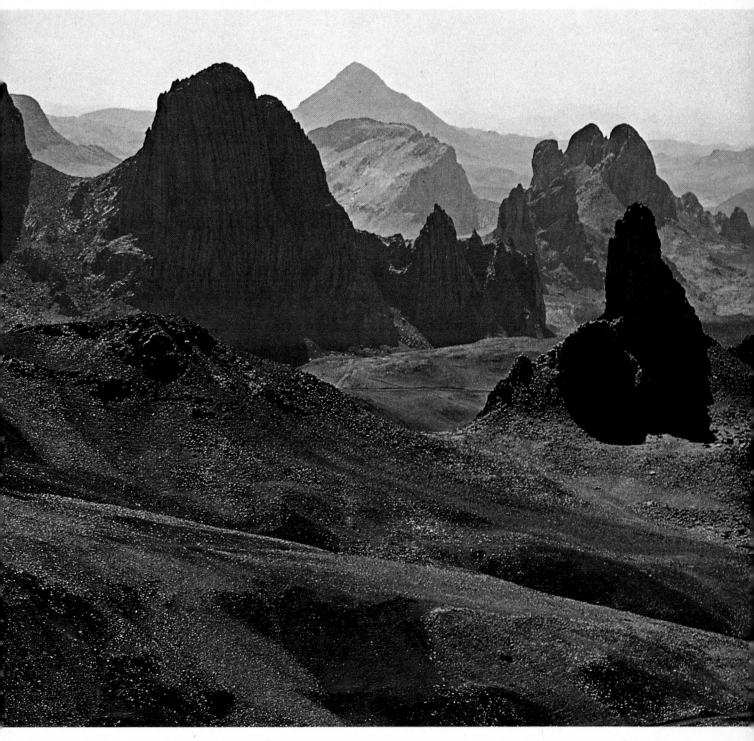

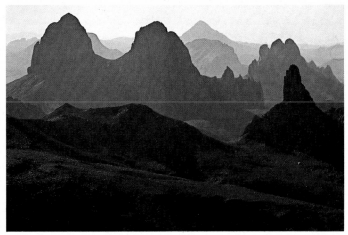

2

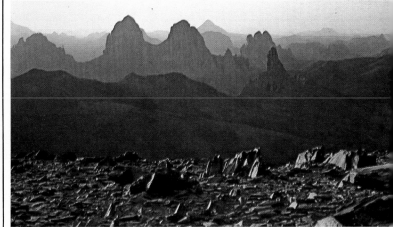

3

snow, beach or desert. The sensitivity of a color film labeled as ASA 64 can go as high as ASA 125 on a glacier. You must avoid excessive contrast between dark and bright areas. A person photographed in profile in relation to the sun will be completely cut in half by the difference in light intensity between the illuminated side of the face and the side in shadow. One side will be completely overexposed and thus transparent, while the other will be underexposed, that is, as black as coal. Like a silhouette, both sides will have lost all detail.

Shutter Speed

Don't be afraid to use high speed in order not to be obliged to use low f-stops. Amateurs are often afraid to go beyond 1/125 sec. A shutter speed of 1/500 seems unapproachable to them. Maybe they think unconsciously that it's too fast, that the image won't have time to register on the film, or that it isn't reliable.

Few people use 1/1000 sec. and even fewer 1/2000, just as people tend to avoid high-sensitivity films. They think that even Tri-X, which is only ASA 400, is reserved for professionals. Most people categorically reject this film, not for reasons of excessive definition or graininess, but simply because it is too fast. On the other hand, they don't hesitate to go down to 1/30 or even 1/8 with a hand-held camera. They don't realize that below 1/60, unless you are very skilled, there is a good chance of blurring the image through camera shake. Since a second seems to such people to pass very quickly, even more so a fraction of second.

It must always be remembered that if the subject doesn't move—above all, in the case of landscape—the photographer and the camera are likely to shake, especially if you have just completed a physical exertion and are at a high altitude. For this reason it is often advisable to choose the maximum speed compatible with the aperture opening you intend to keep; this will ensure the sharpest possible photographs.

Sometimes it takes several minutes to catch your breath. The unexpected appearance of a rainbow, of a chamois or of a ray of sunlight between two clouds are ephemeral phenomena. You must be able to act quickly.

But in general, unless the light is very strong, it is rare to be able to have both this optimum speed and the aperture you have in mind. You must make a choice and sacrifice one or the other, or find a happy medium. Many choose the speed which suits their chosen aperture. If you are photographing a moving subject, however, you must give priority to speed. It doesn't matter if you are forced to work with wide aperture.

Excessive Contrast

In the mountains, to eliminate certain excessively violent contrasts, and above all to accentuate the depth of the sky's blue or to emphasize the whiteness of the clouds, it is sometimes wise to resort to a polarizing filter. It must be adjusted while looking through the viewfinder and rotating the filter until you obtain the desired modifications in the coloring. Don't forget that a polarizing filter gives good results only in sunny weather and when you photograph at an angle approaching 45 degrees in relation to the light source. This filter has the disadvantage of absorbing between 1/2 and 2 f-stops, depending on its position.

For black-and-white, at high altitudes, the gentlest film possible is recommended, with very fine grain and sensitivity of about ASA 40. They give a good rendering of the semitones in the scale of grays. For all panoramas taken in high mountains, and for snow in sunny weather, orange filters accentuate contrasts, darken the sky and impart more brightness to the whiteness of the peaks without at the same time distorting reality. Red filters reinforce even more the whiteness of the mountains and make the sky very black. Used intelligently, they give the image as a whole a striking quality.

Most photographs of the Himalayas that appear in books and magazines, where the brightness of the eternal snows cuts violently through the inky black sky, are taken with red filters on film of very low sensitivity. The use of these screens is all the more valuable when the reflection of the ice is strong. But you must remember that some of these tinted glasses can absorb as many as six f-stops. It is obviously out of the question to carry a tripod in the mountains

and it must also be borne in mind that it is difficult to take a picture below 1/60 sec. without camera shake.

The higher you go, the more violent the ultraviolet rays become. It is a pipe dream to think that ultraviolet filters, for black-and-white or for color, play an important role; unless it is that of brightening the sky's blue at high altitudes, or of adequately protecting the lenses from dust. They are more often used out of snobbism than for their usefulness.

In snow more than elsewhere, because of reflection, never forget to attach your sunshade to prevent any extraneous light from penetrating the lens by reflection. Despite this sunshade, when you photograph against the light you will sometimes notice small bits of light on the picture, or round or octagonal dots repeated several times, the number of repetitions often corresponding to the number of layers of glass which make up the lens. These partial veilings can create, especially in color, some rather surprising effects, but it is practically impossible to control the results when shooting.

As with all landscapes, when photographing in the mountains or on a ski trail, place yourself, if not against the light, at any rate always at a right angle to the sun in relation to the subject of the picture, in order to get more perspective. For snapshots, if you want to emphasize facial expressions, shoot definitely against the light (but don't forget to set your f-stop in accordance, to avoid getting black shapes without detail against a white background).

You will obtain the best tints and a more realistic rendering of skin color, especially if the skin is somewhat bronzed, on days when the sun is clouded or even completely overcast. For portraits and snapshots, photographing when the sun is clouded is ideal. On the contrary, for a landscape you must have sun and contrast, or else the colors will be too pastel and the image will lose all its relief. You must also pay attention to the dominant colors of the films, which often emerge when you work in bad weather or by insufficient light. In Ektachrome, for example, you will get a bluish tint if the lighting conditions are defective.

To calculate your aperture and shutter speed when you photograph a snowy landscape (especially if you measure your light with a built-in exposure meter that measures through the lens), be aware that the electric eye will analyze chiefly the light given off by the whiteness of the snow, and will give, notably for the sun, an erroneous result, several f-stops off in relation to the real intensity of the surrounding light. If in this case you follow faithfully the indications given by the needle of the galvanometer, you risk, not (as you might think) overexposing the image, but underexposing it by two or even four f-stops. The snow will no longer sparkle but will take on a brownish tint.

The electric eye can easily indicate an aperture of $f/22$ when in fact you should only be at $f/8$. Thus it is important to make your setting in relation to the surrounding objects which are neutral in color. If there is nothing but white around you, measure the light reflected by your hand when you hold it in the same direction as the landscape you are going to photograph. If the landscape is full of contrast—a forest of dark green fir trees opposed to starkly white snow —the transparencies will look like silhouettes without this correction.

It is better to overexpose slightly in order to obtain details in the shadows. It doesn't matter if the snow is too white. The most beautiful pictures of snowy landscapes are taken in the morning or evening when the light is dull. At night, by moonlight, using a long exposure, you can get surprising results.

Mountain Sports
To photograph a skier in action, set the camera at 1/500 sec. or 1/1000 sec. The landscape will be in focus and, even at this speed, you will get, especially shooting against the light, spectacular effects of bunches of snow swirled up by the movement. To capture the intense expression of skiers in full movement, stand in the track of an obstacle course. With a telephoto lens, compose your image in advance within a chosen frame and click the instant the skier enters it.

Unless you are very expert and have a rapid-setting lens of the Novoflex type, it is practically impossible to focus on a skier who is coming toward you at high

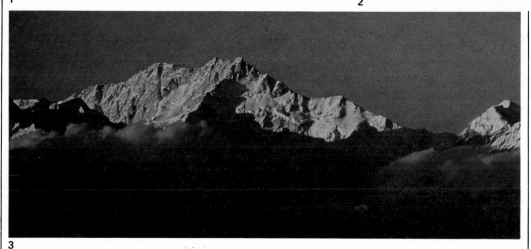

speed. You must therefore set your distance in advance on a pre-selected spot and wait until the skier enters the area that is in focus. The same goes for shooting a ski jump. Don't hesitate to lie down in the snow and photograph at a low, slightly oblique angle. Don't get directly under the jumping-off point, since from there you will see only the bottoms of the skis (unless of course that is the effect you want). Unless you are very lucky, you will probably have to take many pictures before getting an outstanding shot.

It would be unfortunate to reduce mountain photography to a series of grandiose landscapes. At high altitudes, the warm atmosphere that reigns in the lodges is fascinating to observe. There is nothing more sympathetic, after an outdoor excursion and a fresh contact with nature, than to share onion soup or fondue with a group of alpinists you met a few hours earlier balancing uneasily atop a glacier. When you set out on a large-scale mountain journey, you should therefore bring along a few rolls of high-sensitivity film and even a small flash for the evenings around the fireside.

(1) France. 1957. Ecrins. Pentacon, Biotar 58mm, $f/11$, $1/125$ sec., yellow filter, Plus-X.

(2) U.S.A. Colorado. Contarex, Sonnar 135mm, intentional underexposure in order to augment the sense of perspective, Kodachrome.

(3) Himalayas. 1972. Kangchenjunga seen from Darjeeling. Contarex, Sonnar 135mm, $f/5.6$, with tripod, polarizing filter, Kodachrome.

(4) U.S.A. Colorado. Contarex, 135mm, $f/11$, $1/250$ sec., Kodachrome.

The Sea

FOR a photographer, the theme of the sea presents itself in three essential forms: the way we see it when we walk along a shore; the way we see it when we are on a boat; and the way we discover it when we plunge into it. But underwater photography is a specialized field which requires appropriate equipment and special training, so we will discuss it further on.

The incessant movement of water over sand or rocks fascinates everybody. Millions of images of the ocean have been made in all latitudes and in all times. Nobody will ever get tired of taking close-ups of swirling foam, surf, seaweed, the sudden unleashing of the elements . . . these are inexhaustible subjects. Thanks to the colors, the ever-changing light, the reflections of the sun, the constantly evolving volumes, all interpretations are possible. The photographer is free to do as he wishes.

Whether the sea is calm or in movement, you must always try to translate into photography not only what you see but what you feel as you watch it. If the sea is slack, it is important to reinforce this impression of immobility by freezing your waves with a relatively rapid shutter speed on the order of 1/125 to 1/500 sec. If the ocean is turbulent, you can capture the unfurling of a wave or its breaking in close-up with a very rapid speed—1/1000 or 1/2000 sec.—in order to make each drop of water, each bit of foam, visible and alive.

If on the contrary you want to show that the ocean is perpetual movement, you can choose a slower speed, as long as you introduce into your frame a fixed element that faces the roiling of the sea, such as rocks, a pier or a lighthouse. The surface of the sea will appear all the more agitated if it is contrasted with a very sharp static element. Even if the sea is very rough, certain areas will be in focus at 1/60 sec., since there is always the trough of the wave and a few areas of calm in the midst of all the activity. If you work with this alternation of sharp and soft focus, you may obtain a very beautiful and very alive image.

Generally when you intentionally take something out of focus, it is important to have in the final image some elements which remain clear and are differentiated from the rest of the picture. When you pan, the subject that you follow must be as precise as possible while the background is vaporous. If the whole picture is hazy, the image is confused and nothing really is expressed by it, not even the impression of movement or speed that you were looking for.

The coast at low tide is an inexhaustible field for investigation. Without committing yourself exclusively to macrophotography, you can take any number of astonishing close-ups with any reflex camera equipped simply with a macro lens or with a normal lens with an extension tube or extra lens attached to it. By lifting the smallest stone you will make incredible discoveries: crabs, anemones, algae and shellfish with shimmering colors.

On the beach, it is equally amusing to capture the trenches which form on the surface of the sand as the sea retreats. These trenches, photographed in close-up, lose their scale of size completely. The image thus created often gives the impression of a strange delta with tortuous meanderings photographed from an airplane at 8,000 meters.

Protecting Your Equipment

Never put your camera on the sand, even if it is dry. Fine particles will penetrate the interior of the case, blocking it up and possibly causing the mechanism to deteriorate. Watch out for sea spray. Salt is highly corrosive. A camera which is splashed by a wave is irretrievably damaged. You must reload your camera while protecting the film from drops of salt water and from the sun, on the beach as well as on the open sea, for the light is often very violent. Make sure no grains of sand get caught between the emulsion and the camera body; otherwise the whole length of the roll will be scratched.

Photographing on board a fishing boat or a sailboat calls for many precautions, especially if the sea is rough. In that case, prop yourself up on the bridge or hold tight to the roping or the mast. Click the shutter at the precise moment when the boat, having reached either the top or the trough of a wave, becomes immobile for an instant. One wave is enough to wash away a considerable amount of capital and a multitude of dreams. Keep your camera under your

Southern India. 1972. Peasants washing their cattle at the beach of Madras.
Hasselblad, Distagon 50 mm, f/11, 1/500 sec., Tri-X. Intentional underexposure to augment the contrasts and the brilliance of the water.

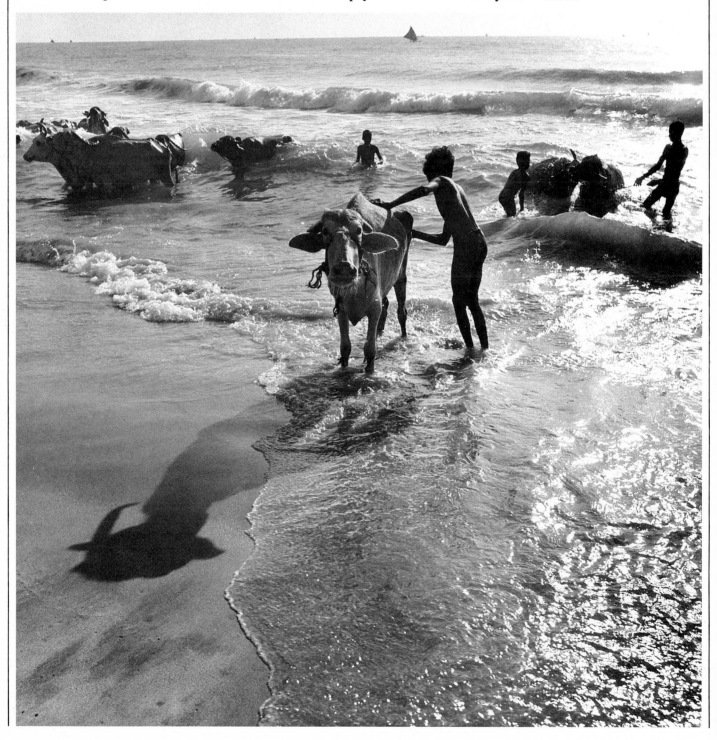

oilskins, and constantly wipe the camera body and lens attachments before and after use. Leave an ultraviolet filter permanently attached in order to protect the lens. If necessary, wipe off the salt which crystallizes on the glass, being careful not to rub hard enough to crack it.

Keep your equipment in packaging that is as watertight as possible, and make sure it is constantly sheltered from spray. Protect the exposed films from humidity. Don't bring any unnecessary equipment with you. Two cameras are enough if you want to work in both black-and-white and color—and two lenses. You will need a small telephoto for taking close-ups of your companions on board and of the neighboring shores, especially when you approach an island, and in hilly countries like Greece, Corsica or Yugoslavia, where it is often possible to come alongside in enclosed creeks with steep perspectives. Obviously there is little interest in photographing the flat coast of the Atlantic off La Baule. All you will see in your image is a band of earth with no relief, wedged between a mass of more or less calm water and a more or less dull sky.

The Pleasures of Risk

Wide-angle is indispensable for capturing life on board. Each crossing, especially if it lasts several days, can give rise to a fascinating document. On a ship on the open sea, passengers and sailors share unusual conditions of life in common, especially if the voyage is out of season, at Easter or in autumn, when it begins to get cold. Everyone confronts fairly rigorous conditions; they are chilled and soaked from dawn to dusk. The effort and fatigue show in the faces. There are any number of interesting expressions to catch, above all in the moments of exertion and tension.

The hold of a boat is always an interesting place full of the unexpected. Don't be afraid to push your film forward two or three f-stops, because generally there is very little light in the interior.

You can also capture the reactions of the boat itself to the elements, by climbing the mast, for example, which will call for some dangerous acrobatics. After all, in photography it is not only the final result which counts but also the emotions you experience while attaining it.

It is fascinating to contemplate the extent to which photography, a simple enough motivation in itself, can push the photographer to the most unbelievable extremes, making both amateur and professional take unreasonable risks.

Underwater Photography

Underwater photography requires a perfect knowledge of the surrounding environment, and also of the photographer's own physical limitations. The majority of accidents that occur underwater are due to a total ignorance of the fundamental rules of safety and not, as you might think, to marine animals, which are not usually dangerous, with the exception of the sharks that frequent certain tropical waters. Even these tend to attack only the ordinary swimmer, since usually they snap at whatever dangles from the surface of the water (arms, legs, etc.), rather than the submarine diver who, for the sharks, is just another big fish among the rest.

The redoubtable conger eels, to whom Roman emperors in jest used to throw living slaves, are in fact timid and usually hide in their hole when something approaches them. They bite only if attacked.

There are, however, several species of poisonous fish such as the stone fish of the Indian Ocean which, with its great power of camouflage, blends with its surroundings and is difficult to see.

The giant clams which were once the terror of professional divers are rarely found on our coasts. One recalls the fearful tales of Japanese pearl divers, obliged to amputate themselves with their knife in order to pry their imprisoned leg from the jaws of a giant mollusk on which they had accidentally stepped. The strength of these clams is such that it is impossible to open them by hand, all the more so underwater where one has nothing to grasp. They cannot be moved, either, since they are attached to the ground.

No experienced diver ever goes down without a knife, not to do battle with the infrequent sharks, but simply to cut himself loose if he gets caught in a

fisherman's trap, something that happens quite often on our coasts. Never dive alone, even if very experienced, since no one is exempt from sudden illness, mechanical failure, or a simple error.

Focusing Underwater

Infinity does not exist in the water. Underwater one photographs at 1 or 2 meters distance at most; beyond that, the screen of suspended particles is so dense that the photograph becomes dim. Hence the interest in using wide-angle to make up for the density of the water. Because of the different indices of refraction of water and air, everything appears larger and nearer underwater. Fortunately, the same phenomenon occurs in the camera's viewfinder. Thus, you focus on a closer distance than the actual distance. There is therefore no problem with reflex cameras.

Since the human optical system corresponds to that of the camera's viewfinder, for nonreflex cameras it suffices to adjust your focus in terms of the apparent distance. For a fish who seems to be 1.5 meters away and who is really 2 meters away, it's enough to focus at 1.5 meters. The same fish, when he surfaces, is 25 percent smaller than he appeared in his element.

Lighting Problems

Lighting is the most difficult problem to resolve, since underwater luminosity, already weak near the surface, diminishes rapidly the farther you get from the surface. In color it is difficult to avoid the dominants. Even at less than 5 meters depth, if you don't use artificial light for color, there is always a blue-green dominant; while with artificial lighting, the red and warm tones are in their normal places.

Since light projectors are heavy and cumbersome, it is preferable to work with a manual flash. In this case it is better to have a single side light attached at 30 degrees in relation to the camera, thus creating small shadows and augmenting the perspective. A flash unit at both sides of the camera would make for excessively flat lighting.

For black-and-white, shoot as far as possible by natural light in order to render the submarine world more fully, since the flash only illuminates the foreground, and the background disappears completely. However, in color, at small depths, the flash is useful, even when there is enough available light so that the background is not completely black. But it is always difficult to predict the balance between natural light and artificial light.

The electronic flash is certainly the solution of the future, but as yet it is insufficiently watertight. It gives a balanced light for daylight film. (About 6000 ° Kelvin, which is ideal for short-distance pictures; but for those taken at more than 1 meter, the sea bed forms a blue screen and in that case it is better to use warmer light sources, such as 4000° Kelvin flashlamps, since the blue light of the electronic flash necessitates filtering in the opposite tendency; and while this poses no problem at a short distance, it is not the same at more than 1 meter, where a warm light source is called for. The guide number of the electronic flash should be equal to at least 35 for an emulsion of ASA 64, if you want to use the corrective filters for photographs taken farther away than 1 meter. If you use a source of 6000° Kelvin at 2 meters without a filter, you will inescapably get a blue-green image.)

From 15–20 meters on, by natural light, contrast becomes negligible, and without precautions or special preparation you will get a gray negative that is difficult to develop.

Low Visibility of Fauna

While certain subjects lend themselves particularly well to black-and-white, others, like coral and starfish, come out better in color. Luck is an important factor in color photography and it is hard to predict the definitive chromatic effect. The same associations of colors may give either marvelous results or washed-out tints.

All seas do not present the same difficulties. In the Mediterranean, the water is transparent. Everything looks small, and one has the impression of moving

1

(1) France. 1957. Ile de Houat. Returning from fishing on a trawler. Pentacon, Biotar 58mm, f/4, 1/60 sec., Kodachrome.

(2) France. 1959. Hossegor. Close-up of sand on the beach at low tide. Exacta Varex, 50mm, macro extension tube, f/4, 1/60 sec., Kodachrome.

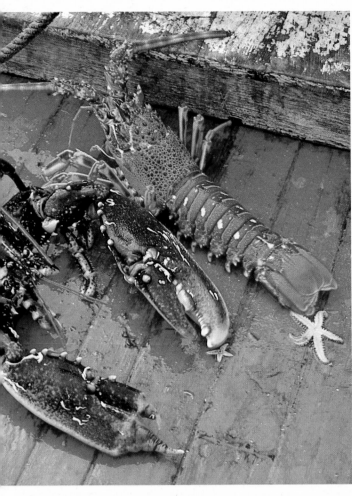

(3) France. 1960. Vendée. Algae clinging to rocks at low tide.
Topcon, Topcor 55mm, f/5.6, 1/60 sec., Koda-chrome.

(4) France. 1960. Brittany. Transparent sea anemones in a pool of water at low tide.
Topcon, Topcor 55mm, extra lens, f/5.6, 1/60 sec., Kodachrome.

2

3

4

through a Japanese garden. Next to the laminaria, the posidonia are minuscule. But you have to pay close attention, because it is easy to descend rapidly into very deep water without being aware of it. Lower than 40 meters one begins to be subject to nitrogen poisoning, so caution must be redoubled.

Each type of fish inhabits a particular stratum of depth; but they diminish insofar as they are pursued by hunters equipped with harpoon rifles. These have practically and definitively destroyed the marine fauna and flora of our coasts. Nowadays you must often go deeper than 60 meters to find groupers, which are perhaps the easiest fish both to kill and to photograph, since they rarely go far from their hole and very quickly get accustomed to the presence of humans. But it is becoming rarer and rarer to encounter one.

Fortunately, there are still vertical walls of rock to which many animals with magnificent colors still attach themselves. You can also lure some fish such as rainbow wrasse to you with bait (shellfish or sea urchin).

The Atlantic Ocean still abounds in fish, and resembles a veritable virgin forest with its huge algae. Visibility is limited, for a vast number of particles, such as plankton, remain continually suspended in the water, which often takes on a greenish tinge.

Few people dare to photograph in fresh water, on account of pollution. Often one has the impression of diving into a sewer, and in most rivers visibility is reduced to less than 50 centimeters. As for lakes, the water is very clear, but cold, and the fish, which are not abundant, tend to be dull in color. A wetsuit is not sufficient protection from the cold.

Since underwater hunting has more and more success, it is strange that underwater photography has acquired so few disciples. True, it is an expensive pursuit, if you consider the investment in diving equipment, the travel from place to place, the boat rental . . . not to mention the time spent and the large number of pictures you have to take to get just a few good ones.

France. 1958. Calais, early morning.
The fog moved in dense patches, and I had to wait for a long time until the boats in the foreground and the fishing vessels in the background were both free of fog at the same moment.
Rolleiflex, 80mm, *f*/8, ¹⁄₁₂₅ sec., Plus-X.

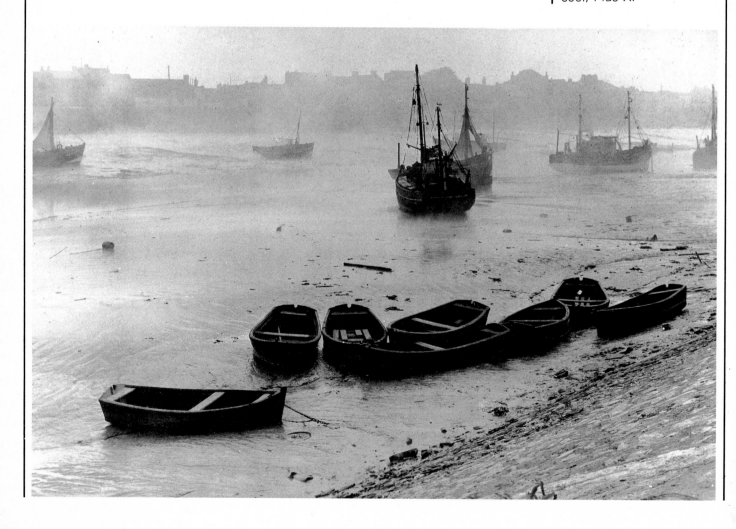

Aerial Photography

PHOTOGRAPHING from an airplane is a real specialization and requires very specific equipment if you want satisfactory results. In the first place it is practically impossible to obtain a good image through a porthole because of refraction caused by the thickness of the glass or plexiglass. The professionals who specialize in this kind of photography almost always work with the windows of the cockpit open, often while seated in specially designed contraptions. For the devoted amateur there remains the photography you can take on board a Piper Cub, small private plane or glider.

The higher you are, the more tendency there is to want to see the whole of the planet spread out. This is an error. Seen from too far away, the highest mountains lose their perspective and seem completely flattened. Rather than trying to show the immensity of the universe, it is better on the contrary to aim at a definite subject.

Unless you are flying over Africa to observe herds of gazelle or giraffes which would flee in zigzag pattern at the approach of a camera, it is best not to fly too low. By maintaining a certain altitude you will have a better impression of a group of houses, the architecture of a city or a village, a section of rugged coastline, the delta of a river or the interior of a volcanic crater. Unless you are in a stationary helicopter (the speed being equal), the closer you are to the ground, the faster the airplane appears to move in relation to the ground; hence the more risk there is of getting blurred images, even if they are taken at 1/2000 of a second.

Recently several fascinating books have been published with pictures made entirely by aerial photography to show systems of architecture characterizing each area of the world, and the evolution of the human habitat in relation to the natural environment, the local cultures and the different races. The juxtaposition of a photograph of a Japanese village with a South American city or a village in northern India can give us much cause for reflection on our notions of urbanism. The ruins of an old fortress or the fluted patterns of a medieval farm take on, at 45 degrees, an unsuspected depth.

Aerial photography plays an important role in archeology. Many Gallo-Roman remains have been discovered in Europe, thanks to this technique. Photographic surveying in Mexico and Guatemala has led to digs which have brought to light evidence of the Mayan civilization.

Up until now aerial photography was reserved for a few privileged initiates. The required authorizations for filming anything at all from the sky were hard to obtain. These rules are becoming more flexible. It is nonetheless true that this remains an expensive hobby which demands much time and determination, because to get good pictures you must fly a great deal and under optimum conditions. It is useless to shoot if you don't have good visibility and adequate lighting.

Never shoot toward the sun, unless it is to follow the shadow of the airplane on the ground or on the clouds below you. Always work away from the light, even at the risk of a few undesired reflections in the image. These, according to their texture—colored dots of various sizes, crisscrossing streaks of light—sometimes even add a dreamy quality to the overall composition. Be careful as

well, when the sky is bright, that the clouds do not form large unaesthetic blotches on the ground.

Lighting and angle play an essential role in aerial photography. The same monument can have much impact or none at all, depending on the direction of the light that bathes it. Mont Blanc, seen against the light early in the morning or late in the evening, especially when it emerges from a sea of clouds, takes on a striking perspective. At noon it loses its majestic character.

In black-and-white it is possible to obtain good snapshots of clouds against the light by using orange and red filters, but color is indispensable for bringing out the multitude of details which can be observed on the ground.

Through the Windows

On an airliner, since you are unable to photograph what you see from your seat, even with telephoto, because of the high altitude (long-distance jets fly at about 8000 meters) and the atmospheric haze which deprives the image of sharpness, you can nevertheless indulge easily in variations on the form and volume of the clouds you pass by or travel through. Catching them against the light, as well as the shining structures of the motors, sometimes creates beautiful effects. It is advisable to sit as close to the front of the plane as possible, so that your view is not blocked by the wings.

But have no illusions: what you can see through the windows of a Boeing 747 or a Concorde is limited and very disappointing. On the other hand, filming what happens on board an airliner can be very amusing. The work of the attendants, the fatigue of the travelers as it manifests itself through the hours, the pilot at his controls. Don't start shooting immediately upon takeoff, but gradually familiarize yourself with the personnel and your new traveling companions.

The interior of a cockpit is always very dark, even the pilot's cabin. The contrasts are extreme. Avoid extraneous light caused by the windows. The sunshade plays an important role in avoiding the light refraction coming from outside.

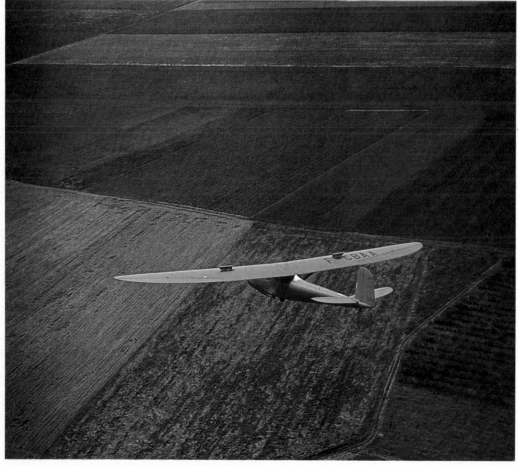

2

(1) France. Glider photographed from airplane. I had my feet attached to the iron bars of my seat so that I could lean out of the cockpit in mid-flight without danger.
Contarex, Sonnar 135mm, f/4, 1/1000 sec., Kodachrome.

(2) On board an Air France Boeing 747, between Paris and Pointe-à-Pitre. Contarex, Distagon 35mm, f/4, 1/125 sec., Tri-X.

1

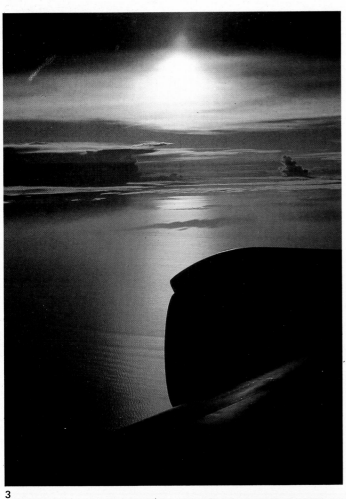

(3) Between Hong Kong and Saigon, at 8,500 meters of altitude.
Contarex, Sonnar 85mm, f/5.6, 1/250 sec., Kodachrome II.

(4) France. On board a glider.
Contarex, Distagon 35mm, f/5.6, 1/125 sec., Kodachrome.

(5) Between Paris and New York on board an Air France Boeing 747.
Contarex, Distagon 24mm, f/4, 1/125 sec., Kodachrome X.

3

4

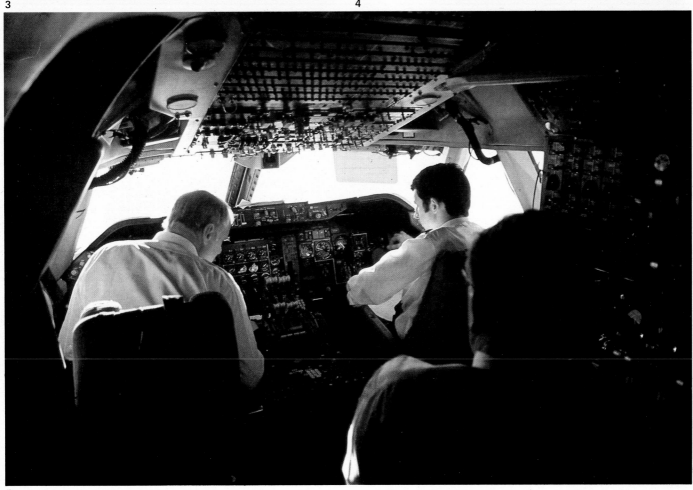

5

Nature

A photographic image of nature can only be a suggestion. It is the impression of a moment, but it should not appear frozen. It is best, therefore, not to work at too rapid a speed. Those who are not used to reading an image don't see the difference between a picture taken at 1/1000 sec. and another exposed for two seconds, as long as they are both in focus.

But someone with a more experienced eye will see, simply by the trembling of a leaf in the morning breeze, that something is going on in the image. He will note immediately that in one spot there is a detail which is not completely immobile. You must be aware of this pulsation when you are taking the picture, so that you will be able to express it through the medium of your camera. In most cases you can translate it almost imperceptibly, in others more elaborately by the use of some technical device.

Choose a grainy emulsion, without too much definition, to overcome the stiffness due to the photographic freezing obtained with a high-definition film like Kodachrome 25. You must go down to 1/30 sec., and even 1/15 sec., using a tripod, of course, as far as you can go without causing camera shake or lack of focus, so that nature will come alive in the image. It is imperative to avoid immobility and the static quality of snapshots. Movement is visible at 1/30 sec., but is no longer perceptible at 1/125 sec. In a photograph taken at a slow speed, with a tripod, so that the main elements of the image are rigorously sharp, you can feel the wind, the air, thanks to a leaf that trembled and in consequence appeared slightly blurred.

One of the fundamental aspects of nature is its strength, its weight in relation to human beings. Each time nature imposes its strength on man, there is nothing to do but hide behind your camera, grit your teeth, and take a picture very quickly, whether it's the turbulence of a sandstorm in mid-desert or the breaking of waves against the rocks on a stormy day.

Macrophotography

Several years ago going down on your belly in a field to film a toad or a salamander not only made people laugh but made them doubt the sanity of the amateur zoologist. Nowadays people are at most mildly surprised to see an ordinary citizen stretched out in the grass to observe a battle between centipedes. In due time, this too will seem natural.

For someone who knows how to see and who is interested in every form of life, the smallest pond can become a theme for meditation and an inexhaustible field of investigation. If you have never had the curiosity to lean over a small pool of water and, immobile, stare at it for a long time, the experiment is worth trying. Unless you totally lack a sense of observation—and in that case you should ask yourself what you are doing with a camera in the first place—you will discover a world you never thought so near. The extreme close-up photography of insects, flowers or crystals, commonly known as macrophotography, is a fascinating domain. For many, however, it remains a sort of austere practice reserved for a small number of people.

Who among us has not been amazed by these little worlds exploding with life,

Cambodia. 1970. Contarex, Planar 50mm, f/8, 1/60 sec.

color and precision that plunge us directly into an unknown universe whose existence we did not even suspect? Nevertheless, all you need do is open your eyes and be patient to discover at your feet the miracle of life repeated a thousand times each instant.

The field extending to the horizon on each side of the road does not at first glance offer any sense of perspective. But if you explore it with a magnifying glass it becomes a fabulous world. The smallest blade of grass takes on the appearance of a gigantic baobab tree. The mandibles of a humble glowworm become more fearful than the largest of dinosaurs.

If you are able at these privileged moments to isolate yourself completely from the rest of the world and give yourself entirely to this exploration, the sense of being out of one's element will be as powerful as in the most fantastic adventure in the heart of Africa. It is a question of imagination, concentration and scale.

You can do this kind of close-up photography with any type of reflex camera with an interchangeable lens, either by using a macro lens of 50 or 100mm or by the addition of an extra lens to the standard lens, or by adding extension tubes, or again by means of a bellows attachment. Most standard 50mm lenses permit photography at 50 centimeters without optical complement. The extra lenses, glasses that are placed in front of the lens, are optical complements which according to their curvature permit extreme close-up photography: from 50 to 35 centimeters, or from 35 to 20 centimeters, and so forth. These extra lenses give good results if they are of good quality; otherwise there will be a lack of sharpness.

For close-up photography, the most practical and least expensive method consists of a series of extension tubes which are placed between the camera and the lens, thus augmenting appreciably the focal length of the lens. For many cameras you can buy an assortment of three different extension tubes with different thicknesses, which can be superimposed on one another. This system is practical only if the camera is provided with automatic aperture selection.

The greater the focal length, that is, the closer the subject photographed, the more loss of light there will be between the lens, the extension tube and the camera. Depending on the distance at which the shots are taken, therefore, the variation in aperture will be considerable. Don't forget to calculate and to adjust the opening of your diaphragm accordingly. These calculations are useless with reflex cameras whose electric eyes are located behind the lens, since the electric eye analyzes directly the light which will register on the film. In this case, the only thing to do (it is more reliable, anyway) is follow the indications of the built-in light meter. To photograph at full aperture would be a grave error. At this small distance you have no depth of field to work with. It is thus imperative to open to the maximum only when focusing if you don't want your image to have only one plane in sharp focus. Macrophotography calls for perfect immobility of the camera and absolute precision of focus if you want the subject to be sharp. An error of a few millimeters and the image will be completely blurred. Also, the smallest gesture on your part is liable to frighten the subject. You must be very wary to get a few inches away from a grasshopper without making him hop.

The most complete and sensible system is the bellows attachment equipped with lenses specially designed for macrophotography and for the reproduction of documents. Both heavy and expensive, it can be used only with a tripod.

Macro lenses have the advantage of being polyvalent. They can be used the same way as standard lenses for ordinary shots like landscapes, snapshots or portraits, as well as being applicable to extreme close-ups. By their optical conception they descend in a 1:1 ratio when they are equipped with an attachment which fits in directly between the case and the lens, while permitting you to keep the automatic preselection.

Artificial Lighting in Macrophotography

Many professionals, to alleviate the relative slowness of fine-grain color films, use electronic flashes, notably ring flashes which are mounted directly on the lens and which light the subject uniformly.

This is useful and sometimes indispensable for scientific photography. On the

1

(1) India. 1972. Sky at monsoon season. Contarex, Sonnar 135mm, 1/250 sec., slight underexposure, f/11, to augment the contrast, Kodachrome II.

(2) France. Crocus. Contarex, Sonnar 85mm plus enlarging lens, f/8, 1/60 sec., Kodachrome.

(3) France. Corn poppies. Contarex, Sonnar 50mm, f/5.6, 1/125 sec., Kodachrome.

(4) Paris. Flower garden at Bois de Boulogne. Lotus flower in a greenhouse. Contarex, Sonnar 135mm, f/4, 1/60 sec., Kodachrome.

(5) France. Tarbes region. Ears of corn.
Contarex, Sonnar 50mm, f/8, 1/60 sec., Kodachrome.

(6) France. Brittany. Lichens encrusted on a menhir at Carnac.
Contarex, Planar 50mm plus extra lens, f/11, 1/60 sec., Kodachrome.

artistic level, the picture, flattened by the profusion of light, loses perspective and contrast. There is no question of playing with shadow or intense light. For amateurs, it is not just the photographic document that is interesting for its scientific value, but the world that macrophotography allows him to discover. You can also use several flashes attached to various parts of the camera. A flash at 45° off the camera is often an indispensable component for extreme close-up photography.

Macrophotography has the advantage of guiding us, at little cost, on a fabulous journey. You don't have to go the heart of the Sahara or to deserted Pacific islands to discover a fascinating world which, enlarged by the lens, becomes an almost terrifying universe. The woods are enough. In the first days of spring, take advantage of a sunny weekend to plunge yourself into a relatively unfrequented corner of the forest. Lie down in a clearing, look around, be patient. You will be surprised, amazed even, by the swarming and unsuspected world you will soon see appearing all around you.

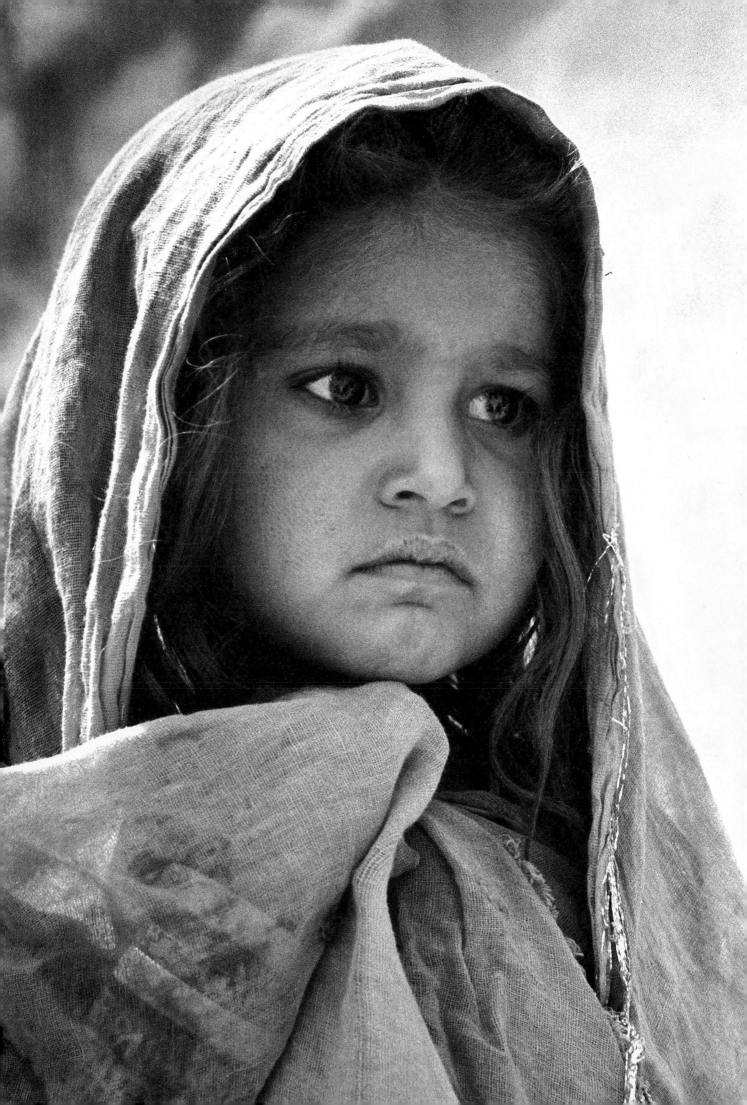

Children

A child's charm lies in his spontaneity, his vivacity. But he never fixes his attention on the same thing for long. The photographer must spot the instant when he enters into contact with his young subject. The child's perception can be compared to a lighthouse that turns around and sends you every now and again a beam of light right in the eyes.

You must wait for this moment of contact with the child to tell him what you want him to do: "Come here, take a balloon," or, "Run to your mother and show how much you love her." Don't try to keep him in the same place too long, but rather let him come and go as he pleases.

In no case can you ask a child to remain motionless for hours in front of the camera. Pose him as little as possible, concentrate on snapshots, have him participate in the taking of the picture by making him laugh or surprising him. If necessary, make him move or change expression by disconcerting him a little. You must capture him in movement, and profit from his spontaneity.

If photographing other people's children is already a difficult task, photographing your own requires even more patience and acrobatics, in order to get lively images that are a real reflection of their daily life. A child of any age tries, consciously or not, to be noticed. The bigger he gets, the harder it becomes to capture him in natural attitudes. The usually boisterous kid suddenly poses in a position he considers grown-up, imitating the comportment of his father or his favorite actor.

The timid adolescent adopts on the contrary provocative and rather unflattering poses. Disturbed by the presence of the photographer and feeling the intrusion of the camera, he makes a face that masks his complexes. His mimicry is for him a means of defense.

But whether the child is shy or arrogant, there are equal chances that he will either look straight into the camera or resolutely turn his head away. If you are insistent, the results will be poor. You'll find you have a series of nearly identical images: either the child stands stiffly at attention with a stupid expression, paralyzed by fear, or else he clowns around by sticking out his tongue or squinting exaggeratedly.

To catch the child's favorite expressions, even if he is very young, sometimes requires trickery and determination. He must not only become familiar with the camera, but must get used to seeing you operate it, so that he ends up completely forgetting the ultimate purpose of your activity. Only then will he be natural, with no posing.

Preferably use a wide-angle to show the child in his usual surroundings among his toys and friends. The standard angle or small telephoto should be reserved for facial expressions. If you are shooting indoors, use a flash aimed at the ceiling in order to approximate natural light. Above all, use no direct flash, which would flatten the perspective and eliminate the sense of movement.

In certain cases, don't hesitate to prepare the scene and even to provoke an event at the right moment. Don't wait until the last minute to set up your equipment, load the cameras and dispose of the flashes. To photograph a child opening his presents around the Christmas tree, set up tree and presents so that

India. 1961. Rajahstan. Contarex, Sonnar 85mm, f/5.6, 1/125 sec., Tri-X.

87

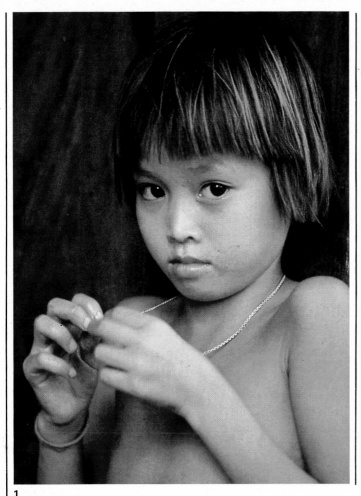

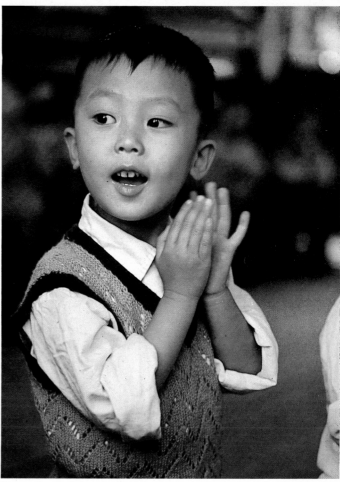

1

2

there is enough distance for you to work comfortably, without having to leap in among the child and the presents at the last minute. By so doing you would risk destroying all the spontaneity.

By Candlelight

The birthday cake with its candles lit up can give spectacular results which are easy to obtain either in black-and-white or in color.

If it is already night, turn off the room lights so that the scene is dimly lit. Whether the child is alone or surrounded by his friends, have him lift the cake with its candles to the level of his face so he can blow out the candles according to custom. Whether you photograph him head on or in profile, bend down slightly so that his face, illuminated only by the wavering light of the candles, detaches itself better from the surrounding darkness.

Watch for the precise instant when, after concentrating and holding his breath, he will attempt to blow out the candles. But if you wait a fraction of a second more, you'll be in the dark. On the other hand, if you click too soon his expression will still be immobile. The most interesting moment will thus be the exact instant when, with all his might, his cheeks puffed up, his eyes fixed on the candles, he empties his lungs in a single effort. But you must have sharp reflexes to click the shutter before even the first candle is blown out, if you want to benefit from the maximum of available light, and there lies all the difficulty and the success of the undertaking. Recommended films: Tri-X and High Speed Ektachrome EL daylight. With this latter film, the skin color will be slightly redder than normal, but using a film designed for artificial light would impart a greenish tinge, giving the child's face a rather sick quality.

The intensity of the light depends naturally on the number of candles, the size of their flames and the distance between them and the child. Don't measure the light by the flames, since the final result would then be very underexposed, but directly on the child's face. In black-and-white (ASA 400) there is a strong

(1) Vietnam. 1970. Contarex, Sonnar 85mm, f/4, 1/60 sec., Kodachrome.

(2) China. 1973. Nursery school. According to Chinese custom, this child is clapping his hands to welcome us into the classroom.
Leicaflex, Elmarit 90mm, f/2, 1/125 sec., Kodachrome II.

(3) China. 1978. Nanchang nursery school.
Minolta XD7, Rokkor 135mm, integral automatic exposure giving priority to speed, Ektachrome E6 ASA 200.

88

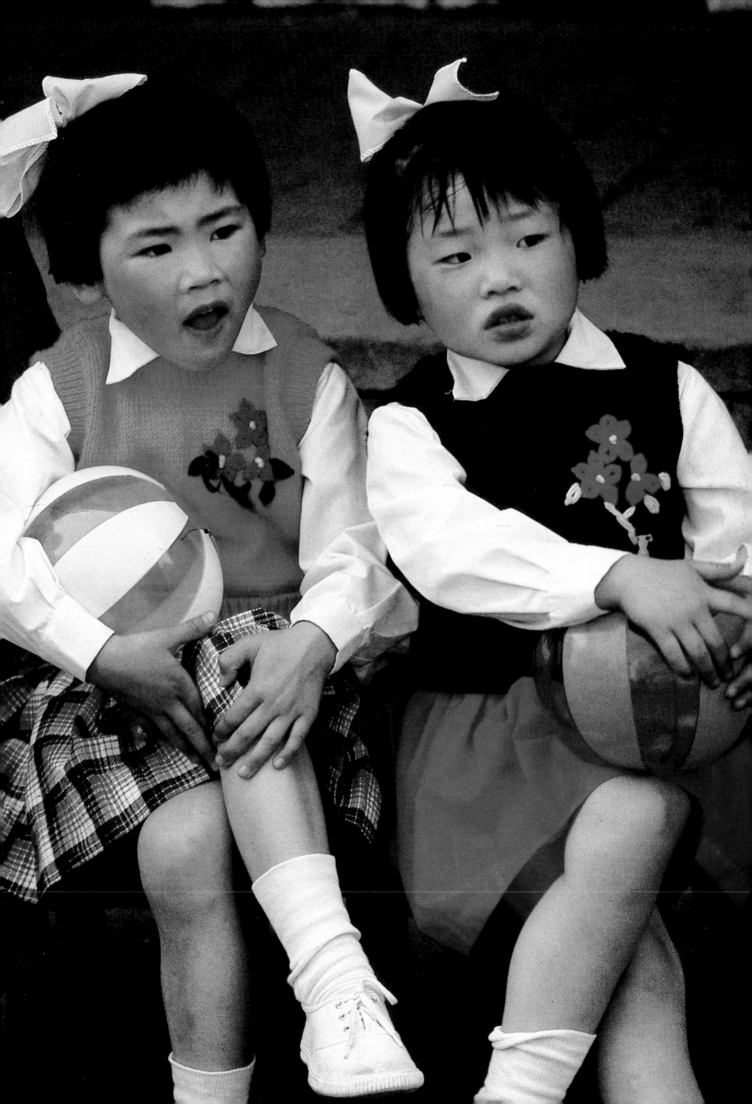

chance the electric eye will indicate 1/60 sec. between $f/3.5$ and $f/5.6$, and in color (ASA 400) 1/60 between $f/3.5$ and $f/5.6$. Given the diminished depth of field, focus on the eyes and lips of the child, which will be the main elements and thus the strong points of the photograph. It doesn't matter if the candles are out of focus.

Photographing the Birth of Your Child
Only a few years ago it was virtually forbidden for anyone not belonging to the medical staff to enter an operating room. Nowadays more and more doctors are agreeable to the idea of a husband being present at the lying-in of his wife.

Photographing a birth requires more or less the same precautions as for filming any other surgical operation. In most modern clinics and hospitals, the operating field is sufficiently brightly lit for there to be no need for tripod or floods if you are using fast film. Never use a flash.

(1) Paris. School for deaf mutes.
Rolleiflex, Planar 80mm, $f/4$, 1/60 sec., Tri-X.

(2) France. Canal of the Loire.
Exacta, Jena 50mm, $f/5.6$, 1/60 sec., Plus-X.

Naturally you should avoid moving around during the operation. Together with the doctor choose the most suitable angle for photography. Keep a certain distance from the delivering woman so that you can catch, with the aid of wide-angle, both her face, the whole of her body and the doctors and nurses crowding around her.

Despite the artificial light of the projectors, for color use daylight films. You must be aware, however, that photographing a birth in color is risky, and results in images that are too realistic and thus completely mask the profound meaning of the event. An infant at birth is often purple and contrasts unfortunately with the whiteness of the sheets and of the nurses' uniforms. In Tri-X, approximately 1/60 between f/4 and f/5.6; in EL, 1/60, between f/4 and f/5.6.

Don't forget to catch the gesture of the midwife cutting the umbilical cord. Don't limit yourself to photographing only the moment of birth. It is fascinating to follow the infant in his first hours of life: don't miss his first feeding. To watch

1

2

3

4

(1) Benin. Porto Novo.
Contarex, Sonnar 85mm,
f/4, 1/60 sec., Kodachrome.

(2) Cambodia. 1970. Vietnamese refugees.
Contarex, Sonnar 85mm,
f/4, 1/60 sec., Kodachrome.

(3) France.
Exacta, Jena 50mm, f/4,
1/60 sec., Kodachrome.

(4) France. Ile de Houat.
Pentacon, Biotar 58mm,
f/4, 1/125 sec., Kodachrome.

his gradual awakening, his first cries, is extremely moving. All these moments have the same imperishable value as the birth itself.

And with what emotion you will record the radiant smile of the mother as she takes her child in her arms for the first time!

Adolescents

To photograph an adolescent well is perhaps the most difficult and disturbing of things. The adolescent, whether boy or girl, is generally an uneasy being. He is often ill at ease in front of the camera, for he does not yet have a clear idea of his own personality. He is often disconcertingly beautiful despite his awkwardness and lack of confidence. To feel and express the poetry which may well reside in this often ambiguous comportment requires much patience and tact.

Don't be brusque; put him at his ease. Give his intuition free rein. Don't try to analyze coldly what you are going to do, for often in such cases nothing of interest results. Be aware that one does not only make masterpieces. Know how to wait, keep a conversation going, lighten the atmosphere by joking or by listening to the model's favorite record. Avoid a harsh light which would accentuate his fidgeting.

5

(5) Paris.
Contarex, Sonnar 85mm, f/2.8, 1/60 sec., Kodachrome.
(6) Yugoslavia. 1969. Young shepherd in the mountains of Montenegro.
Topcon, Topcor 55mm, f/5.6, 1/60 sec., Kodachrome.
(7) India. 1967. Calcutta. Imrat Khan teaching the sitar to his youngest son. Contarex, Distagon 35mm, f/5.6, 1/60 sec., Tri-X.

6

7

Animals

To take a photographic portrait of an animal requires above all else patience. In general, a cat is easier to photograph than a dog, as it is less nervous and moves less. Its glance can become very intense if you stare at it for a long time. On the other hand, a cat does not like posing in front of a camera, while any poodle takes mischievous delight in playing for the lens.

To take a close-up of a dog, you must retain the greatest possible depth of field, hence narrow the aperture. Be aware that if you focus on the nose, the eyes will be out of focus, and vice versa. It is best to focus on the center of the nose for the whole head to be sharp.

Before photographing an animal, you must ask yourself what emotions it conveys; then, armed with the appropriate equipment, let yourself be guided by those emotions.

To photograph a domestic animal, your dog or cat for example, requires almost the same procedure and above all the same patience as when photographing a very young child. Don't hesitate to lie down on the floor or in the grass to get a low angle shot, thus giving the animal an air of majesty. When he watches you, indifferent or cunning, don't hesitate, after you have set up your frame and checked your focus, to whistle to attract his attention. Surprised, he will look right at you for an instant, a paw raised, the ears alert.

Capturing your dog's energy as he leaps for the lump of sugar you offer him is relatively easy. But it is much more interesting to catch his watchful glance as you prepare his meal, or his enraged air when he has been forbidden to follow you. Don't neglect his envious glance, the tearful eyes, the tongue hanging out, when someone is eating meat nearby. With most mammals the expression changes even more rapidly than with a child. Often you have only a fraction of a second to register a moment of surprise, anger or desire.

Sometimes it is a good idea to let animals move around in their usual setting, apartment or garden. Don't insist on making them pose. It might be amusing to create little scenarios for them to act out. That will not necessarily lead to better pictures, but it will be an entertaining occasion. It is always amusing to make harmless traps to lead an animal to do what you want him to, for example, causing a cat to climb a tree to hunt for a tempting morsel.

Avoid the flash and any noisy camera. Animals are sensitive to sounds which we do not even perceive. As with children, don't bother them for long periods of time.

Use preferably a normal lens or, better yet, a small telephoto to capture expressions more easily. The setting in which the animal moves has only a relative importance. In an interior, if the lighting is defective, sacrifice depth of field to speed. It is better to work at 1/125 sec. on $f/2$ than at 1/30 sec. on $f/4$. At the slightest noise an animal may quickly change his position and even run to hide on the other side of the room.

At the Zoo

Despite the bars that separate animals from spectators, the zoo can also be a preferred place for portraitists and nature lovers. But you must be interested

Gabon. 1965. Christmas Eve. Baby gorilla during his transfer by canoe to be given to a European couple living in the equatorial forest who were devoted to animals. His mother had been killed by Pygmies in the course of a hunt. Contarex, Planar 50mm, $f/5.6$, 1/250 sec., Tri-X.

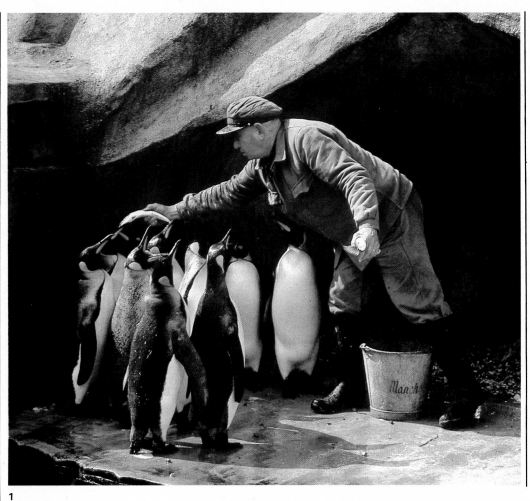

(1) Paris. The Vincennes zoo, early morning. Feeding of the animals.
Contarex, Sonnar 135mm, f/5.6, 1/125 sec., Kodachrome.

(2) India. 1972. Kaziranga reservation in Assam, early morning. I was seated on an elephant, which allowed me to get very close to this rhinoceros without any risk of being knocked down.
Contarex, Distagon 35mm, f/4, 1/500 sec., Tri-X.

(3) Southern India. 1972. Close-up of elephant's eye.
Hasselblad, Sonnar 250 mm, f/5.6, 1/250 sec., Tri-X.

(4) France. Aigues-Mortes. Street cat.
Topcon, Topcor 55mm, f/4, 1/250 sec., Kodachrome.

1

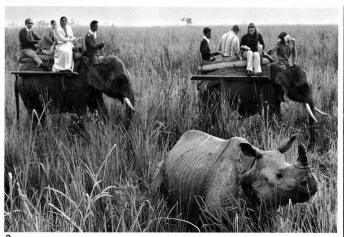

2

3

4

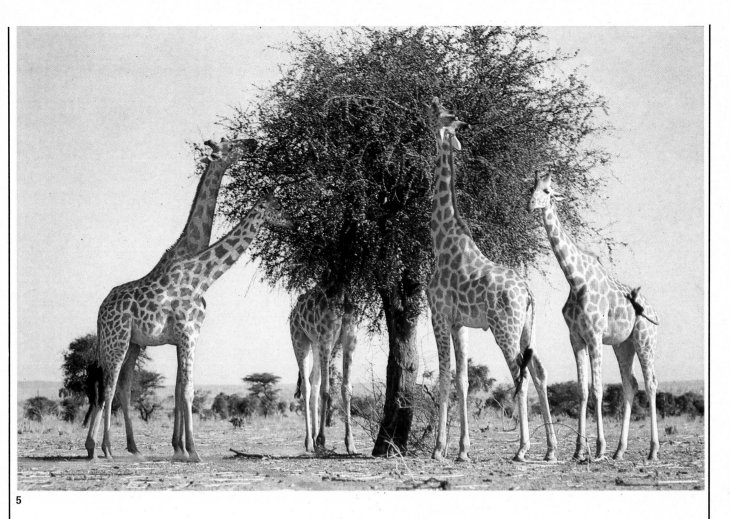

5

(5) Niger. 1969. On the banks of the river between Niamey and Tillaberi. Contarex, Sonnar 85mm, f/5.6, ½₅₀ sec., Kodachrome, polarizing filter.

only in the expressions of the captives and not their shape, beauty or manners. It is rather grotesque to want to photograph a half-paralyzed panther, a zebra whose coat is dullish, a bear with matted fur or a camel who turns desperately round and round for hours inside his cage. On the other hand, to capture the glance and the mimicry of gorillas, orangutans and chimpanzees, even behind bars, can be fascinating. But it is also true that in captivity most animals have a melancholy air.

The best times for visiting the zoo are early in the morning or just before closing, when the guards go from cage to cage to distribute food. What is more amusing to photograph than a troupe of penguins throwing themselves awkwardly at the guards bringing them their herring?

All animals are photogenic, if you have patience. Even the Siberian tiger half-asleep at the rear of his tiny cage will have, at one moment or another, a curious or contemptuous glance worth photographing. The telephoto lens is indispensable. It is even worthwhile to work with wide aperture in order to blur the bars, grills and artificial decor which cannot be eliminated. Even if the light is very weak, be careful that the eyes are sufficiently illuminated, so that you can render clearly the intensity of the animal's glance, since that is really the only interesting thing to photograph about a wild animal in captivity.

Festivals and Carnivals

CARNIVALS are a favorite subject for all photographers who love life and have a passion for snapshots. The color, movement, laughter, the moments of surprise or disappointment, above all the indifference of the participants to the "voyeurs" who spy on them with their telephoto lenses, offer to the observer privileged conditions and an extraordinary field of investigation.

A person in a mask may, because he is incognito, let himself go in a way he wouldn't do if his face were uncovered. Thus, you have all the elements that make for good pictures. However, it is not all that simple to succeed in creating living and original documentation of a masked ball or a parade. It is not enough to photograph the elaborate or beautifully colored costumes; you must get at their symbolic meaning. A close-up of a shawl, however elaborate its design, has no interest in itself if you ignore its significance.

Whether you are in Cologne, Bahia, Basel or Nice, it is frustrating and monotonous to stay among the spectators, photographing in turn the floats or groups as they pass by. To go through the police barriers and plunge into the midst of the participants at the risk of interrupting their enjoyment and being pushed about, if not knocked down, is not easy, either.

You must be in the first row. Once past the barriers, you must stay constantly on the move so that you will not get the same composition over and over. When you stop moving, don't hesitate to crouch down to avoid disturbing the other spectators.

At the outset, there is often a tendency to want to follow the parade and take pictures while walking. You become aware quickly that all you are doing is running after the participants. The festival is already over and the musicians are packing up their instruments while you are still adjusting your aperture.

To take good pictures while moving and walking (especially if you are walking backward) requires a lot of practice. As with sports photography, it is better to find a spot, adjust your focus in terms of a specific place and wait for the subjects to enter the field of sharpness.

If the participants are walking quickly, it is virtually impossible to regulate the camera while they advance. The best moment will be when the parade slows down, giving you time to photograph the figures who have halted to get their breath. Avoid getting stuck on an honorary rostrum among stiffly formal officials.

The Spectacle of the Crowd

When there is a popular festival, the crowd is part of the spectacle. It is by standing among the spectators that you will see confetti fights, outbursts of laughter, signs of fatigue, farandoles, excesses of drunkenness, unorthodox clothing: all of them privileged moments for the photographer.

At the edges of the parade you can take a thousand amusing snapshots which are both part of and outside the carnival. As soon as the last group of marchers has gone by, don't follow the crowd pushing to get to the bus station or the parking lot; stick around and photograph what remains of the carnival after those few hours of joyous abandon.

France. Pop festival in the valley of Bièvre near Paris. Contarex, Distagon 28mm, f/5.6, ¹⁄₂₅₀ sec., Tri-X.

1

2

(1) Japan. 1974. Annual firemen's festival, Tokyo. Contarex, Sonnar 125mm, f/5.6, 1/125 sec., Kodachrome.

(2) Germany. Cologne carnival. Contarex, Sonnar 85mm, f/4, 1/250 sec., Kodachrome.

(3) Germany. Cologne carnival. 1971. Contarex, Sonnar 85mm, f/4, 1/250 sec., Kodachrome X.

(4) Germany. Cologne carnival. 1972. Contarex, Sonnar 135mm, f/4, 1/250 sec., Kodachrome X.

(5) Cologne carnival. Contarex, Distagon 35mm, f/4, 1/250 sec., Kodachrome X.

To take a good photograph you must either love or hate; indifference is fatal. If you are unaffected by what you discover, it is better to abstain from taking pictures altogether, or else you will be just an unhappy technician.

Joy is often tinged with sadness. In Europe most carnivals take place in February. Snow and rain are frequently present. Underline the nostalgic feeling evoked by the contrast between the cold winter light and the vivid color of the masks.

Carnivals can also be approached in terms of fantasy, by shooting very tight close-ups of the masks and isolating them from the context of the city and the crowd. Then you get a magnificent imagery of popular art. The masks, whether of wood or papier-mâche, are often the product of a singularly joyful imagination.

It is advisable to use the most discreet and least cumbersome equipment possible, if you value it, and don't want to knock into other people as you make your way through the crowd.

When you have little distance to work with, wide-angle is necessary for snapshots. You will often have to shoot at point-blank range in the midst of a constantly moving public. You will however also need a small telephoto (90 or 135mm) to isolate certain close-ups, masks, expressions, among spectators and participants. The use of fast film is a must. It is in effect difficult to photograph below 1/250 sec., for the shaking is constant and there is a continual risk of being shoved while you adjust your focus.

The Great Carnivals
The carnival of Cologne in West Germany is one of the most popular in Europe. It takes place at the beginning of February and lasts several days. Hundreds of thousands of people come from the neighboring towns to participate.

The spectacle is particularly intense among the spectators, who do not hesitate to dress up in grotesque costumes and to paint their faces in bright colors.

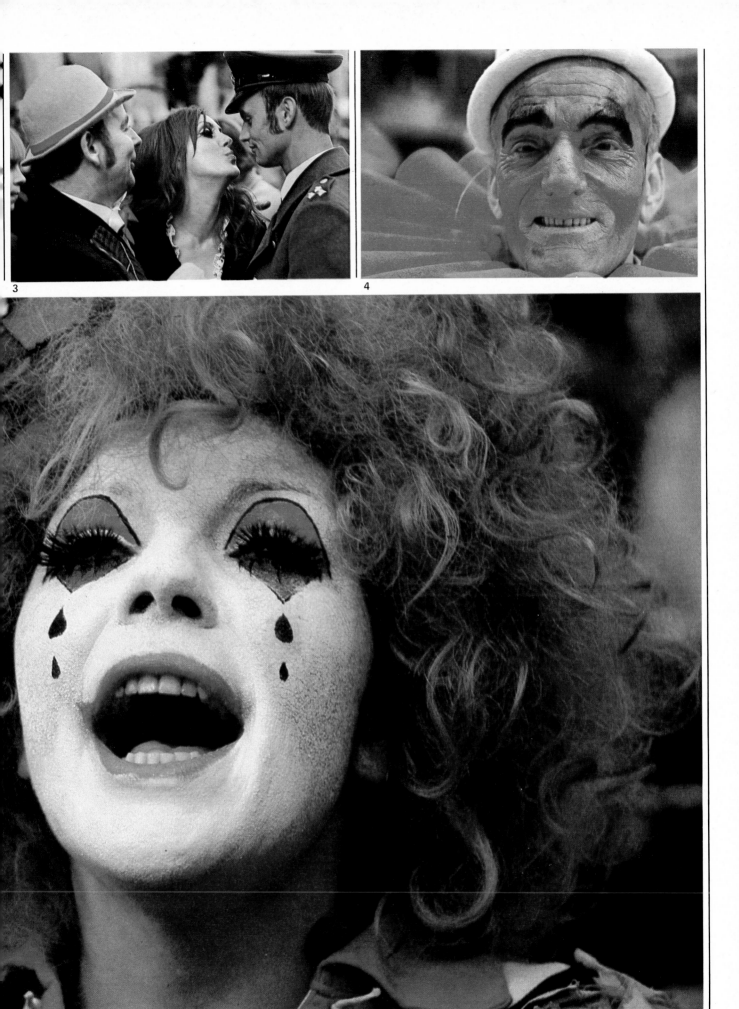

3

4

Everyone gives free rein to his imagination. Crinoline dresses and 1900 costumes are side by side with nearly naked Tarzans, Indians covered with feathers and transvestites with voluminous plastic breasts.

Lewdness is customary. Numerous cooperative ladies, young or old, flash their silk and lace underwear for the photographers.

The procession, which lasts several hours, is made up of very diverse groups, each with its own orchestra of uniformed musicians. Hundreds of horses pull sumptuously decorated chariots, often astoundingly large.

Many of the spectators bring their own provisions of beer or schnapps. Vendors of chips and hot sausages set up stalls at the street corners. If the parade slows down a little, the crowd spontaneously starts singing and dancing wherever they are, on the pavement, in the middle of the street. There is no need for loudspeakers, or for conductors to beat out the rhythm. Everything, or almost everything, is permitted.

In the evening, groups of costumed musicians enter the cafes and the bars and get the drinkers dancing to the accompaniment of accordion, tambourines and cymbals. Vast quantities of beer are consumed. Paper streamers whirl around the dancers in a general tumult. Day and night the spectacle is often so rich in intensity and diversity that you no longer know what to look at, much less what to photograph. In most of the Rhine towns, at Mainz, Bonn, Coblenz, other carnivals, smaller but just as colorful, take place on Shrove Tuesday and the following days.

In Switzerland, the carnival of Basel is notable for the impressive number of masks, and above all for their diversity. Here, satire is the order of the day. No one escapes from it, neither the leaders of the great powers nor the burgomaster of the neighboring village.

Among the best known French festivals, the carnival of Nice can be cited, although the numerous prohibitions which have been introduced have made it lose something of its prestige, since political satire, an aspect of all carnivals, is now forbidden. On the other hand, the parade of giants, and most of the folklore festivals which still exist at Dunkirk, in the north, and in Pas-de-Calais, are still very popular.

If carnivals are less elaborate in Belgium than in Germany, they are no less popular, notably at Binche where the *Gilles,* personages with feather head-dresses and covered with bells, dance with the spectators while others throw oranges at the passersby. The little town of Stavelot is famous for its festival of "the white *Moussi,* " with its false monks, decked in masks and enormously long red noses. At Fosse-la-Ville, there are Punch and Judy figures on long stilts that parade joyously on Shrove Tuesday. At Liège, clowns with exaggerated limbs jump into the crowd to ruffle the spectators' hair with their long arms.

In Italy, especially at Siena, at Perugia, at Assisi, in Sicily or in Sardinia, the great medieval festivals are still celebrated with astonishing pomp.

In Spain, as in Italy, religious festivals must be rigorously differentiated from popular festivals. In other European countries a traditional manifestation is sometimes midway between pious and moving commemoration and riotous laughter-filled crowd scenes. But in Iberia there is a scrupulous and clear distinction between simple merrymaking and religious celebrations. That said, outside of Holy Week, the numerous religious processions, the flamencos and corridas that unite Spaniards in joy or devotion all through the year, one of the most astonishing celebrations is that which is held at Valencia in honor of St. Joseph de Fallas, the patron saint of carpenters. This festival is characterized by its cavalcades, its dances and its numerous parades in regional costume in the midst of three hundred monuments of wood, paper and cardboard specially built for the occasion. To close these joyous festivities, the population sets fire to this imaginary city, which crackles and disappears rapidly in the flames. It is a truly hallucinatory sight.

When photographing a fire, the brightness of the flames is usually sufficient for you to work by available light. Follow the indications of the electric eye and overexpose very slightly if you want to have some details around the conflagration. But unless it is completely overexposed (in which case the flames would

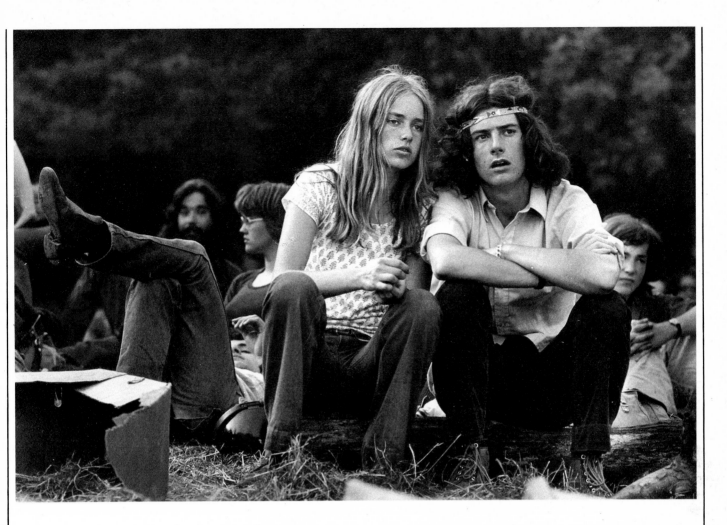

Pop festival in the valley of Bièvre near Paris, at dawn. Contarex, Sonnar 135mm, f/4, 1/125 sec., Tri-X.

lose their brightness completely), the foreground and background will both appear as silhouettes. It is sometimes interesting for this reason to use a small flash to illuminate the foreground, on condition that you use it manually and not on automatic, in order to be able to control it better. You can diminish the intensity of the glare either by putting a handkerchief over the lamp or by adjusting the computer to a higher sensitivity or a closer distance. Set the aperture according to the intensity of the flames, so that they will not be washed-out, and not in relation to the flash. The light of the flash should be considered only as supplementary, for illuminating the foreground slightly, and should not be directed at the flames.

At Basel, telephoto is required if you want to capture clearly the expressions of the masks, often of great realism. There are no, or few, chariots, but there are troupes and musicians with satirical trappings. The official parade is repeated at intervals of three days. It lasts for hours and weaves for several kilometers in the midst of a silent, nostalgic crowd. The piercing monotonous music of flutes and drums only accentuates this dash of romanticism, which may strike us as out-of-date but which remains one of the characteristics of the people of Basel.

The carnival of Basel begins in fact by a parade of Chinese lanterns, at four o'clock in the morning. Traffic is momentarily interrupted. All the lights in the city go out at the same instant that the bells of the town hall begin to chime. Thousands of people slowly begin to move forward. Groups form, spontaneously, intersect, double in size, break apart, all in absolute silence. No one speaks. To make noise with your shoes becomes almost a sacrilege. This parade in the middle of the night, with its rich and intense atmosphere, is a perfect example of something that cannot be captured in an image. It is too dark for the most rapid films. Use a flash and you destroy all the harmony and mystery of this nocturnal procession.

Each year, Brazil attracts numerous charters full of tourists from the four

corners of the world who come to watch and participate in the grandiose pomp of the great carnival. It is true that the Brazilians have retained an innate sense of music and festival, but as in many third world countries, this apparent gaiety often hides profound poverty and suffering, which perhaps explains why the pickpockets are so numerous and so rapid.

At Bahia, the carnival is especially popular, and is different from that of Rio de Janeiro. Here, no ostentatious costumes of expensive silk, no pretty mulattoes in provocative outfits, of the sort you see in travel brochures. People disguise themselves with what they have: a bit of tulle, a loincloth artfully wrapped, a bit of bandage, aggressively colored paints. The festival lasts three days and three nights and the thousands of participants never once stop dancing the samba.

It is very difficult to capture in pictures this flood of humanity, and most of the shots are too stiff and are only an awkward reflection of the permanent and continuous movement which characterizes this carnival.

To get good snapshots of a crowd in motion is especially difficult. Choosing a slow speed to create the impression of movement is very risky because it has been done too often, and it is difficult to come up with something original with this unpredictable technique. There is no miracle recipe. You must be aware that failures are the rule and successes the exception. Parades of different schools of samba take place at night. The lighting is often bad and a flash is sometimes necessary if you want to show the richness and uniqueness of certain costumes.

But let us return to France, where there is hardly a village without its local *fête*. It is of interest to photograph it, before such things disappear completely. Such entertainments often have at least the merit of retaining a good deal of their authenticity.

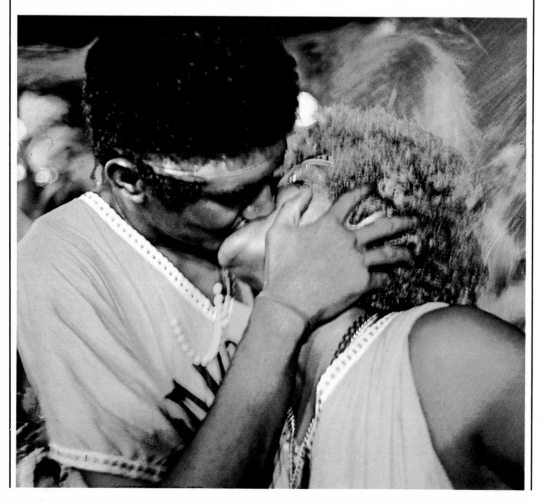

Brazil. 1976. Bahia carnival.
Minolta XM, Rokkor 100 mm macro, f/3.5, ¹⁄₂₀ sec., Kodachrome X. Night available light.

Religious Events

ASTER, All Saints' Day, the *pardons* of Brittany, the 15th of August or midnight mass on Christmas Eve are all occasions of gathering together and rejoicing which deserve to be captured in images because of their solemn, grave, emotionally moving quality.

You don't have to travel to an Islamic country, to Mexico or to Bali to see expressions of great fervor and scenes of intense meditation. Even in France, certain of our religious festivals are still celebrated as in former times by re-enacting the Stations of the Cross, by parades like that of the Sanche procession in Perpignan, and by public benedictions. In some provinces, the devout wear their most beautiful regional costumes for these occasions. It is not rare for such ceremonies to conclude with joyous rural fairs. To photograph the intensity and spontaneity of these manifestations gives us the chance to take a leap into the past and to capture on film what are perhaps the last images of a vanished era.

Every holy place is privileged terrain for anyone interested in the human condition. But whatever your beliefs, philosophy of life or conception of the afterlife, anything connected with religion and popular faith must be approached with much prudence, tact and respect.

On certain pilgrimages, whether Christian, Hindu, Muslim or Buddhist, the most unbearable distress and the cruelest and most unjust suffering are found side by side with the most profound veneration and hope. What is more disturbing or more dramatic than a face, atrociously ravaged by paralysis and pain, momentarily illuminated by a radiant smile and completely transformed by hope?

The most tragic circumstances are often juxtaposed mercilessly with the most comic moments. Faith and hope exist alongside the most abject greed. At Lourdes, as in many other holy places, the vendors of candles, holy images and luminescent Holy Virgins do not hesitate to jostle handicapped people and pious worshippers to get them to buy their goods . . . or nearly so. Such images give one food for thought about a cynicism that is close to cruelty.

The Spaniard, even if he is not melancholy by temperament, likes to celebrate his religious festivals with compunction. Typical, colorful, poignant or impressive in turn, the Spanish religious commemorations recreate each year the framework and atmosphere of the event in its true tradition.

Spanish Holy Week is a privileged opportunity to exercise your photographic talent. At Seville it takes on a particular splendor. For several days and nights, the processions of penitents, their faces masked by enormous cowls, go from church to church. Some of them carry, for hours on end, enormous heavy wooden crosses. Others wear heavy iron chains, still others crowns of thorns.

The *patios,* weighty carts carried on the backs of men, which serve as pedestals for magnificent statues of sculpted wood or stucco representing the Virgin, Christ and all the saints, are true masterpieces. These lively characters depicted in gaudy colors all deserve to be photographed, so realistic and at the same time so moving are their faces. The nocturnal processions are often lighted by a sufficient number of candles or lanterns to be photographed with hand-held camera, without flash, and even in color.

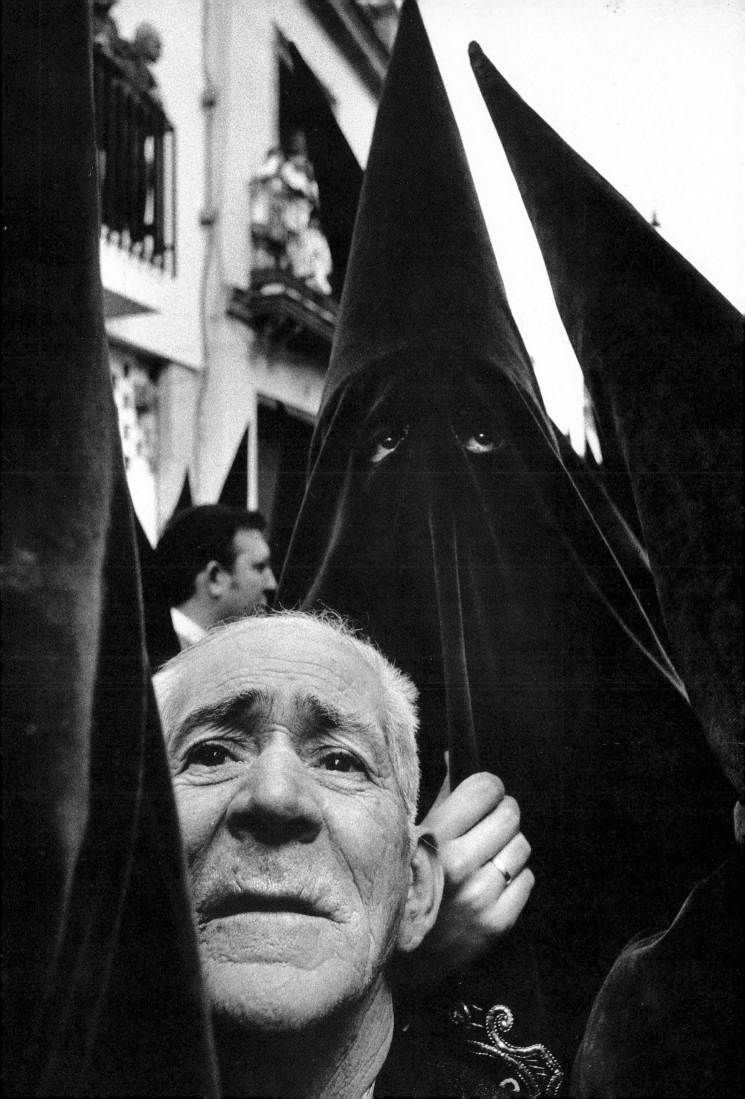

The most imposing processions take place on Holy Thursday and Friday. But Seville is not the only Spanish city that celebrates Holy Week on a grand scale. There are many other places where the same ceremonies are still celebrated traditionally: Zamora, Burgos, Salamanca, Murcia, Tarragon, Cuenca, not counting the many small villages of Castille or the South. If the processions are less grandiose, they are no less touching in their simplicity and spontaneity.

Respecting Others

If it is easy to photograph a procession in progress, the same is not true of the individual participants who follow the ceremonies out of religious conviction. In Spain, as elsewhere, people do not appreciate photographers who take close-ups of them while they are on their knees praying, counting their rosary and lighting a candle devoted to a saint. Many of the devout will turn their heads away if an indiscreet tourist approaches. Whatever your personal convictions, the most elementary decency commands you to have respect for others, especially at a moment as intimate as prayer. To capture an expression of sorrow or profound meditation, even without being seen, is already a kind of violation. To insist, despite the reluctance of the person photographed, is pure boorishness.

Popular piety is indeed a particularly photogenic emotion. But in photography, as in other domains, there are limits which must not be transgressed. This is perhaps what differentiates the true photographer, whether amateur or professional, from the shutterbug who likes to steal images.

Many photographers are content to be competent technicians, with their minds on their manuals and methods. But photography is not only a technique, it is a means of expression. By means of it we are in contact with a man who thinks, sees, feels. You don't ask a painter what brand of pencil or paint he uses. You ask him what he wanted to express, and you tell him what you felt on looking at his picture.

The first question people ask of a photographer, on the other hand, is what

(1) Spain. 1972. Holy Week in Seville. Macarena procession.
Contarex, Distagon 24mm, f/4, 1/1000 sec., Tri-X.

(2) Spain. 1960. Holy Week in Salamanca. Rolleiflex, Planar 80mm, f/5.6, 1/250 sec., Tri-X.

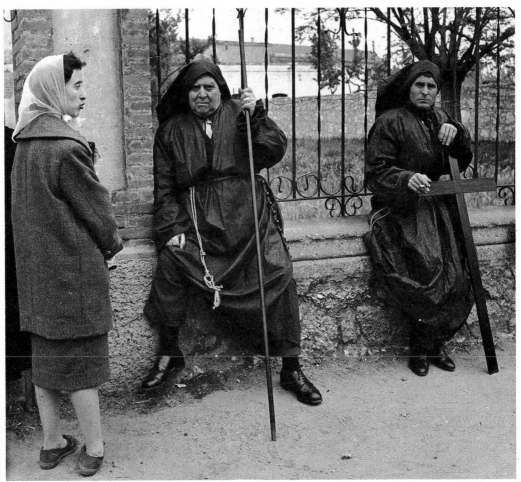

kind of equipment he uses. And the people most given to this aberration are photographers themselves.

Still, it must be borne in mind that art always springs from a choice. You *choose* a lens or a composition, just as you choose a pencil or a note of music. The photographer *chooses* his angle, his subject or his focus, as the painter chooses his color and the musician his b-flat or f-sharp. Many photojournalists hide behind their equipment and their technical knowledge. To look for the man hiding behind the photographer is essential in any introduction to photography.

Why Take Pictures?

When you ask yourself what you are going to photograph, also ask, "Who am I, to be taking a picture?" In this way you will come to a creative cohesion between inner and outer, between self and others. Interrogate your own self, not out of narcissism or egocentricity, but simply in order to be able to function better, to make use of your self. The photographer is always more important than the shutter or the button. The finger that presses and the brain that commands it are infinitely more interesting and complicated than the most sophisticated equipment.

It is thus very important to realize fully why you are photographing this or that. Photography is a violation; never forget it. And this violation is not always committed in order to see better and to understand better what you have discovered. Let's be frank. Too many photographers eat up film only so they can criticize what they saw on their trip and make their friends laugh.

Photographic equipment isolates us completely from the outside world. With our eye pressed to the viewfinder, we see only the tiny portion of the world that it frames. We become obsessed with the image we feel we must capture at any price. In foreign countries and especially in the third world, reassured by the presence of their costly equipment, some travellers think they can do anything.

Intruded on by the phalluses-with-lenses pointed at them, the natives recoil,

1

(1) Spain. 1972. Holy Week in Seville.
Contarex, Sonnar 85mm, f/4, ⅟₅₀₀ sec., Tri-X.

(2) India. 1967. Hindu ascetic meditating on the road.
Contarex, Planar 50mm, f/5.6 ⅟₁₂₅ sec., Kodachrome.

(3) Ceylon. 1975. Fire offering.
Minolta XM, Rokkor 35 mm, f/4, ⅟₂₅₀ sec., Kodachrome 64.

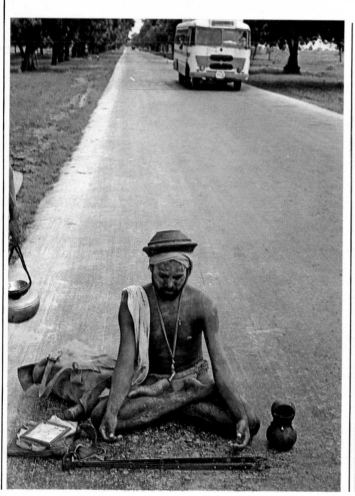

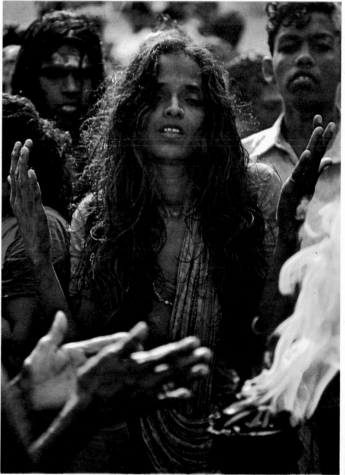

2

3

are fearful, even angry. . . . Defiance on both sides. But why should we have the right to photograph them? And what do they have to offer our fashionable gadgets? Their nudity, a mattress of bamboo, a certain resignation and above all an enormous smile.

There is a way of traveling and photographing which is as colonialist as the attitude of the conquistadors of the past. Ultimately, one should photograph only people whom one really loves.

During the celebration of the Easter Mass in a Russian Orthodox church. Contarex, Planar 50mm, $f/2$, $1/20$ sec., Tri-X, available light.

Preceding page:
Spain. 1972. Holy Week in a small village near Seville. Pause between two processions.
Contarex, Sonnar 85mm, $f/4$, $1/250$ sec., Kodachrome.

Spectacles

TAKING circus pictures is of no interest unless you go beyond the spectacle itself and deal with what the public cannot see and does not even suspect.

Making a photo story about the circus world is an arduous task. It is not easy to get behind the wings. Circus people form a very small, self-enclosed world. They are, to put it mildly, reticent in front of outside observers. To photograph at random a clown in the course of his makeup, in front of his mirror, or a young horsewoman at her exercises, is from their point of view an intrusion.

However, there is nothing more moving than these privileged instants in which beauty and dream are evoked in a setting both unreal and slightly sordid. To approach the circus world you must negotiate in advance. It is often necessary to talk for hours in the nearest bistro to the big top, which serves as a kind of anteroom for the artists, before you can meet the old ringmaster who will serve as intermediary, and then as counsellor in the art and method of getting yourself accepted during the rehearsals.

When you watch a performance, you don't see the anonymous technician who makes the marvelous machinery function. You are fascinated by the handsome horseman—who is moreover director of the troupe—who, all pomaded, sets his horse through capers that he seems to direct at it. But are you aware that the one who has done all the work of preparation is the old trainer no one sees, because he is hidden behind a curtain ready to intervene in case of accident?

Photography enables us to capture moments of ephemeral beauty, such as the hip movements or the sparkling of the silver-spangled costume of the young trapeze artist. Don't limit yourself to showing the wondrous; stress the effort, the fear, the fatigue before, during and after the show.

Never use a flash in the presence of animals, either during a performance or during the rehearsal. This could be fatal for the trainer. Many animals are frightened by flashes and may react unpredictably and sometimes uncontrollably.

Rapid Action—and Discretion

It is a pipe dream to think that one session of photography is enough to get a good story. The conditions of lighting and the rapidity of the action are such that you must watch several performances before knowing what to photograph. It is thus necessary to return several times in succession to the same spectacle to better understand the sequence of events, and to anticipate the high points. Before starting to photograph, it is important to know where to stand in relation to the light, the ring and the public. Be careful not to have a pole or a cable in your field of vision which will cut across the image. There is no ideal spot. The place that will be best for observing the elephants will be too far away for the magician's act that follows.

The lighting is often very flat, not to say nonexistent, in the moments that audiences like best. Often you will get the best results by shooting against the light in relation to the projectors that flood the ring. Especially in color, the halos, stars, big rays of light and even partial hazing which result from the

intensity of the spotlights give the photograph an added dimension of dream and surrealism.

During the performance you will often have to move rapidly from place to place. Study in advance how to move around without making noise, if you have to approach or pull back rapidly from the action. Create provisional itineraries for your movements among the tiers. You must have quick reflexes, because the circus acts are fast-moving. Many a photographer has been caught napping by the dexterity of the juggler who, just when you least expect it, grabs a long pole, balances it on his forehead and acquires, in mid-passage, a trapeze artist fallen miraculously from the sky.

If you decide to change places, don't hesitate, but above all don't dawdle. Either stay in a corner without moving, so as not to bother the audience, or else move as quickly as possible from one point to another, having worked out your route in advance.

You must know exactly what you have in your camera bag, and where each lens is located. If you have a good knowledge of your equipment and a clear grasp of the space in which you will be working, you can be rapid and efficient even in bad lighting conditions.

As for most photography in a theater, preferably use Ektachrome type B, artificial light, for the circus, and advance it three or four f-stops. As there is a shortage of light, you must choose the length of exposure in terms of which lens you use, and choose the lenses according to the available light. With long lenses, it is hard to have sharpness below a certain speed, because of the vibrating of the camera and camera shake, unless you can lean on something for solid support.

It is in fact easier to work at 1/10 sec. with 28mm than at 1/60 sec. with 200mm. If the light is very weak, but the spectacle worth photographing, choose a wide-angle which you can hand-hold up to 1/4 sec. Come close and plunge into the action.

At a concert, theater or even music hall, where the attention of the public is not only visual but auditory, the metallic noise of rewinding a reflex camera can be catastrophic. However, it is still better to use a noisy camera with which you are familiar and which will let you work quickly without any untimely gestures, than a silent camera which you do not know how to use.

It is fundamental not to have to grope in the dark for the shutter button, shutter speed setting or focusing ring. If only out of respect for the musicians and actors, you should know your equipment inside out, and be able to change film in the dark. Avoid shooting when the audience is raptly attentive; wait for the moments of relaxation. Watch out for the low points and dead spots, take advantage of the times when the actors speak in a loud voice, wait for a change of scenery or the noisy arrival of a new character.

A photographer is always a nuisance to others. He must not forget the fact, and must act so that people will not notice him. His most important quality is to work discreetly, with the least obtrusive equipment possible. If you know that the environment is not favorable, but that it is the most important moment in the scene, the one that absolutely must be filmed, take three or four pictures one after another, as quickly as possible, despite the disadvantageous situation, and don't move until the next applause. Don't insist on it if you don't feel up to your best; you will only make ten times more noise than usual.

Reflex Design or Rangefinder Design
Someone who plans to specialize in photographing performances should choose a Leica, which is the quietest camera in the world.

The cameras with rangefinder systems have in effect the advantage of vibrating less and of being less noisy than reflex cameras, because when you push on the shutter button there is no mirror with its complex mechanism to move, but only the curtained shutter. Their focusing is managed by the superimposition of two images. It is a more delicate process if you are not used to it, although many professionals say they prefer it because in their opinion it is more rapid and more precise.

With a Leica, especially when you are working in 90 or 135mm, you have in

(1) Paris. The Muchachos Circus.
Contarex, Sonnar 85mm, f/2, 1/20 sec., high-sensitivity Ektachrome ASA 180. Daylight pushed forward one f-stop. An artificial light film would have given a much colder tone to this same image.

(2) The same.
Contarex, Sonnar 135mm, f/2.8, 1/20 sec., high-sensitivity Ektachrome, daylight.

(3) India. 1967. New Delhi. Putting on makeup before a performance of the Ramayana.
Contarex, Distagon 28mm, f/2.8, 1/20 sec., high-sensitivity Ektachrome, daylight, available light.

(4) India. 1968. Rehearsal of a Nepalese circus.
Contarex, Sonnar 85mm, f/5.6, 1/250 sec., Tri-X.

your viewfinder a much larger field than that which will really register on the film. It is the great stumbling block of the rangefinder system, by comparison with reflex, that allows you to obtain in the viewfinder the same image that will register on the film, so long, that is, as you look in the viewfinder with the aperture set to the chosen position, and not at full aperture, as people generally do.

Speaking of the diaphragm and depth of field, you must always remember that with a reflex camera you look at the subject with full aperture, and that is sometimes unfortunate. What you see at full aperture is very different from what you will obtain at the real f-stop setting, especially if it is small. Unfortunately, by closing the aperture too much, you won't see much in the viewfinder. . . .

You must also be aware that the visual depth of field perceived in the viewfinder is larger than that registered on the film. In effect, the dullness of a 24×36 is not precise enough, and the format is too small, to differentiate with

1

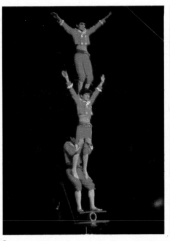

2

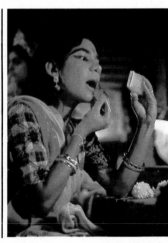

3

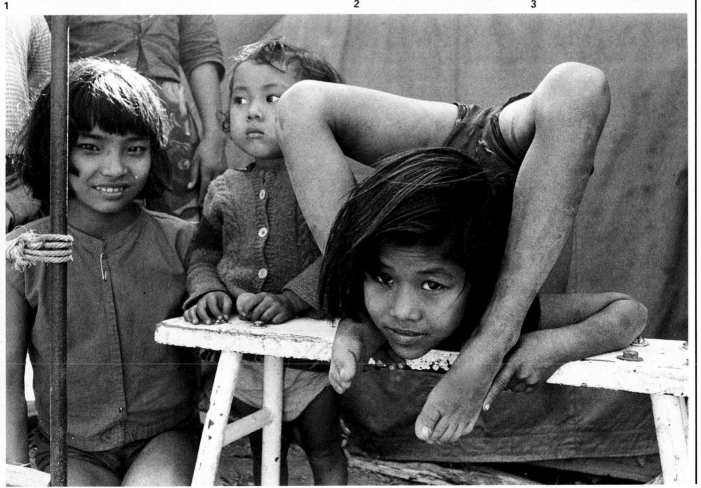

4

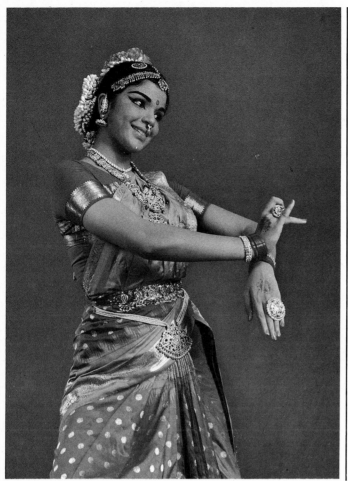

1 2

precision between the contour of different planes. When the photo is enlarged, you will discover that certain areas that were sharp in the viewfinder are in fact out of focus. This obstacle can be remedied by controlling the depth of field not only in the viewfinder with actual f-stop but according to the scale of numbers inscribed on the lens.

Reading a Person Through His Gestures

Photography freezes movement. Automatically there is a gap between the reality perceived by the photographer and that recorded by the camera. The movement is in front of the camera, and it becomes petrified inside the camera. In this connection the phenomenon of cinema should be recalled. If the spectator sees movement on the screen, it is by means of a succession of still photographs, and ultimately by a photographic breaking down of the movement into units of 1/60 of a second; that is to say, the image appears 24 times in a second. The human eye does not perceive the difference between these 24 images projected at a speed equal to or higher than 1/60 sec.

In order to capture a juggler's skills on film, you must take several different shots of his juggling to break down his movements. It is like a return to the principle of movies. To overcome the handicap and give an impression of movement, you can keep the face in sharp focus to show the uncertainty of the expression, while suggesting the dynamism of his actions by keeping the hands out of focus. At a relatively slow exposure speed (1/15 or 1/30 sec.) you may be able to capture a moment when his face is anxious and at the same time frozen, while the hands are out of focus, as are the objects he hurls into space, since these move very quickly; this effect translates, as it were, the movement to the mind of the person looking at the photograph.

(1) Southern India. 1972. Dancer of Bharata Natyam.
Hasselblad, Sonnar 150 mm, f/4, 1/125 sec., studio lighting.

(2) India. 1966. Ravi Shankar rehearsing at home among his followers.
Contarex, Sonnar 85mm, f/2.8, 1/60 sec., Tri-X, available light.

114

Sports

To photograph athletic or action scenes, when the event is happening very quickly and in a way that is especially difficult to capture, it is necessary to make more rigorous advance preparations than for static subjects like architecture or landscape. These can be photographed from different angles and at your leisure; they are not going to run away from you. As paradoxical as it seems, sports pictures are generally taken in a static position and in a much more calculated fashion than photographs of subjects which are themselves static.

During a car race or skiing competition you know that a particular car or skier will pass a certain line at a certain moment, but they will pass at such speed that if your shot has not been prepared in advance there is considerable risk of missing your chance.

Before attacking an athletic event, you must first of all understand and analyze what will be happening on the field or the course, foresee and locate the high points, and choose the place where you will set up to work. If, during a soccer match, you want to catch the ball at the precise moment when it enters the net, you cannot be in two places at once. You choose one spot instead of another because the light is better or because the team in green seems to have a better chance of getting the ball. It is essential to make this choice at the outset, otherwise you run the risk of endlessly running from one end of the stadium to the other and always arriving too late.

Also get into the habit of guessing the field you will obtain with one lens or another, because often it is impossible or highly inadvisable to move during a sporting event. Don't hesitate. Anticipate the action and don't be afraid, even if you haven't had time to focus, to press the button. Often you must waste film and take many bad pictures in order to get one good one, since the action is very rapid. If you spend a long time composing your image you will get nothing. In sports, there is no time for aesthetics. The artistic side of it is reduced to your intelligence and whatever talent you have for anticipating and controlling the future composition.

Even if you are very used to your camera, you should never change your focus during the action. You can rarely get it back again, except during the intermissions. Once your observation post is established, you must focus on the scene of future action, adjust the aperture, the speed . . . and wait.

From where you are you can also, without touching your focus, follow the action so you won't be too surprised when it enters your field of sharpness, and press the button when it arrives in your preselected space.

To cover the whole of a sporting event, it is sometimes necessary to work with a team, not staying together, but on the contrary covering two or three different points where it is probable that the action will be most intense.

Carry your cameras in a solid carrying bag, not too cumbersome and easy to open for changing your lens or reloading the camera rapidly, with a maximum of security. Practice changing your lenses and settings so that it becomes a reflex action.

For most spectacles and sporting events that take place by artificial light, you very quickly reach the limitations of films. Sometimes you must use films as high

as ASA 1000 or 1200 for color (pushed), and from ASA 2000 to 2500 for black-and-white, if you want to be able to get an image that will register. In these extreme cases, there is no longer any need to resort to the electric eye, because it no longer reacts. You are forced to work hand-held, at 1/30 or 1/15 sec., with full aperture; in other words, as far as you can go without causing camera shake. In this case, very luminous lenses are a must. Then, when you have finished shooting, make a test; cut a section of film or even develop a whole roll according to the settings which you believe to be in accordance with the film's exposure, and adjust the developing time of the subsequent rolls according to the results you get with the first.

The sensitivity written on the film package is applicable only to normal use of the film, in regular conditions of natural light. The moment you start working with artificial light, when this light is medium intensity, you must cut your sensitivity at least in half, and even in four when it is very dark. Compared with the exterior light, the artificial light in a stadium causes a film ostensibly ASA 400 to reach only 200. On the other hand, in snow and in country where the reflections off the ground are very intense, the same film may reach ASA 650 to 800. If the exposure times are not corrected in relation to this shift, the films will be overexposed and full of contrast. To lessen this contrast, you must slightly overexpose when shooting, and then underdevelop. For example, leave the film in the developer six minutes instead of seven to get the maximum lightness. In black-and-white, a film with too much contrast gives an image with overtones and with no value between the whites, the blacks and the grays.

The use of the flash is not permitted at most sporting and theatrical events because of the annoyance it causes. Its use is permitted, if at all, only for professionals obliged to bring back at any price images for the press.

When you carry a camera you must be prudent. In many cases someone not lucky enough to have a silent camera should absolutely abstain from filming an indoor tennis match if he is sitting in the first rows, in order not to disturb the players. To click a camera five meters away from a player just as he is about to serve can be very serious. Using a flash at a moment of extreme tension is monstrous. An inopportune flash of light can compromise the results of a match: you must have the wisdom and courage to refrain from photographing if you know it will disturb. Whether at the theater or the concert, at a racetrack or a stadium, at a skating rink or any other place dedicated to sport, you do not have the right to make noise and to disturb actors, athletes, champions and spectators by flashing lights in all directions simply for your own pleasure.

Effects

It is very difficult to be original in sports photography. The results are often bad because they are always the same. To photograph a car race or a horse race, most amateurs and most professionals will resort to the same effect: panning, a technique that consists of following the movement of your subject. You see the car or racehorse coming around the bend, three hundred meters away. You follow them as best you can with your telephoto, as they come closer. At the moment when they are closest to you, still following them with a continuous movement, you click the button. The shutter speed may vary between 1/8 and 1/500 sec., according to the photographer's skill. The background will be more or less blurred, which will enhance the impression of speed, since the car or horse will be relatively in focus. The effect is nice, but unfortunately it has been done over and over by all racing fans. It is a far from original technique.

On the other hand, with a powerful telephoto lens fixed on a very stable tripod, you can isolate the action from its context—let us say, this same car, or the jockey—in a powerful and often very beautiful way. Such an image has sometimes the quality of slow motion in the cinema. The person—the driver or the jockey—is outside of time. If his gesture is eloquent, the result obtained can be striking and has the advantage of not falling back on the facile device of panning.

In sports the use of wide-angle is very limited. Avoid overall shots where you don't see anything. The architecture of a stadium is rarely interesting in itself,

2

1

(1) Japan. 1974. Tokyo. Sumo: during their training, young wrestlers watch two older ones in combat. Contarex, Sonnar 135mm, f/2.8, 1/60 sec., Tri-X, available light.

(2) France. Interscholastic sports competition. Contarex, Sonnar 85mm, f/4, 1/1000 sec., Tri-X.

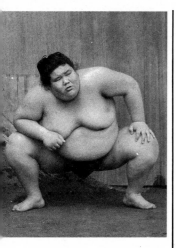

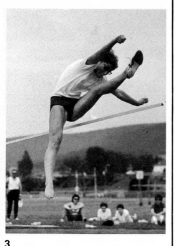

3

(3) France. Training in an open stadium.
Contarex, Sonnar 85mm, f/2, 1/30 sec., Tri-X, available light.

(4) France. Skating on a frozen lake in Alsace. Contarex, Sonnar 135mm, f/4, 1/500 sec., Kodachrome II. The image was intentionally underexposed slightly to augment the perspective of the ice.

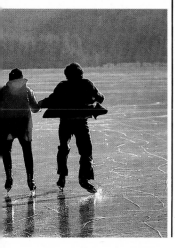

even if covered with little microscopic dots spread out over an enormous field. Thus, unless you make very cunning preparations and have a considerable mastery of your camera, it is especially difficult to take good sports pictures with wide-angle. In effect, sports pictures require you to be in the heart of the action. Waiting for the skier directly as he embarks on the ski run, or getting under the basket during a basketball game, can get you some remarkable effects. But it is rarely possible, and quite dangerous, to be in such places. Wide-angle gives strong images only when the subject is a few centimeters away from the camera. You must therefore use long lenses, for it is rare to be able to get close enough to the action.

Dangers

You must not forget that while a photographer is in principle a voyeur, he has a camera in front of his eyes which prevents him from seeing what is going on outside the viewfinder. In the course of athletic games there may be unforeseen movements, and the photographer risks accidents if he lets himself become too captivated by his subject. Just as he takes a risk by putting his head through the bars of a cage during the training of an animal, or when he approaches a track to capture the car that will be launched at 300 k.p.h. a few meters away from him, it is essential that he have an assistant to hold his shoulders and pull him away in case of danger.

The sports photographer who uses very long lenses is often too wrapped up in what is happening at a distance and forgets what is going on nearby.

The Sidelines of Competitive Events

However devoted the photographer may be to sports, it would be a pity if he watched a car race or an international rugby tournament and limited himself to keeping his eyes fixed on the cars or the players. Don't forget the audience, if only to make sure that at least a few of your pictures come out. Audience reactions in a stadium are often fantastic. Never limit yourself to a single center of interest.

A good photographer should have eyes in the back of his head. For anyone interested in the human condition, the spectacle takes place in the bleachers and on the grass, too. The rougher and livelier the game, the more fascinating it will be to capture the spectators' expressions—enthusiastic, disappointed, and angry by turns.

During the 24 hours of the Le Mans race, because of its exceptional length, a whole way of life is improvised and organized in the long hours around the course. The most enthusiastic fans gather around the fences before the starting signal and never leave their chosen spot until the grand prix is won.

For hours they stay there with their eyes glued to their binoculars, regularly consulting the stopwatch they hold in their excited hands. Don't fail to catch the tense expressions of these aficionados, if their favorite falls behind or advances on the other racers.

Photographically speaking, the night is particularly interesting, not for the effect of the lights glistening on the asphalt or in the pools of water if it has rained (that has already been done a thousand times by all the members of amateur photo clubs), but because of the night life that gradually establishes itself. While those who prefer solitude go off to sleep alone under the trees, the less timid gather together and cluster close to ward off the cold and the wet. Some couples take refuge in the bushes, far from prying eyes (they think). The unfortunate photographer who tries to surprise them in flagrante delicto is likely to find himself abused as a voyeur and is lucky if he gets away with his camera intact.

As the hours go by, tribes form. Fights break out. During the night fires are built. Guitarists, flutists, trombone players get together. Ordinary utensils are pressed into service as drums. Orchestras are created. People dance to rock music to keep themselves warm and stave off boredom.

However tired you are, sunrise is not to be missed. Thousands of spectators, their eyes puffy from lack of sleep, yawn and stretch at the same time. Sullenly

everyone gets up, indifferent to the roar of the cars a few meters away. The biggest fans turn on their transistors to hear the latest results. Little by little, things get organized. The brave go off in search of firewood. The provident or best-organized take out their portable gas heaters while the others try to blow on the wet branches that obstinately refuse to catch fire. Coffee is collectively prepared. The most generous share their provisions. The girls make an attempt at washing-up and making themselves up. A bottle of homemade brandy passes from hand to hand. Vendors of sausages and chips and beer make their appearance and are soon swamped with customers.

If the excitement of the real fans maintains itself over the hours, the fatigue of the others becomes more and more obvious. For them the race gradually loses its interest. Each is already dreaming of getting back to his car or motorbike and sees himself being crowned champion. These thousand instants create the real atmosphere of a race, and it is fascinating to catch them.

Of course, at the end of the race, don't miss the rush of all the fans as they throw themselves on their hero and carry him in triumph to the hurrahs and applause of a moved and admiring crowd. Whether you are shooting at the decisive moment of the arrival or to get the ambiance of the course, as with all snapshots use the lightest equipment possible: two cameras, one equipped with wide-angle and the other with a small telephoto. As for tripod and supertelephoto, give the one you brought to photograph the cars at a distance to a friend to take care of while you walk among the crowd, since you must not hesitate to walk ceaselessly for hours on end if you want to bring back shots that are real, shots that will amuse and interest people, and not just impersonal long shots of the race.

Images and the Law
Every photographer, whether professional or amateur, who intends to publish the photograph of a person must ask him for a written release entitling the photographer not only to take the picture but to publish it in a specified place.

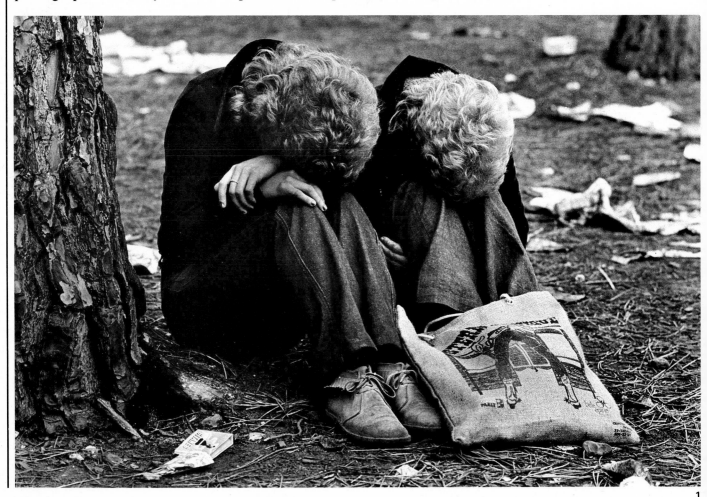

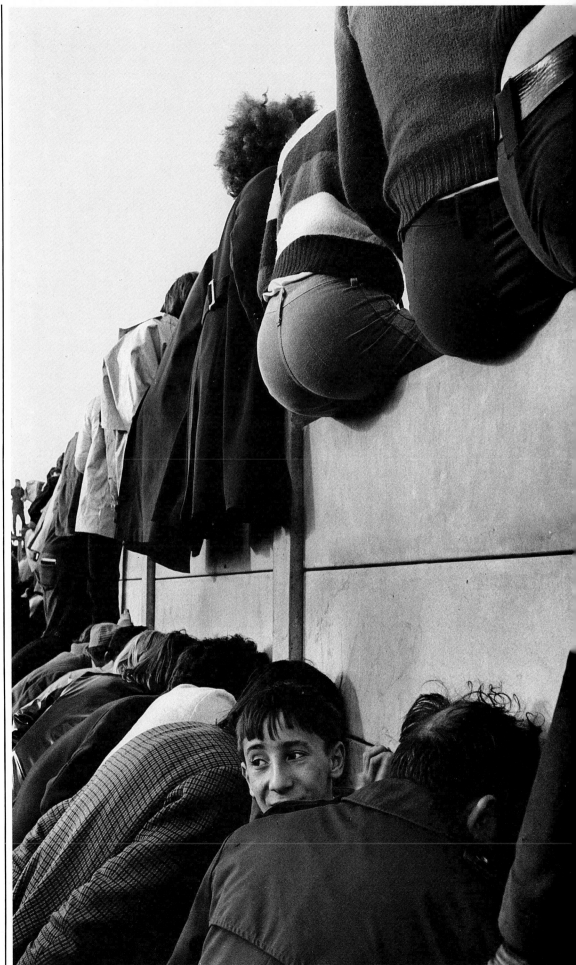

(1) France. 1973. The 24 hours of Le Mans. On the grass at daybreak.
Contarex, Planar 50mm, f/5.6, 1/60 sec., Tri-X.

(2) The 24 hours of Le Mans. 1973. Gate-crashers.
Contarex, Distagon 35mm, f/8, 1/125 sec., Tri-X.

For professional models who work for money, this practice has existed for a long time. Even if it is a delicate point to ask a relative or friend for their signature, you can never be sure that the "dear friend" will not go back on his word, either because he does not like the photograph or because he can make a lot of money by bringing legal action. Even with the written release the photographer is not entirely free of the risk of an eventual court case. Such cases are more and more frequent, and several famous professional photographers have recently been brought into court because of photographs taken in the street.

No one should be unaware of the law pertaining to images, that is, the right of any photographed person to oppose the unauthorized publication of his image. The prejudice caused to the victim by the said publication may be further aggravated by a defamatory caption or a context damaging to his reputation, his honor or his interests.

There are, however, several exceptions, notably for group pictures and pictures of well-known personalities taken in the course of their professional activities: ministers of state, politicians, stage and screen stars, etc.

(1) France. The 24 hours of Le Mans.
Contarex, Distagon 35mm, f/5.6, 1/125 sec., Kodachrome II.

(2) France. The 24 hours of Le Mans. "The infernal circle" at the moment of take-off.
Contarex, Sonnar 250mm, f/5.6, 1/250 sec., Kodachrome II.

(3) The 24 hours of Le Mans. There has just been an accident.
Contarex, Sonnar 135mm, f/5.6, 1/500 sec., Tri-X.

(4) The 24 hours of Le Mans. A few minutes before the arrival.
Contarex, Sonnar 135mm, f/4, 1/125 sec., polarizing filter.

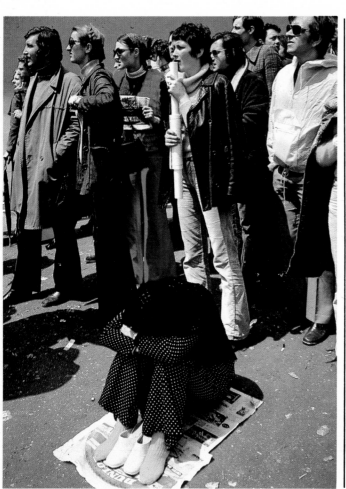

1

2

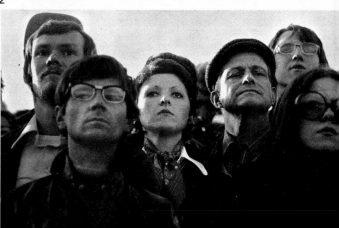

3

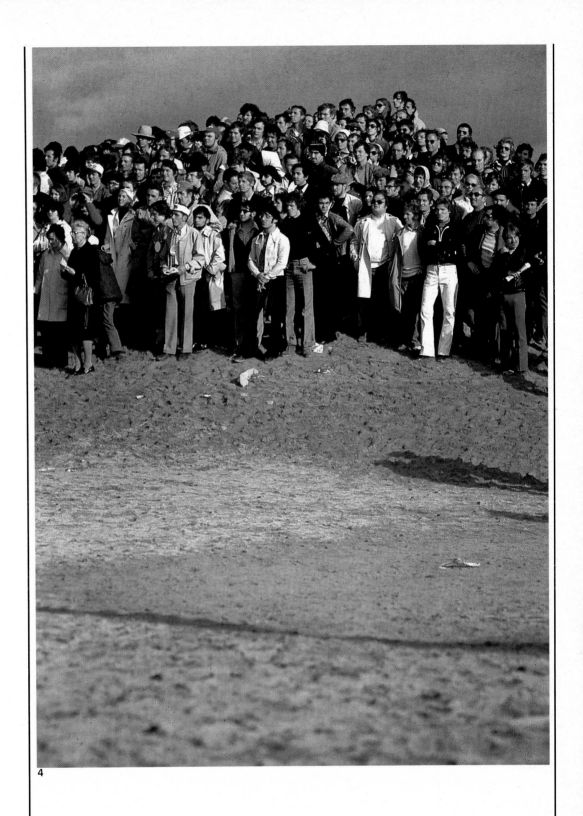

4

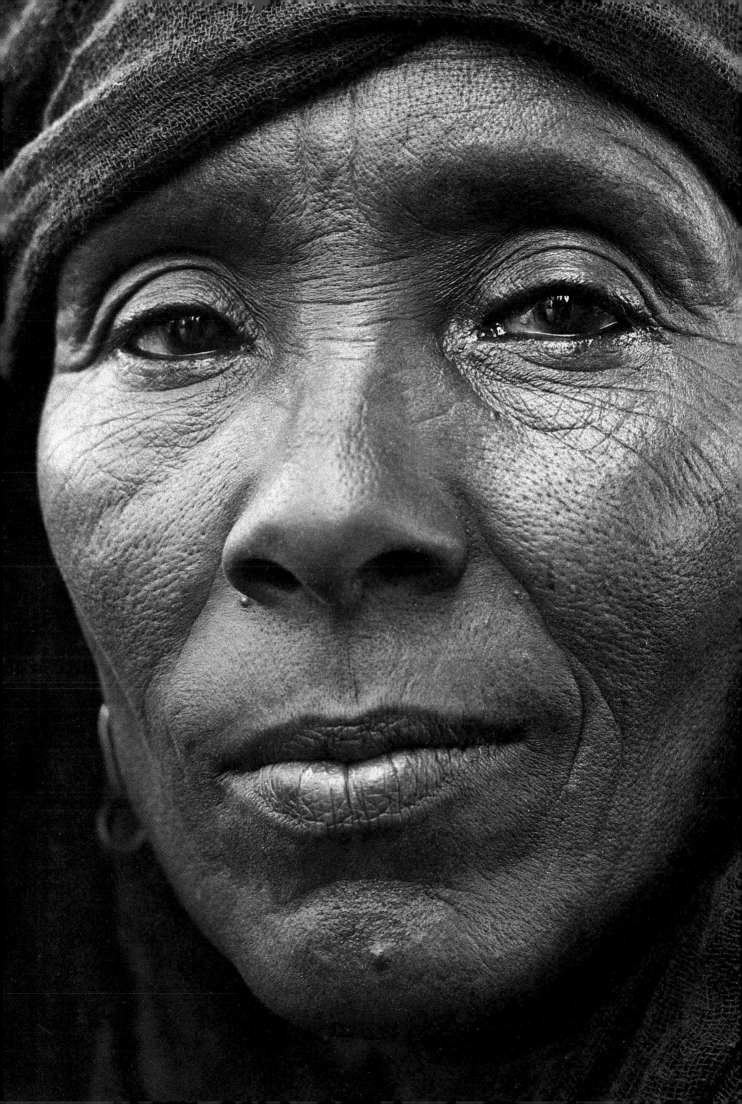

Portraits

THE artificially created portrait—one which is constructed, composed and which results from conscious thought—is one of the most rewarding aspects of photography. Whether in studio or out of doors, it calls not only the photographer's talent but also on the communication between photographer and model, whether the latter is a child, an old man or a nude.

To successfully take a premeditated portrait—not to be confused with the snapshot taken in the street—both parties must want to communicate with each other. For the amateur, the posed portrait is perhaps the easiest thing to undertake, for there are external constraints. He can choose his subjects and his timing freely, and has thus a distinct advantage over the professional, who works in a given time, with imposed subjects, regardless of his mood.

Approaching the Model

There are two diametrically opposed methods for realizing a portrait on command. You can leave your model free to choose whatever position and expression he wishes, or you can direct him to take a pose chosen by you in advance.

Unless you have a very definite idea of the image you are going to create (to accentuate the dramatic side, for example) you will probably profit from the participation of the model and his free evolution in a given space.

If you choose this approach, choose a position in relation to the light, sit down and guide the subject in a fashion appropriate to the lighting and decor. By the relaxed feeling you create you will control the atmosphere at first. The expression, of joy, sadness, or fear, will depend on one's attitude. To shout, to make faces, to blare out pop music and let Vivaldi play softly: all will provoke a variety of different expressions.

It is important to be involved, to establish a dialogue with the person you photograph. The images intervene as stages of this conversation, at the most intense moments. This method naturally calls for quick reflexes and sufficient manual dexterity to maneuver your camera without having to concentrate on the mechanics of it. It is difficult to maintain a continuous dialogue while shooting when you have not learned to adjust your speeds and apertures by instinct. In a case where model and photographer are intimidated, get the model to talk to a third person, while asking him to look at the lens from time to time.

The self-consciousness often provoked by the presence of the photographer allows you at the same time to discover a different aspect of the person photographed. Most people are not in the habit of posing. They remain frozen, tense, full of fidgets. They stiffen up and sometimes great efforts must be made to get them to forget the camera. Avoid keeping the model immobile too long in the same place; on the contrary, invite him to move around and to follow the camera with his glance. Talk to him, distract him, amuse him. There is no absolute rule. Everyone must reach intuitively to adopt the right behavior.

Choose the angle that best reflects the personality of the subject. If you use a long lens, be sure to support yourself steadily.

It is better to be slightly below the line of the model's eyes in order to impart a certain largeness of scale. Photographing from above diminishes the model.

Ethiopia. 1974. Danakil Desert. Nomad woman of the Afar tribe.
Leicaflex, Elmarit 90mm, f/5.6, 1/125 sec., Tri-X

123

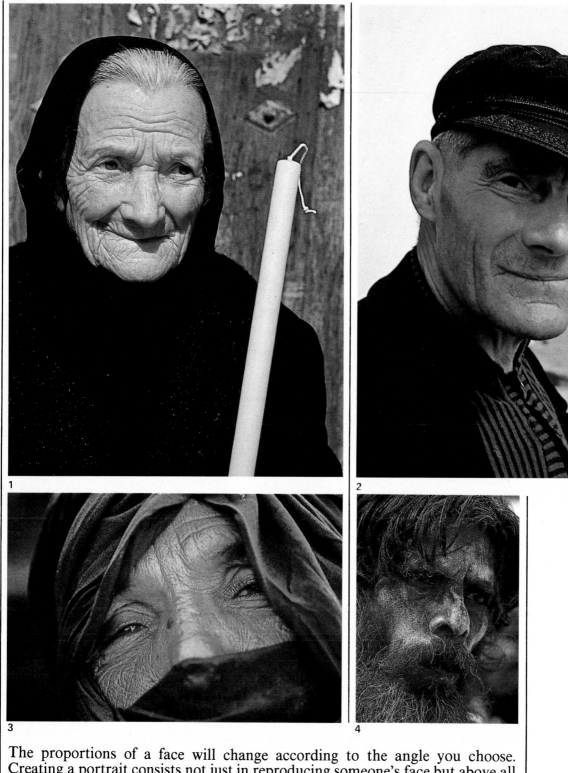

1

2

3

4

The proportions of a face will change according to the angle you choose. Creating a portrait consists not just in reproducing someone's face but above all in seizing its most characteristic expressions. Thus it is often necessary to stimulate an animation which induces the person photographed to take on his most typical expressions.

You construct your image by instinct in the moment of shooting and not in advance. No scenario; you must follow the model, react simultaneously with him and be attentive to the smallest facts and fugitive sentiments which will bring out the expression you are looking for.

The other method, which is just the opposite, consists of letting the person in front of the camera completely alone, without talking to him, and making him wait until he is forced to reveal himself. By his willful and cunningly calculated silence, the photographer traumatizes the model. Watching the model's smallest actions and gestures closely, he creates a veritable psychoanalytic atmosphere.

(1) Spain. 1960. Valladolid.
Pentacon, Biotar 58mm, f/4, 1/60 sec., Kodachrome.

(2) France. Côtes-du-Nord.
Pentacon, Biotar 58mm, f/4, 1/60 sec., Kodachrome.

(3) Southern Sahara. 1974. Tuareg of the Air Mountains.
Minolta XM, Rokkor 100 mm macro, f/5.6, 1/250 sec., Kodachrome II.

(4) Sri Lanka. 1975. Devout Hindu on a pilgrimage.
Minolta XM, Rokkor 100 mm, f/8, 1/125 sec., Kodachrome II.

(5) India. 1967. Bihar.
Contarex, Sonnar 85mm, f/4, 1/60 sec., Kodachrome.

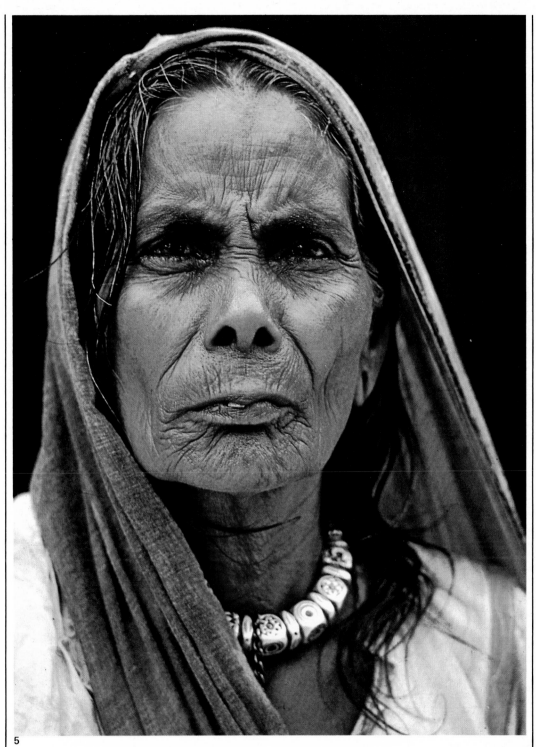

5

Certain professional photographers seat their female model in a chair and leave her there for a while without saying a word. Then they smear her body with oil or powder it with talc, and create a ritual that makes her feel as if she were about to undergo an operation. There is no dialogue by which the model can escape from this artificially created oppression. Many fashion photographers work this way.

Saying to your model "Stand up, move, smile, look at me . . ." is not necessarily a good solution either. From time to time it's a good idea to stop so that the model can regain a certain degree of self-confidence.

It is surprising to note that the earliest portraitists once required their models to remain immobile for more than a minute, imprisoned by braces that gripped their neck and were hooked under their armpits at elbow level. Despite the lack of sensitivity of the plates of yesteryear, and perhaps because of these long poses, the results obtained in that period were often far superior to the portraits being

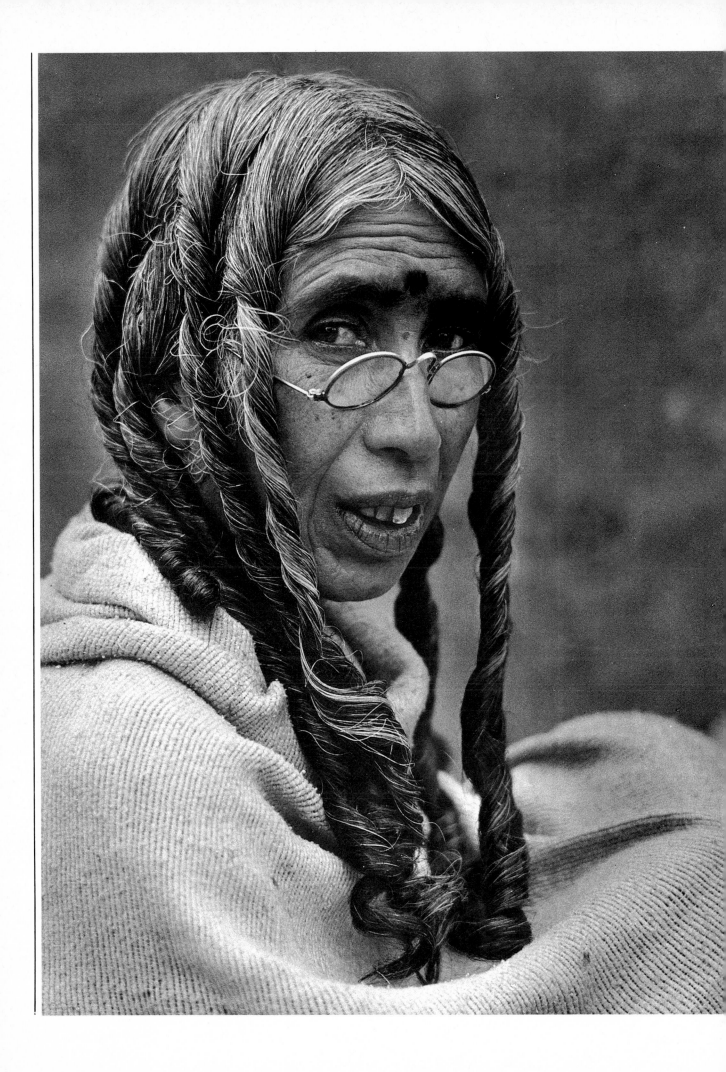

made nowadays. They had a presence, a sobriety and a truthfulness that is hard to find today.

Lighting a Portrait

It is essential to choose your lighting according to your subject. A child's portrait, a woman's, an old man's, all call for different intensities of lighting. Take advantage as much as possible of the softness or contrast of the natural light. This is both the most beautiful and the most difficult to interpret, for it is infinitely diverse, changing every day, varying from one minute to the next.

To find the direction of sunlight that best corresponds to the atmosphere you want to create, it is not the model's job to move, but the photographer's. In an interior, if you resort to artificial light, you can place a lamp at random and then turn it around until you find the best angle. Don't exhaust your model with over-fastidious experiments. Make a mental note of what you see in the viewfinder, calculate that if the light is placed a little bit farther back or to the left it will be perfect in terms of the subject's skin, and make your attempt. It's up to you to create the lighting's atmosphere.

Unless you are an expert, establishing artificial lighting is always an adventure, since you have to define in advance at what point in space you are going to place the model. Choose the background color in terms of the person to be photographed. It should be bright for someone with dark hair, dark for someone with blond or white hair.

In a portrait, while people often tend to cancel out the background, it is sometimes interesting to integrate it into the picture. For that, it is necessary to have a maximum depth of field; close the diaphragm if you don't want the background to be too out of focus. On the other hand, when you want the person to be removed from his context, work with full aperture. With a reflex camera, verify this depth with the help of the button, as needed. Otherwise you will be fooled by the image in the viewfinder (which corresponds to full aperture).

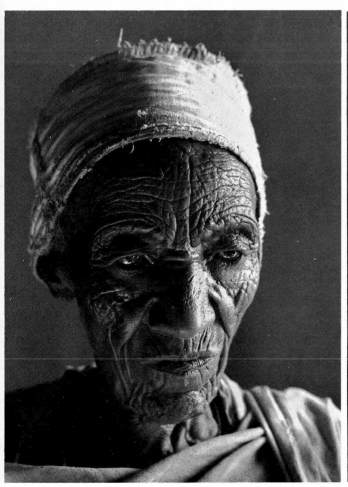

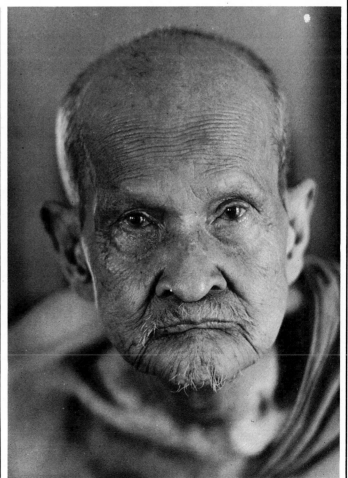

2

3

Opticals

Of all opticals, the most difficult to use for portraiture is normal focus, for it creates bothersome distortions in the face, noticeable enough to spoil the picture without being major enough to be considered as a style or a conscious effect. The same is true of wide-angle, which systematically distorts in the direction of caricature or stylization. But for a portrait without artifice, the best lens is a small telephoto, because it does not make the nose ten times bigger than the eyes or cheeks in the background.

Working with a lens of 80 to 135mm also has the advantage of not forcing you to click the shutter right under the nose of your model.

A longer lens than that, on the other hand, distances too much and causes a loss of contact with the subject. To use a large telephoto, you must know its capabilities and limitations. Its weight risks camera shake below 1/250 sec. Furthermore, the smallest movement on the part of the model will cause loss of focus. To get a precise image, it is essential to work above a certain speed and, contrary to what you might think, not to stop down the aperture too much.

It is important to choose a specific spot for adjusting your focus. Since, as always with telephoto, you cannot obtain real depth of field, it is better to have none at all. However, do not work at full aperture either, but between $f/5.6$ and $f/8$. If you get something that resembles depth of field below that, you will be out of focus. In fact, many lenses lose definition when they are excessively closed. The image is not sharp; you can no longer discern the precise point of impact. If this cannot be perceived immediately by the person looking at the photograph, the portrait loses much of its strength.

Should the Subject Look into the Lens or Not?

The glance is of primary importance in a portrait, since it is the only real contact between the person photographed and the person looking at the picture.

A sideways glance is less attractive than a direct one, but it too can have its importance. Obviously, there are many examples of very beautiful portraits in which the subject is looking away. There is no absolute truth, but in general, to give the image life, the glance should be directed at the lens and there should be a reflection in the eyes.

To photograph a person in a predetermined pose raises many difficulties if you want it to look natural. To attain this semblance of spontaneity, it is important to learn in advance the model's characteristic behavior. For instance, to photograph someone drinking a cup of coffee, ask him first if he drinks it often, at what time of day and where. Watch his expression as he replies. The photographer must always work beneath and beyond the action he photographs, and thus convey a certain continuity. If the model moves, he notes the interesting movements, the way of getting up. When the model sits down again he picks up the coffee cup and raises it immediately. The movement is more spontaneous and relaxed and thus better than if the subject has been posed in a predetermined way.

If the situation is tense from the outset, it is better to start by clicking the shutter right away, without even really looking at what the model is doing, and saying "That's great." In this way you can make the atmosphere more relaxed. Show your enthusiasm. The model must be happy to be there and the photographer must be persuasive. He must stimulate the model, not linger too long or be oppressive, but move and cause movement.

Portraits of Women

Photographing a woman is perhaps the most delicate procedure, especially if you have to show her the photograph afterward.

Learn how to capture the softness of certain expressions. The angle, the choice of film, and the light all play a determining role. At the very least, the model should be able to see herself the whole time in a mirror located near the lens while you press the button, a method frequently used with fashion models.

Grainy films will give the image a certain softness. Shooting against the light will create a slight difference that will accentuate this vaporous atmosphere,

Sikkim. 1972. At the foot of the Himalayas. Tibetan Kampa horseman participating in ritual dances in the presence of the king and queen.
Contarex, Sonnar 135mm, $f/5.6$, 1/125 sec., Kodachrome II.

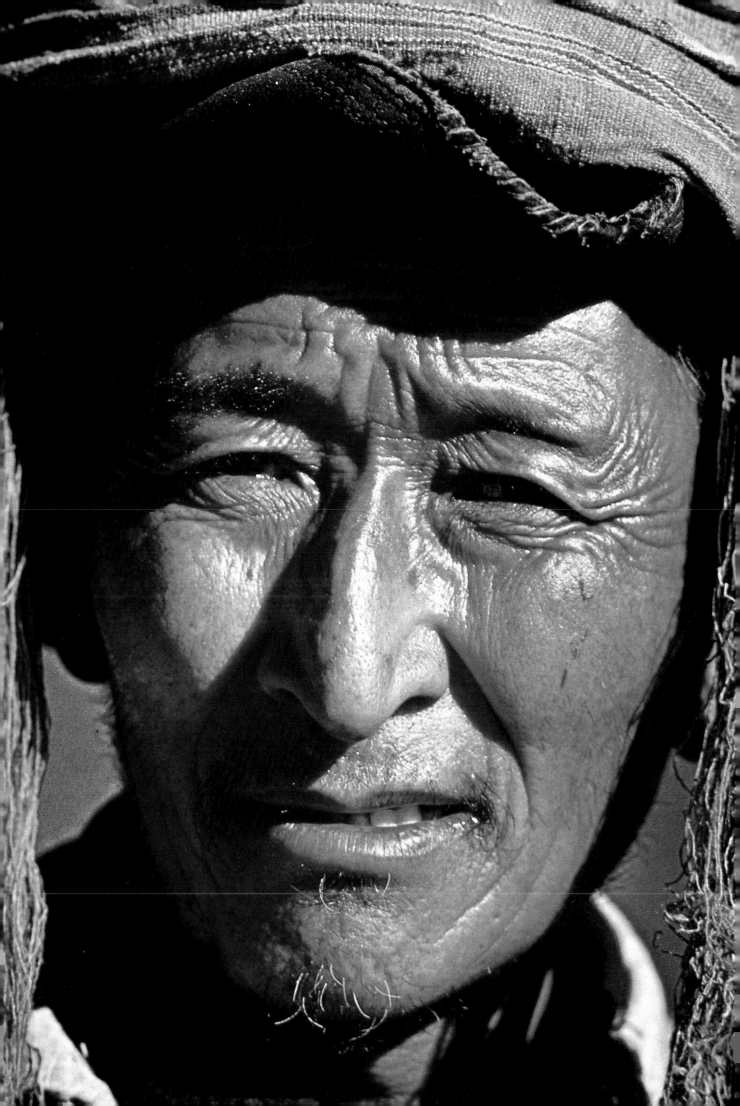

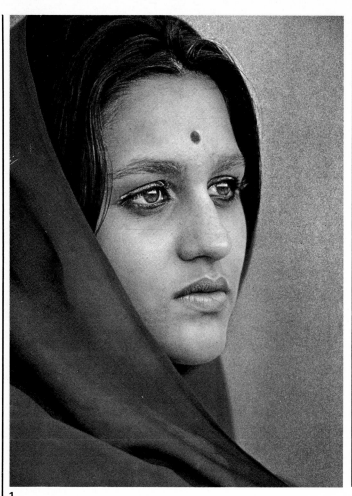

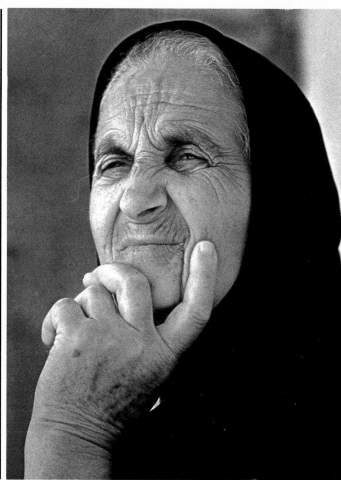

1

2

which is sometimes useful for photographing a young and pretty model. Choose films with warm tones that will better convey the color and texture of the skin.

Old People
From the photographer's point of view, old people can be divided into two categories—those who want at all costs to look young and those who are proud of their age. Naturally, the most interesting types to photograph are those who accept the fact that they are old.

However fascinating it may be to sum up someone's reality in a portrait, if you want to give pleasure to someone who tries desperately to escape from aging, you can resort to numerous technical processes to soften the image and erase the most noticeable wrinkles, both in the shooting and the developing: filter, diffusion, grainy film, retouching, Vaseline on a filter, etc. It goes without saying that to accept such an assignment means you are not really photographing, but are engaged in lab work.

Real photography should be as objective as possible. Each wrinkle has its importance. Light plays a determining role: you must be able to find in the eyes the answers to the questions asked by the face. Amid the marks and deformities of old age, the shining or lassitude of the eyes makes the difference between whether the glance is alive and communicating with others or not.

(1) India. 1968. Bombay. Young movie actress. Contarex, Sonnar 85mm, f/2.8, ⅟₆₀ sec.

(2) Greece. Mykonos. Leicaflex, Elmarit 135mm, f/4, ⅟₁₂₅ sec.

The Nude

A MATEUR nude photography was still impossible a few years ago. Most laboratories systematically destroyed in front of their creators any pictures that did not seem to conform to the letter of the law. That time has passed. But nonetheless it is not easy to create an aesthetically successful nude. Whether the model is a man, a woman, an adolescent or a mother and her child, there is a great risk of falling into vulgarity.

The composition and the choice of lighting play a fundamental role indoors as well as out. Aside from a few exceptions, and unless the model is professional, knowing how to pose even with clothes on is an art, all the more so if one is naked. There are few models who will not be tense in front of the camera, even if the person behind it is an old friend.

In fact, it is almost impossible to give advice for a successful nude. Everyone has to follow his own temperament. For each being there is a different approach. The nudes of David Hamilton, of Jean-Pierre Boret, of Lucien Clergue, of Yoshi Ama, of Jean-Lou Sieff, of Bill Brandt or of Andre Abegg have nothing in common with each other, but all are admirable.

One of these masters of the nude will voluntarily distort the model outrageously with a wide-angle, another will choose an extremely harsh light. Others will put Vaseline on a filter to soften the atmosphere and the colors. Some will use fast and grainy film in order to give the image a pointillist, even impressionist style. For one, a white wall and contrast paper will be a must, to literally shade the body. In this case, only the mouth, the nose, the eyes and the sexual parts will retain a certain aggressiveness.

Others will work in direct sunlight, playing with sand and waves. Others again will be able to realize themselves only in a studio, among unorthodox objects and phantasmagoric decors. It is up to each individual to choose his method according to his inspiration and his aesthetic sensibility.

For some photographers, such as Denis Vicherat, "the nude is above all a being. If I am with a woman who is comfortable in her skin," he says, "I try first of all to express the fact that she feels good, without artifice, with a very natural manner. So, in general, I photograph her in a setting that she is familiar with, where she feels at ease. I wait for an hour before picking up the camera, because I need about that much time to feel in harmony with the model.

"I never hurry, and it is hard for me to imagine that you can take a girl, undress her, put her against a blue, green or red background, take a bunch of pictures and say, 'Come get the prints tonight' or 'We'll start again tomorrow' and move on to someone else. That happens all the time. I would be incapable of it, and I have no desire to do it. For me, it is a relationship with someone. Perhaps it is also an homage to something that I feel and that I find beautiful."

It is disturbing to note that nowadays a number of photographers, like Lucien Clergue, Christian Vogt and quite a few others, intentionally cut off the model's head. Having no eyes, the body becomes an object. Of course, the photographer should be able to express his personality by means of his technique. So let us refrain from condemning this method, but rather note it and question it a little.

Doubtless one could also speak of a different conception of the nude that is

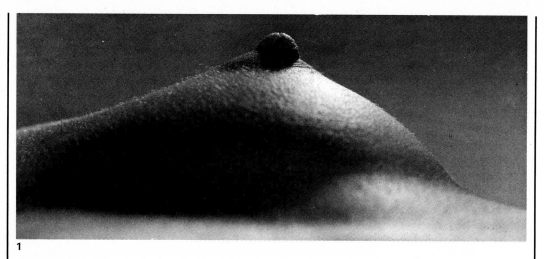

1

found frequently in New York photography, and which betrays a certain fascination with the ugly, even the sordid. But perhaps that is just a fashion.

The Role of Aesthetics in the Nude

It is relatively easy to create abstract art with the lines and forms of the human body, whether masculine or feminine. By using, not necessarily macro- or microphotography, but extreme close-up, you can obtain surprising compositions of forms, curves, delicate shadows, skin details. This can even give really astonishing results when filmed in dull light.

Avoid all violent contrast. The decor should be neutral and unified. Whether black, gray or white, you should not interfere with the texture or details of the skin. Use the f-stop to the maximum in order to have sufficient depth of field, so that the different planes will all be relatively sharp.

Lighting plays a fundamental role. Avoid the flash, which is difficult to control at such a short distance, but do make use of projectors. A slightly low light will allow you to have areas of shadow and light that may make for the success of the picture. The volumes of the body must be continually present.

Black-and-White or Color?

The best nudes to date have been done in black-and-white. Doubtless this is because black-and-white allows more extensive exploration of volumes, contrasts and light. Skin has a uniform, monochrome tint to which color brings no supplementary dimension, unless you go for a very brightly colored, spectacular approach by putting spangles on the face or breasts of the model, or by placing her against a yellow or red background. In that way you will obtain a very provocative and harsh effect. But black-and-white corresponds much more to the delicacy of the curves and the richness of the volumes of a body.

Choosing a Model

Agency models (advertising or nude), just like those who describe their measurements in detail in specialized magazines, are often doubly depressing. For one thing, they do not offer their beauty or their sensuality, they sell it. For another, the ones who work in journalism must correspond to the stereotyped images that prevail in advertising: the Young Assistant, the Smiling Worker, the Typical Frenchwoman, the Ideal Secretary, the Sexy Girl.

These models are furthermore rarely extremely pretty, except in fashion where the model must have an extremely slender and somewhat emaciated body, with long legs and ethereal gestures that you notice more for their angular allure than for their grace.

Collective Photo Sessions

For some time there have existed various photographic schools or academies devoted to nude photography. There, under the direction of a "professor," one or half a dozen "pupils" photograph a model or even several models simultaneously, depending on the establishment and how much money you pay.

(1) Paris. In an interior with a spotlight placed slightly against the light.
Zenza Bronica 6x6, f/16, 1/30 sec., Tri-X.

(2) New York. 1963. Available light.
Contax D, Angénieux 35mm, f/4, 1/30 sec., Tri-X.

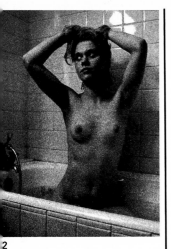

2

All day long the girls pose lasciviously on a platform brightly lit by flood-lights. Striptease is ever-present. The aggressiveness and poses are equalled only by their vulgarity. The photographer is not permitted to get up on the platform. He has only the right to ask the pin-up girl in question to stick out her torso a bit more or to take an even more seductive pose.

Evidently, for most of the clientele the camera is an excuse for giving free rein to their voyeuristic tendencies. The plastic qualities of the photograph obtained are of small import. Photographs taken under such conditions have little to offer.

Approaching the Non-Professional Model

If he does not have recourse to professional models, the amateur, first of all, will have to establish relations of trust between himself and the person chosen, so that she will feel at ease with him.

It is essential that trust be established in what is after all only a game of images, making part, perhaps (and why not?), of the game of love itself. Don't take yourself too seriously, at least in the beginning. If, after a first attempt, you find that four out of five rolls are useless and devoid of interest, but that in the last pictures on the fifth roll there is a hint of something interesting, you must seize on that aspect the next time you photograph and forget about your earlier failures.

Find again the angle which gave you the best results, modify the direction of the light, choose perhaps a more suitable lens—and think.

Which Lens to Choose?

To photograph a nude, it is generally advisable to use a normal lens and a film that is not too contrasty, of the Tri-X type, which has a lovely and very rich granulation corresponding somewhat to the texture of skin. If you want to emphasize the relationships among forms, volumes and light, you should choose a macro lens of 50mm or 100mm, allowing you to approach very close, so that you can get extreme close-ups of isolated details of the body.

In a nude, the entire image should be either sharp or soft. It is unaesthetic to have soft-focus legs and a sharp face, or vice versa. You must therefore have sufficient depth of field so that the different planes will be in focus; unless you set out to do the opposite, so that the model will appear soft and gauzy. If that's the case, you can use diffusion filters, certain kinds of gelatin or commercial lenses. You can also steam up the lens or put Vaseline on a Skylight filter. The result obtained is no longer really a nude study, but rather a pretty shape in a harmonious ensemble where everything is agreeably watery and gauzy.

Soft Focus and Distortion

David Hamilton always seeks that kind of effect in 1900 salons, through a velvety atmosphere or dreamlike decor. The person he photographs is part of the landscape. Since the model chosen is attractive and the landscape evocative, the totality is in harmony and is agreeable to the eye.

Bill Brandt, on the other hand, has made a series of extremely distorted and yet very beautiful photographs with a large-format chamber. Much larger even than wide-angle, it is a tiny pinhole that served him as lens, letting him obtain a depth of field from 2 centimeters to infinity. The bodies of his models became monstrous through the alteration of shapes, and yet their lines almost attain perfection in terms of rigor and sobriety.

Man Ray resorted to solarization to cover his subject and give a somewhat bizarre and unreal quality to the image.

As for Shino Hoyama, he distorts the nude and incorporates it into a total image. The body takes on the form of the pebbles scattered on the beach where he is shooting. He obtains from his models the same lines that can be found in other natural elements. He transports them into his universe. His skies are dense, black and very agonizing.

The Real Motives for Nude Photography

There are many who claim to photograph nudes for purely aesthetic reasons.

133

The formal approach on which we pride ourselves can often be a more or less conscious way of disguising a certain desire. You attempt to find an artistic lighting and to produce effects. You resort to polarizing filters or diffusion filters . . . to appease your conscience and hide erotic feelings of which you are more or less aware.

If photographing a nude is just a pretext or a means of seeing your girlfriend with her clothes off under a floodlight or a flash, there are less costly ways to achieve that, ways that do not require the disguise of a camera. People who take pictures in that spirit often attain a rather unbearable vulgarity; and without trying to deprive anyone of what amuses him, it must be recognized that the result obtained is usually deplorable and depressing.

To photograph a nude should be a graphic game of composition among volumes, light, the model and the environment.

The most interesting pictures are often those in which you see a free body moving tranquilly in a clear, simple and natural decor. But even in a studio, with merely a white background and appropriate lighting, you can create peaceful and attractive images.

Lighting in the Studio
Studio equipment very quickly becomes exasperating: flash, large-format chamber, tripod, floodlights, things that are necessary and yet heavy, cumbersome and relatively immobile. Before using electronic flashes you must have the wisdom to begin by working with tungsten lamps, even if these are weaker, heavier and very cumbersome.

All lighting should be fitted to your own personality. But that personality can only be realized by creating the lighting for yourself. With tungsten lamps, the lighting is very pointed, precise, punctual. Balcar flashes give a correct light, certainly, even in the most varied positions, but their light is also wavering and very standard, without any personality. With Balcars and Godards it is only after months of experience that you can begin to get personal effects, and especially when you have a very good visual memory, allowing you to progressively correct your errors.

There is only one sun; why photograph with ten lamps? Too many light sources destroy each other and give finally a neutral and impersonal result, where a single lamp would have been enough. Study the result you get when it is in a particular spot. Thereafter proceed by experiment. You must move tirelessly around your subject until you find the most satisfying position.

You should never use several floods except in exceptional cases, such as when you work simultaneously on two or three distinct planes, in a suite of rooms, for instance, when the background must be as bright as the other planes.

In any circumstances, the photographer must always put his own personality in evidence. Unless it is a question of exceptional documentation, no photograph is really interesting unless it is the result of a feeling in relation to an object, a being or an event. It should be at once an interrogation and an observation, and in any case the self must be present.

Family Occasions

For the family gatherings at which you may be invited to photograph, reunions, baptisms, marriages, birthdays, it is no use to just keep snapping one picture after another. The role of the photographer is to translate the atmosphere of a precise moment into images. It is thus essential to impregnate yourself with this ambiance so you can work effectively; otherwise you will merely collect a series of ridiculous and uninteresting shots, artificial and crudely posed. But of course it is often this kind of shot that people like to have taken of themselves.

Only a few people will cordially accept being photographed at random in poses that are not always flattering. Don't rush; wait until the atmosphere is relaxed enough for you to grasp it better. You can show how the behavior of the guests evolves, at first very rigid and correct, and then loosening up as the hours pass. The children behave very well at the start of the meal but are acting up by the time dessert is served. Gaiety progressively seizes on everyone. Serious conversations are transformed into joking ripostes.

Use the most flexible equipment possible. Push the films one or two f-stops so as to be free in your movements. Choose a technique and hold to it so that you need not adjust your lighting and your camera constantly, otherwise you will miss many good shots. A party usually takes place in a fixed place where the light doesn't change much. Avoid the flash, which disturbs and breaks the harmony of the atmosphere, even if you have to waste some film by taking underexposed pictures because of the lack of light. If the room is really too dark, choose a miniature flash you can use head-on with long lenses for portraits (since in that case the shadows created are not too disturbing) or obliquely for group pictures.

Have two lenses: a small telephoto, 80 to 135mm, for close-ups, and a short-focus lens, 24 to 35mm, to capture the overall atmosphere. It is important to be able to integrate the people into the place where the party takes place. That way you capture the memory of the people as well as the atmosphere and appearance of the place.

Be careful, if it is a wedding, cocktail party or family reunion. After a while the guests have a tendency to let themselves go, giving rise to images that are embarrassing when sober and that may be found offensive.

I will always remember the family scene I caused in the course of a Christmas dinner by photographing one of my uncles, the respectable director of a large organization, clowning at the table with two white lilies on his head. At the time, since I was just starting out as a journalist, he threatened to have the pictures seized if I attempted to publish them. I was in fact on assignment to do a photo story for a women's magazine on "Celebrating Christmas in France," not a malicious subject on the face of it!

Photographing Weddings

People who ask you to take simple and natural wedding pictures, as if it were a reporting assignment, offer you a dangerous trap. In effect, for most people who consider themselves "in the know," marriage still remains one of the most solemn moments of their existence, and it takes place according to a ritual that

1

2

has not changed for generations. Everybody has to look good and behave well for the occasion. The bride is, of course, ravishing. If she is distorted by wide-angle or immortalized in the middle of an unfortunate grimace, friends and relatives will be shocked and injured in their pride: and they will hold you responsible. Marriage is an idealized moment and it is not for the photographer to perceive it otherwise if he wants to please the people who have invited him.

First of all, establish the most solemn moments in advance, according to the norms of the sacrament. During the official ceremony, you must have the essential moments fixed in your memory, and be ready to record them: the mayor's statement and the exit from the town hall, the priest's blessing, the exchange of rings, the kiss, the exit from the church, the bride going off in the car.

To satisfy friends and relatives you must often take rather stupid pictures of a perfectly honorable event. So don't forget to photograph, from the top of the stairs, the bride and groom all primped up and full of emotion, with the whole family around them. To take such pictures a flash is an essential auxiliary. Used at point-blank range it smoothes over all the imperfections of faces, erases wrinkles and gives a hope of beauty to those who have none.

These obligations fulfilled, you can give free rein to your own creative needs during the luncheon and in the course of the reception, in a relaxed atmosphere.

If you decide to do some realistic reportage anyway, and if you have no fear of familial recriminations afterward, aim the flash at the ceiling. The pictures will be less flattering, but much more realistic.*

When you want to say something important, you think before you open your mouth. The same goes for photography. At first you can keep your distance to

(1) France. In a small Norman church.
Leicaflex, Elmarit 90mm, f/11, 1/60 sec., Tri-X. Electronic flash with two lamps placed on either side of the altar.

(2) France. Telegram of felicitations from an old friend.
Contarex, Planar 50mm, f/5.6, 1/250 sec., Tri-X.

(3) Turkey. 1970. Kurdish wedding.
Contarex, Distagon 28mm, f/2.8, 1/30 sec., Tri-X in interior, available light.

*In this case, to calculate the guide number, you must take into account not just the distance between where the ceiling is lit and the subject, but also the coefficient of light absorption for the color and material of the ceiling. If, for example, the color is red, it will give a reddish tinge to the whole image.

136

3

better observe what is going on, discreetly hidden by a pillar during the ceremony. Be the first one out of the church so you can precede the wedding procession. During the first part of the luncheon, stand behind the buffet in order to get an overview of the situation.

Then, when you consider the atmosphere sufficiently relaxed, plunge in, go from group to group, be everywhere at once. Say hello to everybody, camera in hand. Everyone must see you, know you are there and get used to your equipment and your methods. At first, pretend to be photographing the people around you so that they will be fully aware of your purpose and will end up getting used to your activity. Their initial agitation or surprise will soon change to indifference. If you take out your camera timidly at the end of lunch, everyone will maintain a respectful silence while you adjust your focus, and will wait for the little click, posing stiffly in what they take to be a flattering manner. You must—and this is imperative—make sure everyone continues to act naturally, even when you are photographing them point-blank.

Baptism

To take successful baptism pictures, you must be familiar in advance with the important moments of the ceremony. It lasts only a short time, and the current rite calls for baptisms to be performed in groups, the priest blessing several children with the same prayer. Photograph the godmother proudly taking the newborn infant into her arms; the priest sprinkling water on the forehead and putting salt on the infant's tongue; capture the infant crying, and the mother, confused and troubled, rushing over and trying to calm him down, while the anxious father looks on. And don't forget, when the ceremony is over, to take some close-ups of the baby on the church steps to please the parents, even if his eyes are still red with tears.

It is prudent in any case to establish a relationship of warm sympathy with the priest. Be discreet; not hesitating to ask him if you are disturbing him is the

best way to be accepted. He will be flattered and grateful. The church is his world and he can ask you to leave if he thinks you are disturbing the harmony which is meant to reign between the faithful and himself.

Out of consideration for the other people present, don't make noise, and assume the serious air appropriate to the holiness of the place. Most people participating in a religious ceremony have a serious and emotional expression and will reproach anyone who does not share their feeling by displaying an irreverent attitude.

Candid Photography

It is relatively easy to film friends and relatives at a family gathering or a religious ceremony, but it is not the same when you want to record these same people in their daily life.

Photographing your family, friends or even strangers in a given place, in a familiar setting, or a house, leads you to search for and then capture their personality without their direct participation. It could be your father at his work, children quarreling, or friends playing lotto or bridge.

The wisest course is to observe in advance everyone's attitudes and behavior, and not to make yourself noticeable when you arrive with your camera. Don't run away if the subject catches you focusing on him. Instead, have a warm smile after you finish shooting, to reassure the model and show that you have not tried to take him by surprise—unless, of course, you are trying to do just that. If that is the case, be ready with a hearty burst of laughter to excuse yourself and avoid any misunderstanding.

(1) Paris. July 14th ball. Contarex, Sonnar 135mm, f/5.6, 1/250 sec., Tri-X.

(2) Paris. Christmas Night at mens' shelter (les Petits Frères des pauvres) in the 13th arrondissement. Rolleiflex, Planar 80mm, f/2.8, 1/30 sec., Royal X Pan, available light.

(3) Paris. July 14th ball at Vert-Galant, on Ile Saint-Louis. Contarex, Sonnar 85mm, f/2, 1/15 sec., Tri-X, available light.

1

2

The Third World

U NLESS you are rather cynical, photographing in a third world country necessarily poses a certain number of problems, moral as well as technical. It is a delicate matter to intrude with our prejudices and fixed ideas, and above all with our monstrous cameras, among people who are both very different and much poorer than we are.

Photographing people in developing nations can certainly be approached in different ways: the two most common are either to try first to have a dialogue with the people you want to film or else to surprise them at random and photograph them point-blank.

Whether from ignorance or presumption, most travelers do not encumber themselves with moral principles, and are content to make use of the places they visit any way they like. But has one really that right? Professionally, this approach is no doubt defensible in a period of extreme crisis—during a famine, a war or a serious epidemic, when it is important to explain and show the suffering to more prosperous countries. The photographer who witnesses such a disaster may feel it his duty to publish images which are only the reflection of a painful reality.

Sensationalism

It must also be remembered that exceptional photojournalism is rewarded with money and prizes. That encourages people not so much to show the horrors of the human condition but to bring back the scoop that will bring them fortune and glory.

Michel Laurent, for instance, won the Pulitzer Prize for a particularly horrifying picture he took during the India-Pakistan war. This shot, published throughout the world, played a decisive role in connection with torture which was then widely practiced. In fact, when Indira Gandhi, then Prime Minister of India, saw the photo displayed in a foreign magazine, she immediately ordered severe punishment for such abuses within the army.

If photographing the violence and misery of others already poses problems to a professional, how can an amateur, whose photography is for himself alone, devote himself to this kind of thing?

Photography: Violation or Communication?

Photography ought not to be a systematic violation, but on the contrary a means of communication, a possibility of knowledge, a form of union between the photographer and the person photographed; and not a hermetically sealed barrier, as is too often the case.

Behind the viewfinder, not only do you feel protected, but you see other people through a magnifying glass, like strange specimens that you study as you would bacilli under a microscope. You think in terms of composition, light, framing, colors; but rarely about the people themselves.

Except in exceptional cases, you should abstain from photographing "the others" before you have greeted them and received their consent.

Moreover, portraits stolen at random often have the same sad, trapped qual-

During the Kumba Mela pilgrimage, which takes place every twelve years. This ascetic has taken a vow to remain standing for twelve years without ever lying down or even sitting.
Leicaflex, Elmarit 90mm, f/4, ¹⁄₆₀ sec., Kodachrome II.

141

1

2

(1) Pakistan. 1966. Road-workers on their way to repair a railroad track in the desert.
Contarex, Sonnar 85mm, f/4, 1/500 sec.

(2) Mexico. In a covered market in Acapulco.
Leicaflex, Elmarit 24mm, f/2.8, 1/30 sec., Tri-X.

(3) At the Indian-Nepalese border. 1961.
Rolleiflex, Planar 80mm, f/5.6, 1/60 sec., Tri-X.

(4) Ethiopia. 1974. Camp of famine victims during a drought.
Leicaflex, Elmarit 90mm, f/8, 1/250 sec., Tri-X.

(5) Niger. 1974. Market near Zinder.
Minolta XM, Rokkor 100 mm, f/4, 1/250 sec.

(6) India. 1968. In a village of Bihar.
Mamiya C 33, 105mm, f/5.6, 1/125 sec., Tri-X.

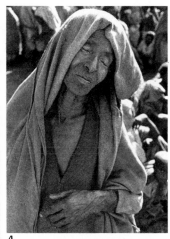

4

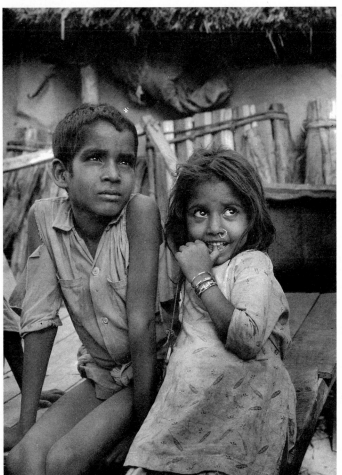

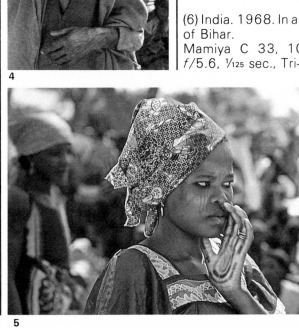

3 5

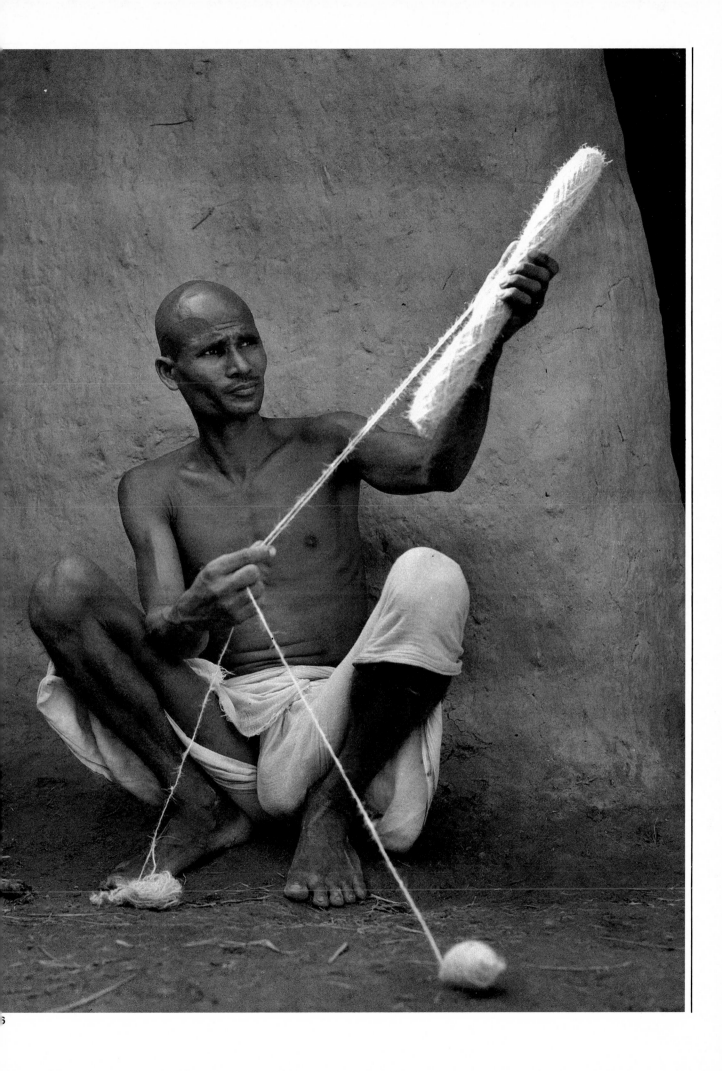

1 | 2

ity, devoid of interest because of their monotony. Even if you think it difficult to communicate with natives possessing a different language and culture from ours, don't forget the smile, that universal instrument of communication, which is marvelously efficient and goes well beyond words.

A friendly hand gesture is sometimes enough to dissipate misunderstanding. As far as possible, of course, ask the person you wish to photograph what he does. This can be done rapidly. It is easy to see if you have established contact. It then becomes easier to ask him for permission to photograph. If the response is favorable, behave so that your rapport will be relaxed when the camera starts to run. In this way you will be able to obtain a portrait of greater intensity, one in which the glance will be all the more penetrating because you have created a desire for communication.

Of course, never ask the person you wish to film to stand facing the sun, stiff as a board, waiting for the little click. On the contrary, urge him to go tranquilly about his work, and wait patiently for his expression to become fully natural. At all costs avoid taking a forceful attitude. Just because he is naked or more impoverished than you does not mean he is entitled to less respect.

Whoever approaches photography in this communicative spirit will obtain in the most natural of ways some very convincing results. Instead of frozen expressions, paralyzed by mistrust, fear or hostility, you will discover in your prints glances of sympathy, of friendship even, which will sum up in a way beyond words the instants and the emotion of true encounters.

Isn't that the most beautiful souvenir you could bring back from a journey?

(1) Black Africa. 1974. The sultan of Zinder in his palace.
Minolta XM, Rokkor 24 mm, f/2.8, 1/20 sec., Kodachrome X.

(2) India. 1968. Maharajas and rich families with their old clothes and cars for the sake of the photograph.
Contarex, Sonnar 135mm, f/5.6, 1/125 sec., Kodachrome.

(3) India. Bombay. 1967. Contarex, Sonnar 85mm, f/2.8, 1/30 sec., Kodachrome.

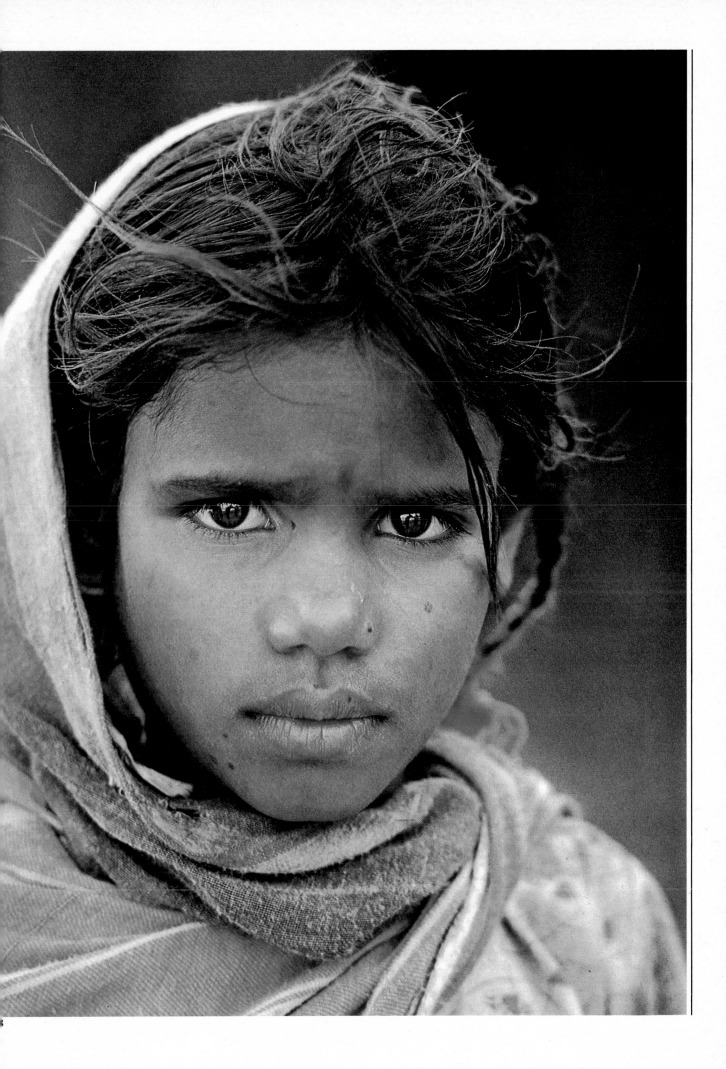

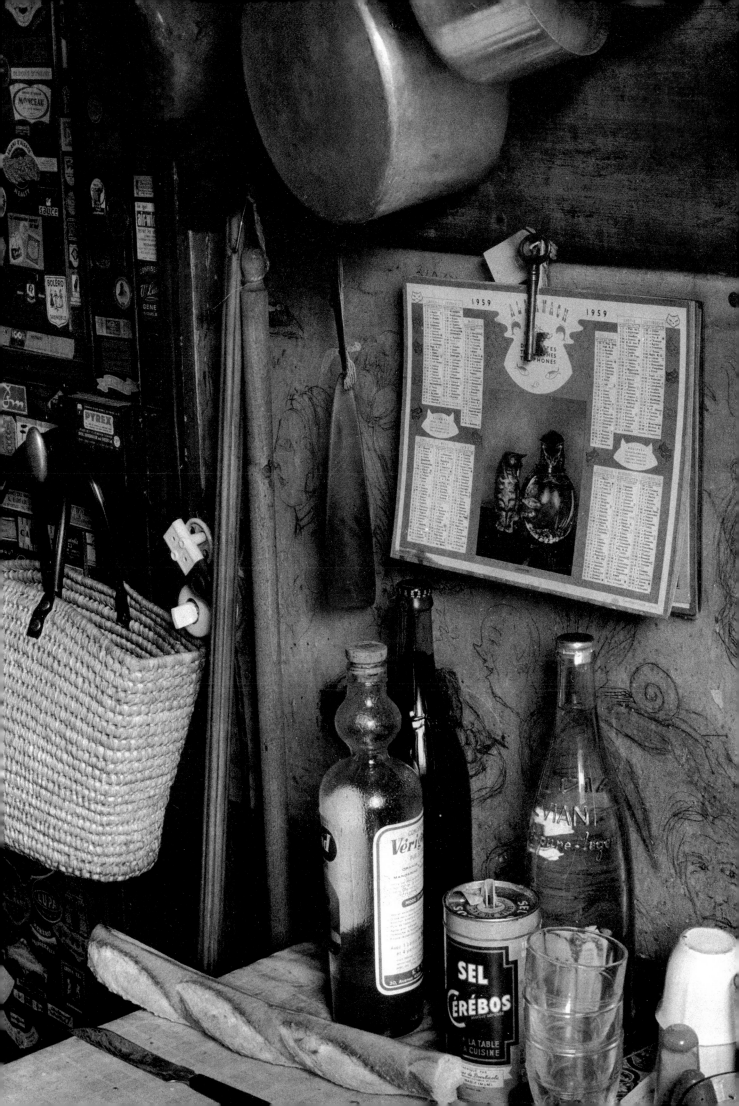

An Amateur's Responsibilities

PEOPLE have lost the habit of looking at what's around them. The moment they arrive somewhere, they reach for their camera and start shooting right and left. But it doesn't last long; soon they stop photographing, because the world around them no longer interests them. Nevertheless, a stranger, with his fresh vision, will discover unusual aspects of our daily life, things different from other places, moments that we all live without noticing them anymore.

It is this rather bitter fact of life that gives such interest to the method of the new photographers of New York who, with their hyperrealism, seize on the image of anything, or so it appears, anything that presents itself, without distinction or choice. This is above all a conceptual method, seeking to demonstrate that anything is interesting. The way the housekeeper dresses corresponds in effect to a precise phenomenon. The pots of geraniums decorating the suburban patio have their reason for existence. Who knows if, in several centuries, one or the other of these seemingly insignificant documents will be consulted as precious archives by sociologists and historians? Thanks to Atget, who labored for years to photograph the small neighborhoods of Paris simply and without artifice, we can today rediscover a whole aspect of turn-of-the-century life.

This new form of photography, called "snapshot" in America, which consists of photographing everything you see, should not be neglected, if only because of the social elements it contains. It has perhaps less social value, since it permits no interpretation to the photographer, but it has the advantage of teaching us to see and helping us to discover what surrounds us every day without our noticing it. These images are both easy to read and interesting as testimony of a period.

These very simple photographs make us reflect as deeply on some old stones, a sordid street, or a bunch of advertising posters, as on a group of anonymous people in everyday poses.

To photograph what seems banal forces us to think about what goes on around us. Mostly we do not see the people we live among. Only spectacular accidents attract crowds, for they appeal to primary instincts, but no one cares about a person who faints or is in danger on the street. Everyone passes by, indifferent. People look on with a sad and nostalgic eye as the old neighborhoods of Paris are destroyed, saying simply, "It's too bad!" and when the new high rises go up they say only, "How inhuman!"

If one were to photograph these old houses before they fall, and then the towers that go up to replace them, perhaps people's consciences would wake up to what is occurring around them. This kind of realistic photography is not an interpretation, but simply testimony; hence its value and its importance.

The amateur photographer can, in this domain, play an important role. To record this new vision of the world, he does not need to know special techniques or possess special equipment. With a simple Instamatic he can present a simple, objective image of his environment, on which he has more to say than might be suspected. How many photographers, when asked if it is necessary to take courses for becoming a photographer, reply that all you need is to read the instructions on a roll of film and buy any camera, even the cheapest, to make significant pictures.

Paris. 1959. Rue Gay-Lussac.
Pentacon, Biotar 58mm, f/8, on tripod, available light, Plus-X.

1 2

To a large extent they are right. The most advanced technique cannot replace the essential, which will always remain talent and openness of spirit.

Knowing How to Limit Your Universe
The professional photographer who has acquired solid experience in his trade and who for years has had the chance to question himself, to use different kinds of equipment, to try them out and choose them in terms of his needs and feelings, ends up after all this by zeroing in on his own personal problems and photographic obsessions.

Usually this leads him to simplify his equipment, because he becomes aware that ultimately he can really express himself only through a very few items of equipment. Only a few cameras and lenses really suit his personality and what he wants to do. From that point on he limits his territory. He no longer seeks at all costs the latest technique. He becomes aware that the approach to the image should be as pure and unembellished as possible.

Photography is at the outset such a vast domain that whoever gets interested in it tends to be extremely ambitious. He wants to take giant steps, to advance like a pioneer through the wide open spaces. He wants to master and control a huge variety of techniques.

Hence he is obliged to pay attention to technicalities and refinements, marvellous lenses, impressive zooms, enormous telephotos. He wants to devote himself to pure creation and at the same time discover macrophotography, animal photography, large-scale photojournalism. The diversity of cameras is so rich that he dreams of possessing them all so he can analyze them.

This need for absolute knowledge is a very human thing. But—fortunately—it is proper for a man, after he reaches a certain level of knowledge, to limit his universe, the better to cultivate his own garden.

Photographing small ordinary instants of daily life, without any spectacular effects, is something that forces the photographer to look around and to think about what he is doing and what is taking place. Even if it is aesthetically debatable, the new American photography, which intentionally shows people badly framed, their arms or heads cut off, distorted houses, landscapes where no rule is respected, is nevertheless very important, for it shows all kinds of elements mixed together, with no artistic preoccupations, just as they really are, without any telescopic or artistic soft-focus to emphasize the main subject.

Every amateur has this at his disposal, as long as he knows how to see, to speak and to show what lives around him, at the same time that he learns all the contingent technicalities.

(1) Paris. In a cafe on Boulevard Raspail. Contarex, Distagon 28mm, f/4, 1/60 sec., available light, Tri-X.

(2) Paris. Playground of a primary school. Contarex, Distagon 35mm, f/5.6, 1/250 sec., Tri-X.

148

Choosing Your Equipment

I T shouldn't be thought that the quality of a photograph depends mainly on the complexity of the equipment used. Remarkable shots can be taken with very simple cameras. In fact, the quality of the lens is more important than any other factor.

There are many, who consider themselves in some sense artists and who are interested in photography, who categorically refuse to get involved with technique. This approach is, up to a certain point, not altogether incompatible with a desire to take interesting pictures. But someone really devoted to photography is nevertheless well-advised to acquire a good 24×36 reflex camera with interchangeable lens (usually called a 35mm SLR in the U.S.). On the other hand, someone who merely wants to bring back pictures of his trips or his vacations, without loading himself down with heavy equipment, can content himself with a simplified non-reflex, smaller and cheaper than a reflex.

Finally, for someone who looks on photos simply as souvenirs, for whom composition and the artistic side have no appeal, and who is not keen on technique, an Instamatic or other similar cameras should be perfectly sufficient.

The First Camera

If he wants to make rapid progress, the beginner should begin by photographing with only a small amount of equipment. A good 24×36 with a single lens already lets you explore a vast domain. Especially when you are an amateur (that is, by definition, someone who loves what he does), it is important to deepen your understanding of what you undertake. And to do that, you have to limit yourself at the outset, however frustrating it may seem, and climb up the ladder bit by bit.

Too many accessories lead the beginner to spread himself thin before he has acquired a solid grounding in the field. You get lost in technique. To start off with a number of lenses can only create confusion. For the outsider, it is harmful to begin by using certain lenses without having first assimilated their technical requirements and their interest. You must first know the possibilities and limits of the standard lens in depth.

To know at the outset what you want to do is not something that can be taken for granted, especially for the novice with no previous interest in photography who suddenly decides at a certain moment in his life—whatever his age, experience or education—to take pictures.

Someone who wants to devote himself to photography, like any person who wants to give himself over to any art, must go beyond the boundaries of his new universe and become interested in other, parallel artistic areas. He should constantly educate his eyes and his sensitivity, not only through photography, but by every possible means, by looking around him, taking walks, looking through illustrated books, going to the movies, visiting exhibits of paintings.

Trying to understand and analyze what others have already done is always enriching. Especially in the beginning, it is often easier to interpret an existing work of art than to apprehend nature in a purely abstract fashion. To wish to acquire a sense of composition, of spontaneity, of technique and light, entirely

by yourself, without referring to what has already been done, is both pretentious and limited.

Photography covers a vast area and no individual can pretend to deal with the whole of it. Portraiture, journalism, landscape, architecture, still life, creative photography or snapshots of daily life: each requires not only a method that differs, but also frequently entirely different equipment. It is useless to burden yourself with accessories and lenses that may prove useless.

Different Kinds of Cameras

Cameras can be roughly divided into four categories: (1) Instamatics and similar cameras; (2) 24×36 non-reflex cameras; (3) 24×36 reflex cameras with interchangeable lenses; and (4) large-format cameras.

Instamatics and similar cameras. With a permanent lens and rudimentary focusing, these are the cheapest cameras. They are lightweight and small. No settings are required. They load easily. There is no film to rewind. The film cassettes fit easily into the camera body, and their use is simplified to the utmost; all you have to do is compose the shot and click. "Kodak does the rest," as the ads say, at least in theory. You can get good results when the lighting condition is favorable, but it is impossible to shoot in shadow or when the light is too weak.

Disadvantages: the possibilities are limited and the results are often mediocre, the moment you have to work under more complex conditions.

These cameras can in turn be subdivided into two categories: formats 110 and 126. The 126 models, which were first marketed about ten years ago and whose square format is 28×28, are being gradually replaced by the 110 models, which have the advantage of a 11×17 rectangular format. Today two out of three small-format cameras are 110 models.

These cameras are small and can easily be put in your pocket. Their success is no doubt connected to the fact that they are more elaborate and compact than the 126 models, despite their smaller size.

Minolta even makes a reflex camera of this type, equipped with an electric zoom. While its price is approximately the same as any 24×36, the results are greatly inferior.

Since nine out of ten amateurs basically make color negatives printed mechanically on paper, it is difficult to recognize any major difference between the 110 and 126 formats: with both of them it is hard to make an enlargement larger than 9×12 centimeters.

But most amateurs are happy with that dimension. Nevertheless, the color slides made with these cameras are so small that it is difficult to project them without special and expensive equipment. Mounted on 5×5 slide frames and projected with a normal 24×36 slide projector equipped with a standard lens, the 110 or 126 color slides appear tiny on the screen.

When one speaks of photographic productivity, the images made with these simplified cameras should be mentioned above all, since they represent 80–90 percent of the world photography market.

Non-reflex 24×36 with permanent lens. Most of them are today equipped with electric eyes and sometimes even automatic setting of speed or aperture. These cameras are simple, small, and thus not cumbersome. They give accurate results. They are particularly suited for people who are not really interested in creative or artistic photography, but who want to take pictures as notes to assist them in their work. Their optical quality is often the equal of a reflex, but their possibilities are very limited. Since you cannot change the lens, you have to use a fixed focal length which varies, according to brand, between 40, 45 and 50mm. The focusing is often done by rangefinder.

You can buy a good 24×36 non-reflex whose optical and mechanical quality is largely equivalent to any average reflex camera for considerably less money than a reflex camera.

The M series of Leicas, while also non-reflex, belong in a special category. The manufacture of the M5 model, with an electric eye behind the lens, has been suspended in favor of an improved version of the old M4 model, still without electric eye. Even though old in design, it is still used by certain kinds of

1

(1) Benin. 1966. In a small village in the north. Mamiya C 33, 180mm, f/5.6, 1/250sec., Tri-X.

(2) France. Child of immigrant workers in a slum. Exacta, 50mm, f/5.6, 1/125 sec., Plus-X.

professionals, especially for journalism. Of all 24×36 cameras, it is far and away the most durable, silent and precise. Its use is delicate and calls for a very good knowledge of photography. The aperture must be preset manually.

The CL is a simplified Leica. Light and compact, it is especially suited for travelling if you consider it as a kind of notebook for jotting down images. Its rangefinding viewfinder is geared for only two lenses, 90mm and 40mm, and that is doubtless its major shortcoming. While the 90mm telephoto lens is great for portraits, close-ups and landscape, the 40mm on the other hand doesn't cover a wide enough angle to encompass all the needs of journalistic snapshots.

Large-format cameras. Once the most widely used, their number grows smaller every year, even among professionals. The currently most common formats are: 4.5×6cm., 6×6 cm., 6×7 cm., 4×5 (inches), 5×7 in. and 8×10 in. Not long ago most postcards were made on 9×12 plates and printed by direct contact. We will not discuss here the plate cameras and perspective chambers whose use is reserved for certain types of professionals: fashion, architecture, landscape, advertising. Difficult to use, they call for real technical skill.

24×36 reflex. With interchangeable lenses, they are by far the most popular cameras, and the most reliable and practical for most purposes. Most 24×36 reflex cameras sold today are what is known as "integrally automatic."

Automation

While cameras with electric eyes behind the lens have been marketed for a number of years now, fully automatic cameras that correct the aperture and shutter-speed setting on the basis of what the electric eye reports have recently made their appearance.

At first it was necessary to regulate the needle of the exposure meter while manipulating either the aperture ring or the shutter speed ring, until they coincided at a marked spot.

Now most Japanese and German manufacturers make cameras with automatic exposures. All you have to do is focus and choose a shutter speed or f-stop in order for the electronic mechanism to control and assure a perfect exposure, in terms of the sensitivity of the film which you have transmitted at the outset to the electric eye.

There are two types of automatics—those with electronic shutters and those with automatic diaphragms. For the first, you choose a given f-stop before starting to photograph, and the shutter speed is chosen automatically in terms of the electric eye. In the second case, you choose the speed at the outset while the f-stop establishes itself automatically.

Is it better to give priority to automatic speed or to automatic f-stop? The opinions are divided. Some claim that the choice of f-stop, because the depth of field depends on it, is more crucial than the speed, and that in the majority of cases it doesn't matter much whether a picture is taken at 1/60, 1/125 or 1/500 sec. If the speed indicated in the viewfinder is too slow, you can always open the diaphragm until the speed returns to a position which will prevent camera shake (if there is enough light for that).

For cameras with automatic diaphragm, it is the diaphragm that sets itself directly on the basis of the light as indicated by the electric eye, according to the sensitivity of the film and the pre-selected shutter speed. While most automatic cameras give priority to automatic speed selection, it still seems to me more important to be sure of your speed of exposure, which should never change unbeknownst to the photographer while he is at work on a given subject, than to be sure of the exact diaphragm opening. A person walking should be photographed at 1/250 sec., at least, or else he will be out of focus. The f-stop is of minor importance in this case, except for the question of depth of field. The implication is that you have to focus very carefully.

Cameras with automatic diaphragms have a reputation for being more fragile than those with electronic shutter speed, since for most of the foregoing the transmission of the opening and shutting of the diaphragm is done by a mechanical lever rather than through electronic contact. The lens being always in a full-aperture position, the diaphragm is meant to close instantly on the f-stop

determined by the electric eye at the instant of shooting.

For both types, those that give priority to the diaphragm and those that choose speed first, the rapidity of the electric eye's action is the essential element. Today, the electric eyes fueled by silicon cells are particularly fast, and they have the advantage of having no memory; that is, they react instantaneously to the light registered by the camera. You can take pictures in shade, then in sunlight, in the space of 1/4 sec. and get an exact result each time, whereas formerly the galvanometers retained a memory of the previous readings for a short time. But, in fact, is this really so important? Such arguments are mainly indulged in by camera merchandisers.

1

Ground Glass Viewfinders

In most reflex cameras the glass for viewfinding and focusing is interchangeable. Some are divided up into grids. Others are specially designed for architectural or microscopic photography. Still others facilitate focusing with large telephoto lenses.

The viewfinder glass with simple ground glass permits an excellent focus in the center of the image, but there is a definite darkening around the edges. With certain cameras equipped with a "spot" light meter (that is, focused on a precise zone in the center of the image), this ground glass is surrounded by a dark circle whose circumference indicates the limits of the light meter's field.

Modern ground glass is often doubled with a Fresnel lens designed to clarify the shadows. Others are equipped with split-image (or crossed-image) rangefinders. These facilitate the focusing, especially when there are verticals and horizontals (trees, houses, etc.). The microprism which is added to certain ground glasses allows precise focusing.

I equip most of my cameras with simple ground glass, for they make it possible to concentrate more easily on the composition of the image, since the eye is not constantly distracted by lines and circles intersecting within the image.

Every reflex, however perfect, loses many of its advantages if you don't change the lens, because you keep the reflex system anyway. That is, what you see in the viewfinder passes through the lens and is equivalent to what will really register on the film (aside from depth of field, since you work at full aperture).

For the real devotees of photography, the choice will be different according to whether they are more interested in close-ups, in snapshots, in landscapes or in architecture. While it is true that you can photograph just about anything with any good camera equipped with three lenses—a wide-angle, a standard focus and a small telephoto—the fact remains that each type has its peculiarities and thus corresponds to a certain use.

The extreme wide-angles and supertelephotos, whose use is much more difficult than people think, ought to be reserved for professionals and really accomplished amateurs. It is better to have only two or three lenses, but of excellent quality, and whose focus corresponds exactly to what you want to do—rather than having an impressive collection of zooms or lenses of different foci, but of mediocre quality.

It is not always the lenses designed for wide aperture (and that are the most expensive) that are necessarily the best; quite the contrary. The lenses with the best definition and the best color quality are rarely those with the widest apertures.

While there is hardly any difference anymore between the sharpness obtained by different manufacturers' lenses, few owners of costly lenses are really capable of fully profiting from the possibilities of their equipment.

(1) India. 1968. Calcutta. Contarex, Sonnar 135mm, f/4, 1/500 sec., Kodachrome.

(2) Brazil, 1973. Carnival in Bahia. Minolta XM, Rokkor 28mm, f/5.6, 1/250 sec., Kodachrome.

(3) France. On the Brittany coast. Contarex, Sonnar 250mm, f/5.6, 1/250 sec., Kodachrome.

What Lens to Choose?

Wide-angle. It is a must for all snapshots, when you want to be really in the heart of the action or when you want to show the subject of the action in his immediate context.

A man walking in the street, filmed with telephoto, will be completely removed from his environment. He will be haloed with an area of blur that puts him in a somewhat unreal, floating scene. The same person photographed with

wide-angle (and from closer by, of course) so that he occupies the same percentage of the image, will be shown precisely in his context. You will see not just a bit of pavement but, in the background, the details of the street behind him.

The major disadvantage of wide-angle is that it forces the photographer to shoot very close to the principal subject. Hence there is a risk of distortion if he wants to make him emerge more forcefully, to avoid having him lost amid a crowd of details which bring only a certain confusion to the composition.

Wide-angle is also very useful for landscape photos in which you want to emphasize an element in the foreground. You frame very tightly on that element while being careful that it only occupies a minimal part of the totality of the composition, which will not prevent it from playing a preponderant role in the image, yet without obliterating the rest of the surroundings. In effect, it can be interesting to emphasize a branch of dead wood or a tuft of rushes within hand's reach. The image will lose its flatness and will gain in depth and perspective.

Wide-angle, allowing you to make use of the objects in the foreground while composing your image so that the whole setting registers in the shot, gives you the option to get an impression of space. Depending on the illusion of depth you want to create and the interest of the subject, you can focus either on the foreground or on the horizon. The fact that one or the other plane will be slightly out of focus will provide an additional dimension.

2

3

Without a foreground, a street scene, photographed from a distance with wide-angle, will appear, along with the people animating it, ridiculously small. There is neither distance nor perspective and the document loses all its strength. The more elements there are, the more difficult it is to differentiate them from each other if they are located on the same plane.

Contrary to what you might think, even though the depth of field of this focus is very extended and allows you to have sharp focus both close and at a distance at the same time (if you make full use of the f-stop), the use of wide-angle is very delicate. The horizontal and vertical lines have a tendency to recede or to bend somewhat if the camera is not held vertically in rigorous fashion in terms of the subject photographed.

You must also remember that the foreground is not only important but disproportionate as well, in relation to the rest of the image. To shoot a portrait in 24mm from very close up is to distort it intentionally. The nose becomes enormous and the chin and forehead ridiculously small and receding. The exaggeration will be all the more accentuated as you come closer to the subject and shorten the focal length.

Telephoto. Like a telescope, it permits you to come close to the subject. It is the ideal lens for portraits, animals, certain snapshots and for landscapes—especially of mountains—in which you want a blending of the different planes. In general, it is needed for all scenes you are unable to approach more closely. It is also useful whenever you want to isolate the main subject from its context, since the depth of field is very limited and hence whatever is behind or in front of what you focus on remains out of focus.

Photographing with a long lens requires rigorous focusing. The longer the lens, the nearer the subject will seem, the more limited the depth of field and the greater the risk of camera shake. This explains why most pictures taken with telephoto without a tripod are out of focus. Unless you are highly skilled, it is difficult to work with a 100mm below 1/125 sec.

Many amateurs want to get a 300, 400, even 500mm mirror lens when they don't even own a standard lens, simply because they think that with such a lens they can photograph things they can't normally see, for example, a person 20 or 30 meters away in close-up. Often their conception of photography is closer to rape than to journalism, since they want to seize the expression of someone who does not want to be filmed.

Portraits cannot be done with a 300mm. A 135mm is the maximum. The result is that despite the expensive equipment they have bought, these happy amateurs return from their excursion with a picture so out of focus that at best it could have been taken with an Instamatic.

Except for athletic photography, fewer and fewer professionals use large

telephoto lenses, since they are heavy, cumbersome and very expensive.

The Novoflex opticals, commonly called photographic rifles, are the telephoto lenses usually used by people who photograph animals. They are equipped with a crosspiece that permits an extremely rapid focus, simply by finger pressure.

Standard lens. A component of most cameras, the standard lens varies between 45 and 50mm, according to brand. Disdained by professionals, it is nevertheless considered the universal lens beyond dispute. It is the one that comes closest to human vision and which reproduces different planes with normal volumes. Hence there is no distortion for either near or far distances. In most cases it is the easiest lens to use: group, landscape, medium shot, snapshots taken at middle distance. . . . Because it is relatively neutral, it makes it easier for the beginner to discover his first aspirations.

Often one has a desire to photograph and to buy a camera without knowing exactly what you want to do. It is only after experimenting that you discover a vocation for one area or another.

Why have the makers dubbed the 50mm a standard lens? Doubtless because, since no lens really corresponds to human vision, it is the 50mm which ultimately gives the proportions most faithful to what we imagine. With this lens you get perspectives similar to those the brain formulates.

In fact, 58mm would be closer to reality, in terms of the perception of the human eye. The Russians and many Japanese have chosen it as a standard lens for equipping many of their cameras.

It is essential to serve your apprenticeship in photography using only this standard lens (50, 55 or 58mm) at the outset. The limits of the field of this lens will make you understand all the better, in a practical way, the uses of a telephoto or wide-angle.

Zooms. Most manufacturers today offer a wide range of impressive zooms. With one or two exceptions, they are not yet entirely reliable. They are both too big, too heavy and too complicated to operate, or else they are not luminous enough, or not powerful enough, or too bulky. Those with a macro setting allow you to photograph from very close up, but only in wide-angle position, when it is just the opposite that is called for.

The ideal would be to create a zoom whose focus would vary from 24 to 90mm, which would open at $f/2$, and with which you could make your setting from 70 centimeters to infinity, regardless of the chosen focus, with a simple hand movement on a spiral gradient. It would also have to be neither bigger nor heavier than a standard 90mm, and its definition and rendering of color would have to be impeccable. Some day, no doubt, it will exist. Such a photographic auxiliary would enable one to cover nine-tenths of photographic needs. The first company that puts one like that on the market will probably make a fortune, for it will certainly become the basic lens for all professional and amateur equipment.

Film

There are no truly universal films, either in color or black-and-white. Depending on what you want to photograph, and especially on the basis of your taste and style, you make a choice between the different brands of film, and then between the different emulsions within a particular brand. I will not recommend one brand rather than another. They all have their advantages and their disadvantages, and also a dominant peculiar to each of them. Some prefer the warm tone of Agfachrome, others the cool colors of Ektachrome.

Let each make his choice after comparing them. You should know that each type of film suits a particular kind of use and gives different results, depending upon whether it is used in direct sunlight, in shadow, indoors, or at night.

As a general rule, the slower the film (that is, the more reduced its sensitivity), the more saturated the rendering of colors or of the scale of grays, if it is a black-and-white film. Having relatively little grain, these slow films (ASA 25–50) give a maximum of nuances in the details, but they also require much more light to register an impression, or else very long exposure times, which eliminate any chance of taking a snapshot except in direct sunlight.

On the other hand, fast films (above ASA 64), which render color less faithfully and have a thicker grain, allow you to photograph subjects in movement, even in defective lighting conditions.

If you don't have a light meter, consult the explanation furnished with each packet of film. These instructions are well written; don't forget to take them with you and don't hesitate to reread them whenever you change setting or lighting. If you have a light meter, you must regulate it in terms of the sensitivity of your film, which is indicated by ASA and DIN.

Color films. For color, Kodachrome 64 can be considered the film easiest to use in most cases. It gives results of practically the same quality for all outdoor shots, whether in shade or direct sunlight, and for landscapes as well as for portraits and snapshots. However, if it is underexposed, especially with a flash, it has a tendency to take on a greenish tinge.

For that matter, all films have a dominant hue that emerges in case of underexposure. Ektachrome tends toward blue, Agfa toward red. Having said that, the conservation of Kodachrome 64, its color saturation and definition are nonetheless inferior to Kodachrome 25, which remains the privileged film for pictures that require a perfect sharpness, vivid contours and as faithful as possible a reproduction of reality.

Kodachrome 25 and 64 have one advantage over other color films such as Ektachrome, Agfachrome, Fujichrome and 3M: they keep better after they have been exposed. They are more resistant to heat and humidity. Above all, they benefit from a finer and more transparent definition, which makes them the ideal film for color slides. Unfortunately, even though Kodachrome has a wide tolerance, it is impossible to modify its development in case of under- or over-exposure, while most other color films can be worked on easily during their development, and pushed one or even several f-stops without notably altering their tones.

Ektachrome has the advantage of developing easily and in record time, which explains why it is so prized by professionals, despite its somewhat grainy definition, compared to Kodachrome.

Ektachrome E6 ASA 400, daylight, which can be pushed to ASA 800 or 1600, allows you to do almost any interior shot with available light.

The following should also be mentioned, in the new Kodak range of color films of the Ektachrome type:
—Ektachrome E6: ASA 50, artificial light
—Ektachrome E6: ASA 64, daylight
—Ektachrome E6: ASA 160, artificial light.

The Kodak Company has also created a duplicating film of ASA 8. It exists in 135 format and in films ranging from 4×5 inches to 30×40 cms.

These five emulsions are developed by the same method. The real sensitivity and the eventual filtration are indicated on films intended for professionals. The heat measurement of professional films is calibrated for screening at 5000°K, while amateur films are made for 3200°K, the temperature required for projectors. The images obtained with these new E6 films are particularly beautiful. The whites are clean, the shadows full of detail and the calorimetric confusion reduced. Ektachrome E6 64 is notable for a definition and a rendering of color much superior to the old Ektachrome X, but it is still too early to speak of its qualities of conservation.

In fact, each film has its own characteristics. Certain brands have warmer tones than others. Agfachrome is known for its browns and for the delicacy of its greens, Ektachrome for its blues and Fujichrome for its greenish dominants. There is no discussing taste and color. Everyone should choose his own film according to these criteria. But it is best to stick to one type of film and to explore all of its possibilities in depth instead of switching all the time from one film to another.

Black-and-white films. For black-and-white, Kodak Tri-X can be considered the "universal film." It gives excellent results in any conditions of shooting, in low light as well as high, thanks to its high sensitivity (ASA 400) and to the fineness of its grain. You can easily double and even triple its speed. Only its

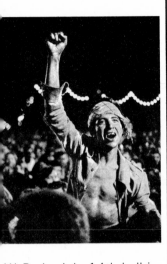

(1) Paris. July 14th ball in the Tuileries Gardens. Contarex, Sonnar 135mm, f/2.8, 1/1000 sec., Tri-X. Available light.

(1) India. 1971. Camel market in the Rajasthan. Contarex, Sonnar 135mm, f/5.6, 1/250 sec., Kodachrome II.

(2) Paris. School exit. Rolleiflex, Planar 80mm, f/5.6, 1/125 sec., Tri-X.

development will differ, depending on the contrasts of the subjects and the sensitivity at which it has been exposed. The quality of its development is essential if you want to get good results.

This film is used nowadays by most professionals, in 24×36 as well as 6×6, and for interiors as well as exteriors. However, it is not advisable for macro and microphotography or for the photography of sculpture, where it is important to see the smallest details with extreme precision, because of its somewhat rough granulation.

For summertime use (seaside or mountain vacations) Ilford FP 4 (ASA 125) gives excellent results and should be sufficient for the knowledgeable amateur.

We should also mention Recording Kodak, which is considered the fastest film in the world and which can be pushed as far as ASA 6000. Its gelatin is extremely fragile; it keeps badly and cracks easily.

For a beginner, ultra-rapid films, in color or black-and-white, should be definitely avoided, since their use calls for much experience. They are to be used only in extreme cases, when there is no alternative, since the slightest deviation in exposure or developing the contrast of the negative is augmented. The resulting images will be very hollow and completely lacking in perspective.

Very fast films and very slow films have one common denominator: both become very contrasty when they are not properly exposed and developed. The easiest films to work with are usually those situated between ASA 200 and 400 (Ilford HP5, Kodak Tri-X, etc.).

However, it must be acknowledged that emulsions beyond ASA 1000, when they are skillfully used, sometimes give, thanks to their outsized grain, a certain very striking relief, notably for portraits. In effect, the grain is a kind of grid which you must take into account.

Paradoxically, it is easier to make large-scale prints of high quality with Tri-X than with films of lower sensitivity, but in that case you must take advantage of the specificity of this grid by making sure the grain is uniformly sharp. Hence the need for a very high-precision enlarger. The grain, if it is sharp in the print, makes up in a sense for the lack of sharpness of the film itself. With an ultra-slow film, if the definition is not good, the picture is truly out of focus and the lack of grain accentuates this impression, while the same image taken with fast film may, by its texture, in spite of the lack of definition, be interesting to look at.

Each year, many travelers have their films spoiled by passing through the X-ray machines at airports. Recently, the Film Shield company has developed plastic bags equipped with a leaden film specially designed to protect photographs, and effective against X-rays.

Some Practical Tips

People who use their cameras only occasionally, and put them in the closet the rest of the time, should ask themselves when they start on their vacation when was the last time they used them. If it was on their last vacation, a checkup is urgent. A camera, especially a very high-precision and transistorized one, runs down much more by being unused for a long time than by being used regularly.

It is essential to use it periodically if you want to keep the shutter from jamming or the lubricating oils from drying up.

Shake your camera from time to time so you can hear if there are any loose screws inside the body or the lens. That happens frequently with Japanese cameras. From time to time verify that the speed and aperture rings are not acting up. Make sure you can focus smoothly without any jolts, and that there is no resistance for certain distances.

On this subject, it is important to carry your camera with the lens closed, that is to say, set on infinity. In case of shock, it is much less vulnerable. The longer the focal length, the more the focusing rings are in danger of being damaged in the event of an accident.

After not using a camera for several months, the oils tend to harden. Don't worry if the focusing is a little hard. As long as there is no mechanical damage, the focusing should regain its usual elasticity after you have rotated the lens a few times.

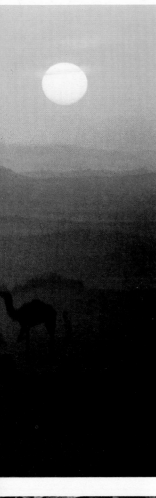

If you leave a half-exposed roll of film in the camera for several months, don't bother to develop it unless it contains some very valuable souvenirs, since it is highly probable that the film will have deteriorated by then, especially if it is color.

Before using your camera, it is important to dust it off and to make sure the shutter is functioning normally. Make sure the glass components are clean. Wipe them regularly. A thumbprint on the lens will cause a blurred picture. There are antistatic brushes that remove dust easily. If there are still traces of dirt (having first made sure you have removed any grains of sand), moisten the lens by breathing on it and wipe it very gently with tissue paper of the Kleenex type, as you would a pair of glasses. But be very careful not to scratch it.

When you change your film, use the opportunity to clean the inside of the camera with another, stiffer brush. Most scratched photos can be attributed to solid particles which get caught inside the camera between the film and the camera body. The film gets scratched as it advances.

If possible, take a sample roll before starting out on your journey. Better to waste a roll than to lose all the pictures taken abroad because the shutter was blocked or just slightly jammed. You must regularly verify the batteries of the built-in light meter if you want to avoid slides that are all white or all black, according to the whim of the exposure meter. Check your camera at least a month before your departure, since it may have to be repaired and you have to allow enough time for the repair service.

Most amateurs hand in their equipment for repair a few days before their departure, and the repair services are often full up. Even if they agree to do the job by the date specified, it is often impossible for them to give it the same care they would under normal circumstances.

As was already mentioned, never leave your camera or film out in the sun, or on the back seat, or in the trunk of a car, which in hot weather becomes a furnace. Films can lose all the brightness of their colors in just a few hours.

Always be careful when loading and unloading the camera. All of us have had at some time the unpleasant surprise of finding that the last roll of film was torn, bent or loose because it wasn't firmly joined with the sprockets. If the film doesn't advance, all the pictures you think you are taking will register on nothing. Such an accident can have several causes.

Some photographers, for reasons of economy, trying to get one or two extra pictures for their money, don't wind the film sufficiently well into the wind-up reel when they load their camera. At the least pressure the film comes loose. To avoid this you must not hesitate to wind the film well along, and to manipulate the winding lever until the sprocket holes on both sides of the film are simultaneously engaged with the sprockets that control the advancing of the film.

Naturally, by following this advice you will lose one or two shots on each roll. But that is better than having the film come loose at the beginning and thus losing the whole roll.

For good loading, after releasing the shutter and before advancing the film, wind up the film very gently without disengaging the mechanism of the camera body, until you feel a slight resistance. Starting with the next picture, when you will wind the film again, the rewind button will rotate. That is the proof that the film is really advancing.

Film can also break and become detached from its cassette if, when you are near the end of a roll, you pull too hard on the rewind lever to try to get one last shot. In case of such an accident, you have to unload the camera in the dark, wind up the film by hand and hide it from the light in a sealed box with all the risks that this additional activity can give rise to. There is the further danger that a film whose sprocket holes are damaged may not advance when it is being developed. You must never force a film forward in the camera.

At the seaside, watch out for the spray, which corrodes steel, and grains of sand, which can scratch lenses and block the mechanism.

Avoid keeping exposed film for too long, especially in warm and humid conditions. The latent image is unstable, especially for color, and it continues to evolve. Develop the film as soon as possible. Keeping it in the refrigerator in the meantime is the surest guarantee that the colors won't alter.

(1) India.1968.NewDelhi.
Bengali student.
Contarex, Sonnar 85mm,
f/5.6, 1/60 sec., Koda-
chrome.

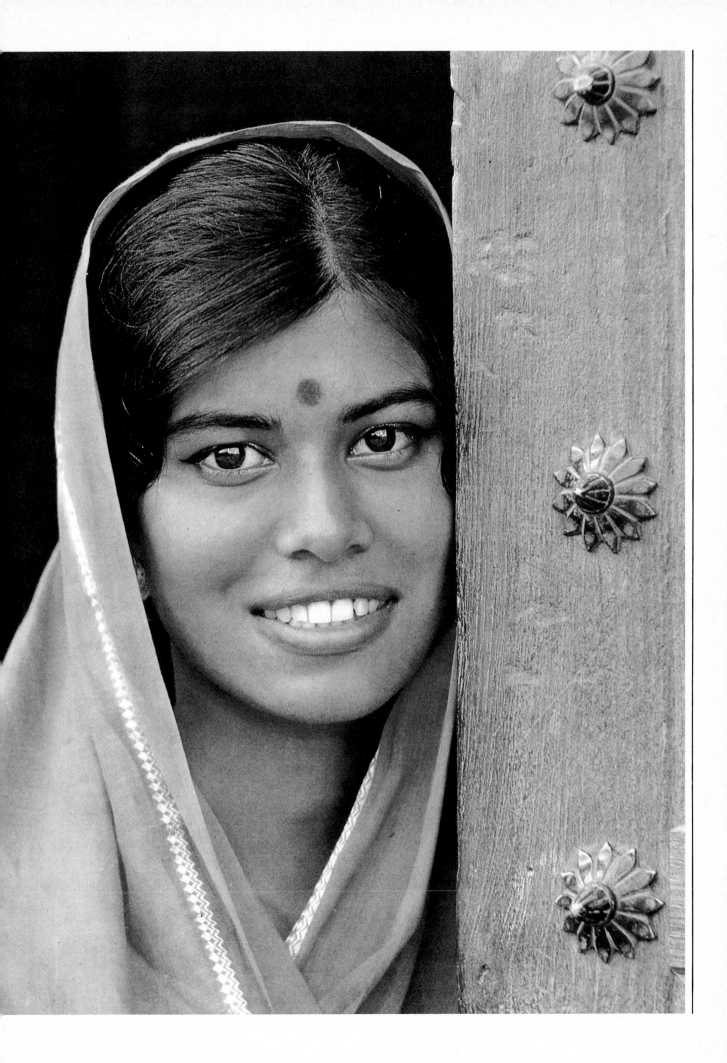

Printed in Italy by A. Mondadori, Verona